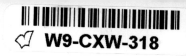

GERMAN ROMANTIC PAINTING

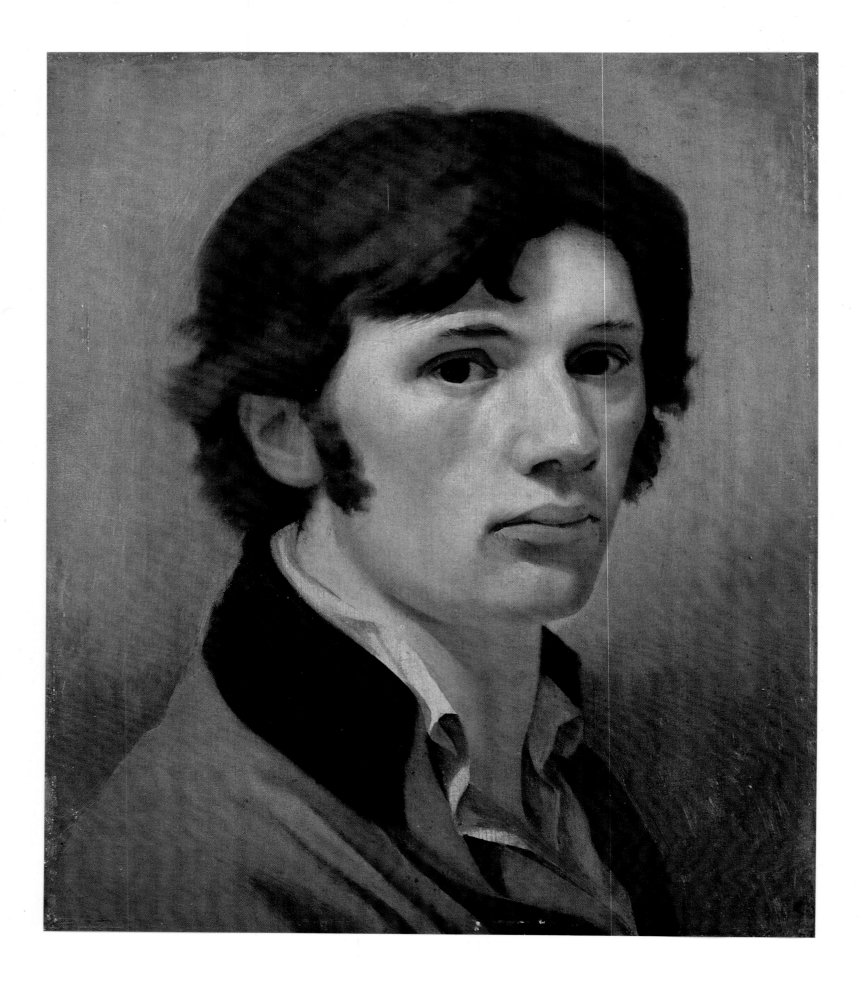

GERMAN ROMANTIC PAINTING

Hubert Schrade

Translated from the German by Maria Pelikan

Harry N. Abrams, Inc., Publishers, New York

Editor: Edith M. Pavese

Library of Congress Catalogue Card Number 72-149856
Standard Book Number: 8109-0141-2

Printed and bound in Japan

CONTENTS

COLORPLATES

WHAT IS ROMANTIC—WHAT DOES "ROMANTIC" MEAN?

The "romantic" pictures shown in this book are frequently classified as "classicistic," "romantic," or "realistic." But the distinctions which these sub-classifications try to make are often barely tenable and at times completely untenable. At the time these pictures were created, there was general disagreement as to what exactly should be designated "romantic." Friedrich Schlegel in his "Brief über den Roman" writes: "Romantic is whatever shows us a sentimental subject in fantastic form. . . . And what, then, is a sentimental subject? Everything that speaks to our sentiment—not our sensual, but our spiritual sentiment."

This is, of course, a rather wide definition, and so it cannot surprise us when Schlegel insists: "All poetry must be romantic." Nor is Ludwig Tieck's definition any more precise: "That word 'romantic' . . . has caused considerable mischief. It has always annoyed me to hear people talk of romantic poetry as if that were a special kind of poetry. People are trying to put it in contrast with classical poetry and so to establish a juxtaposition. But poetry is first and foremost poetry, it will have to be that, always and everywhere, whether we call it classical or romantic."

In a conversation with Johann Peter Eckermann (April 2, 1829) about the meaning of "classical" and "romantic" Goethe said: "I have thought of a new definition that describes the relationship quite well. I call the classical healthy, and the romantic sick. And, seen in this way, the *Nibelungenlied* is as classical as Homer, for both are healthy and sound. Most recent works are romantic, not because they are new, but because they are weak and sickly; and the old is classical, not because it is old, but because it is strong, positive, and healthy. If we distinguish between classical and romantic in this way, we will soon get everything straight."

On March 21, 1830, Goethe brought up the subject again. He told Eckermann that he had "striven to present everything in the manner of antiquity, in definite profile, and to avoid all vagueness and uncertainty as practiced by the romantic

method." And he went on to say: "The idea of classical versus romantic poetry originated with Schiller and me. I insisted on an objective approach to poetry and would not hear of any other. But Schiller, whose work had an utterly subjective flavor, thought that his was the right method and, in order to defend himself against me, wrote his essay about naive and sentimental poetry. He proved to me that I was romantic in spite of myself and that my *Iphigenie auf Tauris*, with its powerful emotions, was by no means so classical or so much in the manner of antiquity as one might perhaps think. The Schlegels picked up the idea and pursued it further; by now it has spread over the entire world and everyone is talking about Classicism and Romanticism—something no one even thought about fifty years ago." On October 17, 1828, Goethe had angrily exclaimed: "What good is all this rubbish about rules that date back to a rigid, outdated period! And why all the noise about classical and romantic! What matters is that a work is sound through and through—that's what makes it classical."

The same might be said of painting and the graphic arts in the period under discussion. True, there were definite differences in style. Some of them are very important, and we have done our best to point them out. Still, these differences are not quite so great as one sometimes tends to think, and certainly not so great as the art world of the period, with its parties, factions, and splinter groups, would have us believe. If anything, criticism had become sharper than in the preceding period. August Wilhelm Schlegel had, "in his younger days, a bad reputation. He was looked upon as a kind of Herod who had caused the slaughter of countless innocent books." And pictures fared no better than books.

But have not criticism and party politics always been part of art history? Ever since the Renaissance, writing about art has assumed increasing importance in the life of art, and greatly contributed to the formation of parties. The Renaissance re-

belled against the Gothic. But while one group considered Michelangelo its hero, another group favored Raphael—and both groups evoked classical antiquity as their criterion and impartial judge. Raphael, indeed, became the idol of the academicians. He maintained this position through the period of Classicism and with the "romantics" of the period discussed in this book. But wherever Raphael reigned supreme the Venetians, with their passion for color—which "realism" was to share with them later—had a hard time defending themselves, for there was nothing in classical antiquity that seemed to justify that passion.

Even in the sixteenth century voices had been raised against the Renaissance adulation of antiquity. Basically religious in origin, these voices objected to the "pagan" spirit which the cult of antiquity had brought with it. By the seventeenth century the religious question had begun to play a much smaller role. The slogans of the "battle between the ancients and the moderns," which was fought at the French Academy while all of Europe —or at least those Europeans interested in art— watched, were "drawing" versus "color." The partisans of drawing maintained that color was merely an addition to the basic design. The color partisans tended to see it as the decisive creative element. Only those who agreed with them were considered truly modern. Thus the concept of "painterly" and "modern" entered a reciprocal relationship that remained in effect until late into the nineteenth century.

Nevertheless, the adherents of antiquity, of Raphael and Poussin—and the proponents of drawing—refused to concede defeat. They were justified insofar as the opposing party, too, was paying homage to antiquity—in its own way. Thus it was not an unprecedented situation in the history of Western art when, at the end of the eighteenth and the beginning of the nineteenth century, "classicists," "romantics," and "realists" were aligned— or seemed to be—against each other in parties. Of course, many party differences were based on differences in creative approach. Even the old controversy over drawing and color was being resurrected. But far more important now was the religious question, which had begun to take on a new kind of significance. Added to this was the question of nationalism. Let us examine the religious elements first.

8

THE AESTHETIC CHURCH

In 1737 Balthasar Neumann began the construction of the stairway in the Würzburg Residenz. He crowned it with a giant vault of over seven hundred square yards, without central columns. This architectural feat alone deserves admiration. And, while the architect's patron, the prince-bishop and vice-chancellor Carl Friedrich von Schönborn, did not stint in admiration, one of his successors, Carl Philipp von Greiffenklau, certainly responded in spirit when he refused to leave that great vault blank. In 1750 Greiffenklau commissioned the only man who in his opinion had the creative power to paint so vast a ceiling, Giovanni Battista Tiepolo. To the Venetian Tiepolo color was, of course, more important than drawing. And there seemed to be no limits to his imagination, so that the commission to decorate the ceiling with a huge picture representing the four continents did not disconcert him in the least. He completed the work in 1753 (figs. 1–3).

The visitor to the Würzburg Residenz enters through a doorway that lies in semidarkness. On the left there is a grand staircase which one approaches with some hesitation. But every step reassures, for with every step the room becomes brighter. The staircase provides an ascension in the symbolic sense as well as in fact. Halfway up, one is transported beyond one's wildest expectations. The vault contains a sky that belies, or rather completes, the architecture, which appears to be leading toward a sky that rises above it and yet defines it. In that sky Apollo is seen before his heavenly temple in an aureole of sun rays. In the earthly regions the four corners of the earth are represented by groups of figures.

Not Christ but Apollo reigns in this heaven. He holds an object which is difficult to recognize in his upraised left hand—some say it is a statuette of Victory. But, whatever it may represent, the god holds it and gazes at it as if it were something sacred, a Palladium, a wonder-working image. No Christian could have looked with more complete

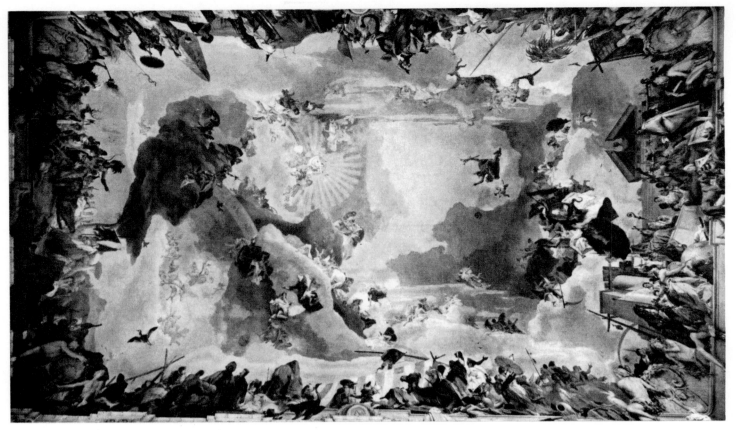

1. Giovanni Battista Tiepolo. *Allegorical fresco with the four continents.* 1752–53. Ceiling over the grand staircase, Residenz, Würzburg

adoration at the miraculous images of his own religion, for which churches were being built everywhere with all the intoxicating artistry of which the Baroque was capable.

Apollo appears here as the ruler of the world and its heaven, and he is as enthralled by a work of art as if the salvation of the whole world depended on it. But Apollo is being approached by two female figures personifying honor and glory who are presenting him with a medallion portrait of the prince-bishop. For a prince to let himself be carried into the sphere of the divine—thus competing, in a way, with the canonizations of the Catholic Church—did not seem excessively provocative once the "most Christian" king, Louis XIV, had set the example as Le Roi Soleil. But even at Versailles, with all its cosmic references in palace and park, there is no composition that has such an all-encompassing effect of architectural ascent to higher regions—with the four continents and the sky above—as the Würzburg ceiling. The fact that the portrait and not the prince-bishop himself is being elevated is in accordance with ecclesiastical custom by which the images of canonized saints are drawn heavenward. The paintings in the nave of Saint Peter's are a case in point. At Würzburg, however, the picture of the prince-bishop is not being carried

up into the Christian heaven but to the heavenly temple of the sun god of antiquity.

Christian art has shown God the Creator with the features and attributes of Christ. But Christ, as God the Creator, was never explicitly represented as the god of art. That role had been Apollo's ever since the Renaissance. The patron deity of art also became one of the favorite subjects in art. Apollo was depicted in a variety of guises, up to and including that of world ruler. Tiepolo's painting shows how far an artist could go in that respect. While that fact is astonishing in itself, it seems even more astonishing that a Christian bishop could consent to have a pagan god elevated to this position, even when confined to his princely palace; astonishing, too, that the bishop did not object to having his portrait carried toward the temple of that pagan god. One certainly has the very decided impression that art meant everything to the bishop. The reverence with which Apollo regards the artifact in his hand set a "divine" example for the art "worship" that was to characterize the prevailing attitude toward art in the years to come.

In 1755, two years after Tiepolo had completed the Würzburg ceiling, Johann Joachim Winckelmann published his *Reflections Concerning the Imitation of the Grecian Artists in Painting and*

9

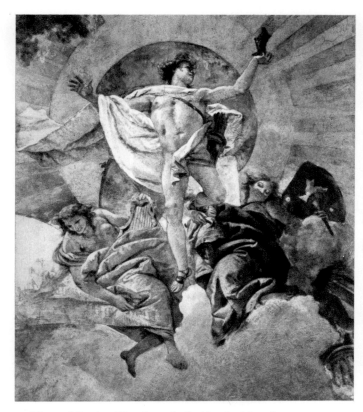

2. Giovanni Battista Tiepolo. *Apollo* (detail of fig. 1)

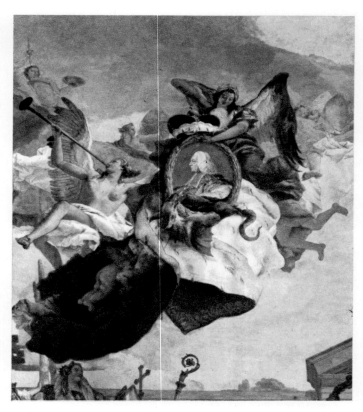

3. Giovanni Battista Tiepolo. *Prince-Bishop von Greiffenklau* (detail of fig. 1)

Sculpture. The slim monograph had an enormous effect. With complete conviction Winckelmann declared: "The only way for us to become great, nay, inimitable, is to imitate the ancients. . . . The great feature which all Greek masterpieces have in common . . . a noble simplicity and quiet greatness. . . . Just as the depth of the ocean always remains still, no matter how turbulent the surface, so the expression of all ancient Greek statues shows—all passion notwithstanding—greatness and serenity of soul."

Winckelmann did not know Tiepolo's fresco. But since he rejected the "impudent fire" of the Baroque even though he appreciated its art, he would necessarily have had to reject Tiepolo too. The question remains, however, who was more of a "pagan": Winckelmann, the "new antiquarian" who wanted to remain a "pagan" in spite of his conversion to Catholicism, or the prince-bishop who let the most luminous of pagan gods be worshiped as god of the world and yet considered himself a Christian.

At that time, it seems, art had the power, and with this power the ambition, to abolish the boundaries between antiquity and Christianity, or at least to create the illusion that they had been abolished.

Another member of the highest aristocracy, another prince of the Church—not merely a bishop but a cardinal of the Curia—was Alessandro Albani. From earliest youth he had been so obsessed with classical antiquity that he refused to be ordained a priest. Instead he aspired to and attained the office of cardinal-deacon. The prince "is now building a villa," wrote Winckelmann in 1757, "a miracle of art in all men's eyes . . . the most admirable object in Rome . . . except for Saint Peter's Cathedral, his villa surpasses everything that has been built in recent times." This comparison with the noblest sacred edifice of Christendom must not be dismissed as a mere phrase. For Cardinal Albani was "the greatest antiquarian in the world; he brings to light what has been buried in darkness." Note the religious tone. The cardinal built his villa in order to preserve in the light of Apollo what had been wrested from darkness. Its chief inhabitants were to be not human beings but statues, columns, capitals, and inscriptions from monuments.

In 1760 Albani commissioned Anton Raphael Mengs to create a ceiling painting for the main hall of his villa (fig. 4). Of course the picture had to show the patron god of the arts for whose sake the villa had been built, and, indeed, it does show

Apollo and the Muses. This *Parnassus* is considered the essence of German Classicism. And it was its strict Classicism that made that picture a sensation in Rome and beyond. "Mr. Mengs's ceiling," writes Winckelmann, "amazes all who see it; it seems a work of magic." If any fresco deserves such extravagant praise, it is Tiepolo's. Mengs's painting is by no means magical. In every respect it represents a protest against Tiepolo's work.

Tiepolo's fresco is unthinkable without the architectural space it arches over. It raises and widens that space to cosmic proportions. Mengs's work is an easel painting moved onto a ceiling. As such it cannot and does not make allowance for the fact that the viewer must look up at it. It does not belong on a ceiling but on a vertical wall, for like all easel paintings, it calls for the viewer to stand facing it. Here space is merely background for the figures and, as such, does nothing to diminish the importance these figures claim for themselves. As for the figures themselves, Winckelmann ventured the opinion that "Raphael has produced nothing to compare with them and none of his works were of such sublime perfection." Mengs himself was presumptuous enough to insist that in his drawings Raphael had not attained the truly beautiful style.

His outlines, Mengs said, lacked elegance, distinction, delicacy; his Madonnas, modeled after Roman peasant girls and not copied from antiquity, were trivial and coarse. At least Winckelmann's judgment of Raphael's *Sistine Madonna* was a far cry from Mengs's. But that did not stop Winckelmann from regarding Mengs as "the greatest artist of his time and possibly of future times as well." "He has risen phoenix-like from the ashes of the first Raphael to teach the world about beauty with his art, and to soar to the loftiest heights of human accomplishment."

Of course, we really cannot agree with this high praise. Apollo and the Muses do not even appear to stand in any convincing relationship to each other in Mengs's picture. They do not really form a group, if we regard a group as something more than a mere physical configuration. The god is only superficially the center of the composition. Nothing emanates from him, nothing leads to him. What mainly distinguishes him from the other figures is the fact that he stands taller than the Muses and that, in contrast to them, he is nearly naked, a straightforward nude. The Apollo Belvedere, undoubtedly one of Mengs's models, radiates immeasurably more dignity and divine luster than does

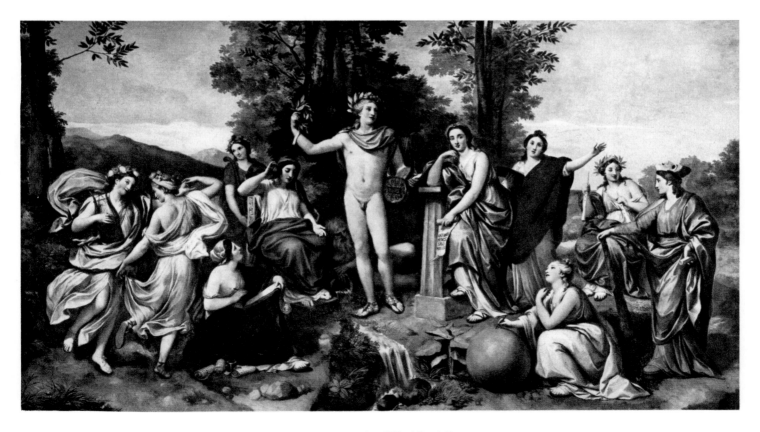

4. Anton Raphael Mengs. *Parnassus*. 1761. Wall painting, 9'10" × 22'4". Villa Albani, Rome

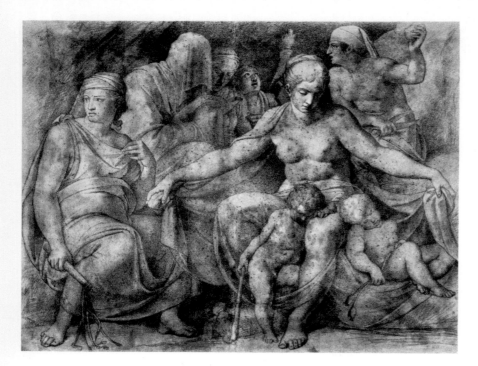

5. Asmus Jacob Carstens. *Night and Her Children*. 1795. Pencil, 36 × 46″. Nationalmuseum, Weimar

this figure. Mengs's nude proves him to be the kind of painter who knows all the rules of art and how to apply them cleverly, thinking that cleverness is all that is needed for the creative process. The divine spark that still animates Tiepolo's Apollo—which Winckelmann probably would have branded as "impudent fire"—is missing from Mengs's work. It has been smothered by rules, and so has imagination. We are left with a cold, artificial figure which should by rights be ashamed of its nakedness. But it isn't. It exhibits itself in an affected pose. No matter how religious a man Mengs himself may have been, his Greek god is totally devoid of religious fervor. And Winckelmann was badly deceived in thinking that Mengs's picture could reaffirm his own paganism. Friedrich Hölderlin's admonition, "Be pious as the Greeks were!" might well apply to Winckelmann. But Mengs certainly does not evoke the kind of piety Hölderlin had in mind. Even Goethe, in the second chapter of his work on Winckelmann—entitled "Heidnisches" (Pagan)—far outstrips Mengs's approach when he refers to the pure "veneration of the gods as ancestors, as opposed to the mere admiration of works of art." Mengs's Apollo is a perfect example of what happens when art has become totally separated from the divine. "We're too late, my friend! For the gods, though their life is eternal,/Dwell among us no more, but high above our heads." Those lines by Hölderlin might bring to mind Tiepolo's fresco, except that the poet then

continues: "There, in their world without end, they hardly seem to acknowledge/that we too are alive, such is their heavenly love."

It has often been said that Asmus Jakob Carstens, a Schleswigian by birth (1754–1798), was Mengs's successor in classicistic art. It is true that in his early years Carstens was deeply impressed by Mengs's *Considerations on Beauty and Taste in Painting* (1762), but that did not last. While still at the Copenhagen academy, which did not live up to his artistic expectation, he had studied the reproductions of Greek statues with awe. But he was equally enthusiastic about Ossian—so much so that he composed some bardic songs in Ossian's style. The uncanny, the darkly fateful, the colossal aspects of Ossian attracted Carstens. This explains why he valued Michelangelo above Raphael. Soon after his arrival in Rome he felt entitled to write: "People stare in amazement; they don't understand how I was able to bring the great style from Germany to Rome, nor how I came by it."

In 1795 Carstens arranged an exhibition of his work which did not contain a single oil painting —only drawings and watercolors. He never really became a painter, but remained a draftsman all his life. This could be taken as a sign of rigorous adherence to academic Classicism—if Carstens had still been an academic Classicist at that time. But he was no longer anything of the sort, as his cartoon of *Night and Her Children* (1795; fig. 5) shows. Mengs would undoubtedly have deplored it. He would not have acknowledged this accumulation of figures as a group—thinking that he had succeeded in creating a perfect example of a group with his *Parnassus*. In Carstens's picture there is no center, no symmetry, no apparent unity, no space, but only the indication of a cave so low that none of the figures would be able to stand upright in it.

Viewed by an academically trained eye, the composition seems to defy all the rules. Nevertheless it demonstrates an inner law of its own. What seems like arbitrary arrangement is actually the result of a sense of order which consciously ignores schemata in favor of its own creative freedom. The figure of Night is seated at the right. Spreading her mantle, she displays her children and her own beautiful motherly body. To judge by their attributes, the children represent Sleep and Death respectively. To the left of Night is Nemesis. She is

seated, but she seems ready to leap to her feet. Her right hand holds a scourge, and her left toys with a fold of her clothing. Her gaze is directed at something outside the picture which remains undefined for the viewer, but which she fixes with such purpose that her gaze becomes threatening. Her tense, collected, momentary attitude contrasts with the timeless unfolding attitude of Night. It is a contrast comparable to that between contemplation and threat, between the protective, embracing mother and the avenging heroine. Behind the latter sits the figure of Destiny, stooped by age and with her head veiled. She is reading in her book, a sacred object which she holds in veiled hands. Two of the Fates, Lachesis and Clotho, sit beside her; Atropos, the unchanging, sits apart, facing her sisters, directly behind the mother figure of Night. Like Night, she is half draped, but her posture and the expression of almost mannish relentlessness place her in sharp contrast to the mother figure.

According to Carl Ludwig Fernow, Carstens took the subject of his picture from Hesiod. But it seems equally probable that he was influenced by the *Götterlehre* (Mythology) of Karl Philipp Moritz who, in contrast to the proponents of academic Classicism, felt that true creativity must be based on the imagination. To him art was the "language of the imagination." Moritz envisioned, in addition to the bright light of Apollo—indeed, within that light—the darkness of unfathomable, inexorable fate: he envisioned night as well as day. "Night," he writes, "hides and veils everything, which is why she is the mother of all beauty, and of all terror, too. Out of her womb is born the radiant day in which all forms unfold. And she is also the mother of Destiny in all her enigmatic darkness, of the relentless Fates . . . of avenging Nemesis . . . of the brothers Sleep and Death." These ideas are not derived from Homer—who represented Apollonic day for this period—but from the chthonic depths of Hesiod.

This distinction touches upon the basic difference between Mengs and Carstens. There, the bright light of day in which the figures are posed; here, the half light of a cave that might well be the entrance to the netherworld. But the remarkable thing is that against the darkness, the menace, and the inexorable sense of fate Night in the beauty of her body appears definitely turned toward the light of day. Her children, on the other hand, are merely harmless boys.

Carstens had turned from Christianity early in life. The dark powers of fate meant more to him than Christian providence. "He placed his religious faith in art," says Fernow. Even in Copenhagen he stood before antique statues with a "holy sense of reverence." It is remarkable, though, that the fateful image of Night, in spite of its paganism,

6. Johann Samuel Bach. *Ideal Landscape.* 1776. Kunsthalle, Hamburg

7. Daniel Nikolaus Chodowiecki. *The Enlightenment.* Etching

13

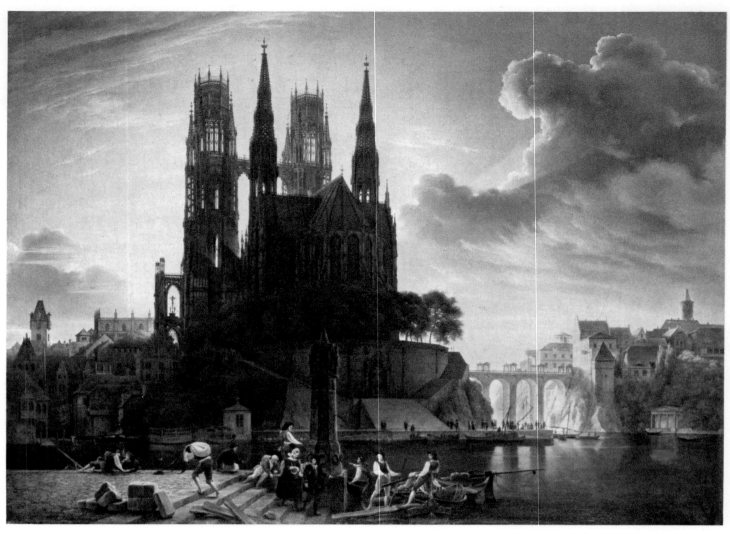

8. Friedrich Schinkel. *The Cathedral*. 1815. Oil on canvas, 28 3/8 × 38 5/8″. Neue Pinakothek, Munich

suggests the influence of Christian imagery. Neither in classical antiquity nor in post-classical art had Night ever been represented as wearing a mantle in which to hide her children. The protective mantle, on the other hand, is a very familiar attribute of the Virgin as patron saint. And the figure of Destiny is holding her book in veiled hands—a custom once prevalent in Christian ritual with respect to the Bible. It is quite possible that the artist was unconsciously influenced by these Christian motifs, whereas the influence of Michelangelo must have been far closer to the conscious level. But the Christian influence remains a fact for art historians to ponder. Conversely, we have to admit that Carstens's *Night* would look quite different if his interest in Hesiod had not been preceded by his enthusiasm for Ossian's mist-shrouded figures. The cave motif could be traced back equally to Ossian or to Christian paintings.

Landscape painting had never played a significant part in Carstens's work. But when he was near death, he drew a paradisiacal landscape with idealized figures, the *Golden Age*. To him, that golden age lay in the future not the past. The picture was meant to embody his vision of eternal beatitude, for he believed himself to be a pagan to the end. Never having been much interested in landscape painting, however, his waning powers could not take him beyond the commonplace, despite Joseph Anton Koch's encouragement and friendly suggestions.

Koch painted the human figure too, but for him landscape was the essential thing. His great *Landscape with Rainbow* (colorplate 4) of 1805 is a milestone in art. The flat foreground of the picture is framed, on the left, by a rock with some trees growing on it and, on the right, by a group of trees and shrubs. The frontal plane, which rises very slightly toward the back, is crisscrossed by trees and bushes and a winding brook in an animated rhythm of light and dark greens, pinks, whitish and grayish tones. Behind the plain we see hills, mountains, mountain ranges. In the distance, where the sea blends into the land almost without

14

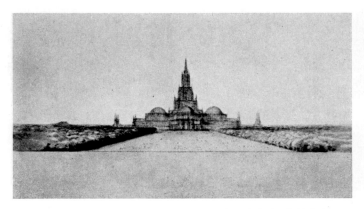

9. Friedrich Schinkel. *Design for a National Cathedral.* Schinkelmuseum, Berlin

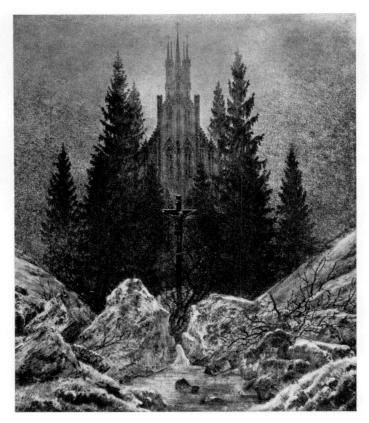

10. Caspar David Friedrich. *Church in the Mountains. Enchanted Church* c. 1820. Oil on canvas, 17 3/4 × 15". Kunstmuseum, Düsseldorf

transition, the mountains become somewhat lower and take on a bluish tinge. Over it all is a large sky full of heavy clouds with occasional patches of vivid blue that becomes lighter toward the horizon. A great rainbow spans the entire wide countryside. Where the mountains rise from the plain stands a fortified city, and on the slope behind it, another city that seems even more fortress-like. Both cities are in full daylight, but the lower is the more luminous of the two. Its walls, gates, towers, and houses are dominated by a classical temple. It does not actually lie in the center of the city. Nevertheless, it forms the core of the entire composition. It almost seems as if the rainbow had been flung across the world chiefly for that temple's sake.

In the foreground, at the left, we see a shepherd and his flock. He leans against a rock, playing his pipe, while two girls, one in red, the other in light blue, listen. The second girl is pointing toward the temple city with her right hand. The group is completely integrated into the landscape. Actually the girl's gesture is superfluous. By its shape and appearance the temple city can be recognized quite easily as the holy city it is meant to be within the context of the picture.

At the time Koch painted the picture a common saying was that architecture is "frozen music." Goethe referred to it, too, but while Goethe derived "the highest moral and religious enjoyment" from the harmonious organization of an edifice, Koch felt impelled to add a formal touch of consecration to his city by providing it with a sacred building. But the sanctifying power is here vested in a Greek temple rather than a Christian church. It radiates light as if its god's day had not passed. Koch's entire landscape has been called heroic, perhaps

rightly so. Certainly it is "heroic" for a pagan temple to assert itself thus in a Christian world. On the other hand, the pastoral scene in the foreground is an idyl with no heroic context whatsoever—as is the boat in the middle ground, gliding along so quietly, with the water reflecting it and its occupants. The grandeur of Koch's design—despite the idyllic element both in the city and in the landscape at large—becomes even more apparent if we compare his picture with an ideal landscape (fig. 6) by Johann Samuel Bach, a son of Philipp Emanuel Bach, the composer.

In Bach's picture, dated 1776, all is idyl. The temple stands on a hillside, surrounded by "atmospheric" ruins, and is itself a ruin. Before a statue of a goddess some women and girls are performing a ritual that seems more graceful than deeply religious. The statue is almost in the center of the picture, but at some distance from the temple. The aqueduct in the middle ground, which emerges briefly from the woods, attracts the viewer's eye nearly as much as the temple. Unquestionably Koch's landscape is much more definite, more articulated, and—despite the ideality which it, too, retains—much more "real." Its temple, by virtue

15

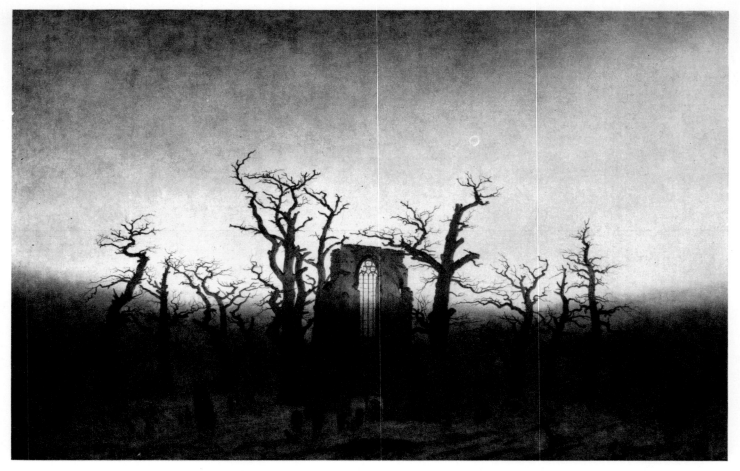

11. Caspar David Friedrich. *Abbey Amidst Oak Trees.* 1809–10. Oil on canvas, 43 5/8 × 67 3/8″. Staatliche Museen, Berlin

of its position in the picture and the light that lies on it, appears more hieratic. Of course this hieratic effect is of a purely aesthetic nature.

There are examples of such hieratic moments in Nicolas Poussin's work. But Koch's landscape is more "realistic," which places the aesthetic, quasi-religious power represented by his temple in a different relation to the real world. We can understand the kind of power Koch had in mind when we recall Tiepolo's fresco, described earlier. The Baroque master, in a flight of the imagination that carried him beyond all earthly boundaries, felt no compunction about placing the temple of the god of art in his heaven. Koch brings the temple of art back to earth.

Koch's picture was completed in 1805. In 1804 Beethoven finished the *Eroica*, which he had originally wanted to dedicate to Napoleon. There is no trace of the idyllic in Beethoven's symphony. A decade later Napoleon was defeated. The Germans hoped for a unification of their country, which was split up into many small states. This unification was to bring about a renewal of the national life; all foreign elements were to be eliminated. Ger-

mans sought to find a more intimate contact with their own past, and to many, this national renascence also meant a religious revival; in fact, they considered it essential. Prussia, having led the insurrection against Napoleon, seemed destined to lead the religious renewal as well. *The New Church* was the title of a pamphlet, published anonymously in Berlin in 1815. Its author was a Protestant theologian, Martin Leberecht de Wette, who had been appointed a member of the newly founded University of Berlin in 1810.

De Wette fought against the Enlightenment. What he strove to establish was not uncritical faith but "reason and faith in alliance" with each other. Such an alliance was only possible, De Wette felt, if faith prevailed over the *Zeitgeist* (spirit of the times). For the latter "decides which images are comprehensible, stirring, inspiring for each period . . . it rebels against the old images and rejects them; now it must either create new ones or rejuvenate the old ones. . . . But which images are the right ones has long been an issue dividing and confusing us; and doubt as to whether the current images are the right ones has caused the decay of our religious life.

12. Georg Wilhelm Issel. *Gray Winter Day at the Bodensee.* c.1816/17. Oil on canvas, 14×20 1/4″. Kurpfälzisches Museum, Heidelberg

13. Johann Friedrich Weitsch. *The Tomb of Anton Raphael Mengs.* Kunstmuseum, Düsseldorf

"Art and poetry . . . [are] for the educated person of our time the most effective inspiration of religious feelings. Faith most directly manifests itself in feeling. But the best servant of religious feeling is art." Actually De Wette did not so much think of painting and sculpture because, he said, they worship "human beauty." What he had in mind was the "most spiritual" of the arts, namely, music. The Protestant in him felt duty bound to reduce the importance of pictorial art. But then again he was unable to renounce the love of pictures altogether. Anyone who denies that pictures have the power to awaken religious feelings and make religious statements cannot, after all, be a truly cultivated person. And although "in the sight of God the faith of the educated and the uneducated is alike," De Wette always speaks as an educated man addressing educated men. The Enlightenment had been hostile toward traditional religious art—it would have liked to do away with it altogether. And if such "pagans" as Winckelmann, Carstens, and Goethe rejected Christian subjects, their attitude was chiefly rooted in the Enlightenment, which, in turn, was undeniably Protestant in origin. In 1792 Daniel Nikolaus Chodowiecki published an etching entitled *The Enlightenment* (fig. 7) in the *Göttinger Taschen Calender*. The Enlightenment, he says in the accompanying text, could and did have its ridiculous aspects. Nevertheless he considered it a necessity. As yet it had only a few symbols, the most genuine of which he felt to be the rising sun. And so Chodowiecki shows the sun, casting its light upon a landscape in which a church steeple is seen. But the church is architecturally quite unimportant, and it is dwarfed by both the tall trees in the foreground and the sun, which rises in full radiance above the distant mountains. Chodowiecki's

etching is not a great work of art. But we may well regard it as a symbol, created by the *Zeitgeist* and valid within its context. Even De Wette would have acknowledged it as such. He demanded that members of the clergy be the "most enlightened of our contemporaries." But a theologian does not have the same freedom as an artist. No matter how earnestly he strives to be cultivated, he must also affirm his faith in the Church at all times. Thus De Wette demanded that "in every larger town, in every metropolitan or provincial capital, there should be erected a great temple . . . in the noble style of ancient German architecture . . . as a monument to our newly resurrected religion and the salvation of our fatherland." He felt he might even welcome a return to those "pious monastic institutions" that had put their mark on the old German churches—more often than not in the form of pictures—provided they remained "pure and free" from all "superstition."

In those years De Wette's wish for a "noble temple in the old German style . . ." was given visible shape by Friedrich Schinkel. True, Schinkel did not actually build such churches; he only painted and drew them (fig. 8). Again and again his imagi-

17

nation was aroused by the image of an "old German," i.e., Gothic, cathedral dominating a city. Of the pictures he created on that subject there exist two almost identical ones in Berlin and Munich. The cathedral stands on the bank of a river, on a rocky hill buttressed by a wall. This makes the hill seem like the base of a monument. A circle of trees in full foliage surrounds the cathedral, whose apse, transept, and four towers are clearly visible. The main towers are only loosely connected to the brownish body of the church and are more transparent than the main body. We can only assume that the church interior must be shrouded in holy darkness shot through by occasional glimpses of silvery light. A two-story porch, attached to the side of the left tower, contains a Crucifixion which we see in silhouette against the light sky. There is another, larger Crucifixion facing the viewer in a niche set into the base of the cathedral. It is almost directly in the center of the lower half of the picture. A grand staircase leads up to it and helps draw the viewer's eye toward it.

The city is seen on either side of the cathedral.

Unlike the cathedral, it is not entirely Gothic in style. There are a few Gothic houses, some Renaissance, even some classicist buildings. The river flowing at the right of the cathedral is spanned by a high bridge with rounded arches, leading from the cathedral to the city on the opposite bank. There are tempietti and monuments on the bridge, but we cannot tell whether these belong to the church or to the temple-like building behind the bridge. Another, smaller temple stands at the edge of the river, as if under a spell, in a little grove below the city.

What is very strange is the immediate foreground, which stands in open conflict to everything described so far. It contains a fisherman's wharf with a stout pillar marking its location. An animated group of men in bright clothing is assembled, among them fishermen, anglers, sailors, porters, and a man leading his wife toward a boat where some sailors wait. The whole scene has a genre quality not really in keeping with the awesome grandeur of the cathedral.

Another wharf is on the opposite bank, and

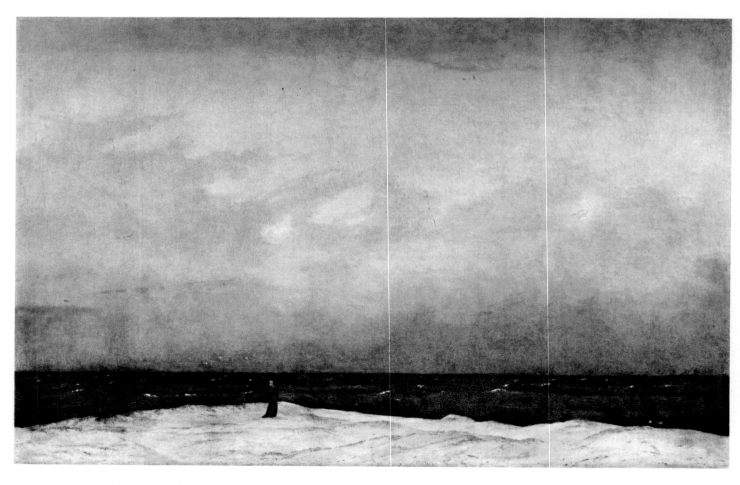

14. Caspar David Friedrich. *Monk by the Sea.* 1809. Oil on canvas, 42 1/2 × 67". Staatliche Museen, Berlin

18

there too we see boats in the water and people walking or standing on the shore. They seem rather shadowy compared to the clearly defined figures in the foreground. But that is just what adds a touch of mystery, almost a ghostliness, to the activity beneath the brightly illuminated bridge. The figures seen in silhouette up on the bridge are similarly ethereal—as are the two tiny people at the top of the stairway to the right below the cathedral. How did those two get to that spot? Did they come across the bridge or up the stairs? They would be the only people actually to have used those stairs. The stairway is very broad and inviting—yet not one of the people on the riverbank seems to show the slightest desire to accept the invitation. The grand staircase is empty of people, all the way up. Compare that to the steps that lead to the wharf in the foreground! Even its color is lively—a cheerful reddish tone—whereas the stairs leading to the church are dull brown, blending into the deep shadow all around. Those muted browns not only make the emptiness of the stairs more apparent, they actually make them look like a forbidding or forbidden realm.

What kind of cathedral is that to which no one ascends, despite the invitation extended by its stairs? The two people at the top of those stairs are mere shadows. They appear to face the radiant setting sun, as if the sun were the true source of divine revelation. The figures of the Crucifixion on the left of the cathedral are also facing the sun. The entire cathedral faces it. This is why the choir and nave are in shadowy darkness and the spires stand dark against a radiant blue sky. Even the dark clouds have moved aside to let the sunlight emerge in its full brilliance. As a result, the houses and the upper temple at right are bathed in light. The same warm light does not touch the western side of the cathedral. The church on the whole appears dark, powerful, threatening. Although its spires point skyward, it does not represent a true *sursum corda*. The hearts of men are not drawn to it, no worshipers approach. The cathedral seems a tall, gloomy monument to a church rather than a church itself. The painting is the product of a mind whose knowledge of cathedral art combined with a vivid imagination to inspire the creation of this memento of vanished forces that long ago drove men to build such edifices.

Actually at one time it looked as if Schinkel

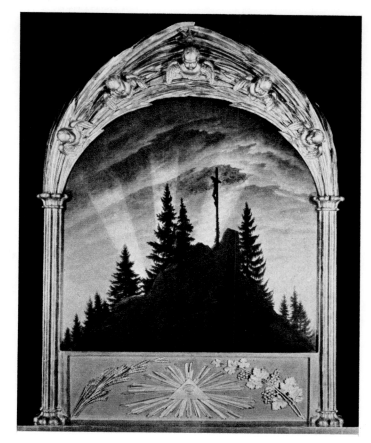

15. Caspar David Friedrich. *Tetschener Altar (Cross in the Mountains)*. 1807–08. Oil on canvas, 45 1/4 × 43 1/2″. Gemäldegalerie, Dresden

might really build the kind of church he had created on canvas. After the Wars of Liberation many felt that a suitable monument should be built to commemorate the essence of what those wars had accomplished. King Friedrich Wilhelm III was very enthusiastic about the idea. But unlike many other people, he felt that such a monument had to be a church—a Gothic church. And if there were any German architect with the imagination needed to design such a church, Schinkel was that man.

The master actually began work on the project, but it never went beyond preliminary designs, fascinating drawings, brilliant statements. Schinkel hoped his cathedral would become a center of artistic endeavor for the entire nation (fig. 9). In a period that scattered its energy in various diversions, it seemed extremely important to "concentrate all the nation's energy in a single worthy object," that is, a great artistic enterprise that was to be carried over from generation to generation and find renewal within each new generation. To Schinkel this seemed more fruitful than "a hundred years of academic teaching."

Schinkel's plans miscarried for many reasons. Aside from political causes, there were definite religious and artistic reasons for his failure. Like De Wette, Schinkel wanted his cathedral to serve

16. Adolf von Menzel. *Make Way for the Great Raphael*. 1855. Germanisches Nationalmuseum, Nuremberg

arouse an emotion that will elevate the aesthetic experience above mere enjoyment by means of the sublime tinged with the quasi-religious. Their pictures demonstrate what Wilhelm Heinrich Wackenroder expressed in words: "The Gothic church and the Greek temple are equally pleasing in the sight of God."

as both a church and a monument. This in itself would not have been a completely incompatible combination, as the Baroque churches dedicated to Santa Maria della Vittoria have shown. But Schinkel's monument-cathedral lacked the religious foundation on which those Baroque churches had been built. Of course, we know of many churches that took hundreds of years to complete, but none of them had been begun with the explicit idea that, as a matter of principle, work on them should outlast the generations. There is no religious justification for such planning, and Schinkel's plan was not based on religious but solely on artistic ideas. Generations were to work on the cathedral for the sake of the renascence of art. Schinkel's cathedral would have been an "aesthetic church," just as the temple in Koch's rainbow landscape is purely an aesthetic temple.

The idea of an aesthetic church seems to have originated with the poet Friedrich Hölderlin's brother. In a letter dated June 4, 1799, the poet refers to it, and points out the difficulties of organizing such a church. But "the highest goal provides the best test," and so he concedes that its realization might well represent the "ideal of all human society." Schinkel's cathedrals and Koch's temples are very different in shape and style. But both are symbols of the idea of the holy as seen from the aesthetic viewpoint. They have no relation to actual forms of religious worship; they are meant to

THE ENCHANTED CHURCH

Caspar David Friedrich must have painted the little picture of a church in the mountains (fig. 10) about the 1820s. Brown, somewhat stagy-looking rocks form the foreground. A little stream runs between them, emerging in the exact center of the picture, directly beneath a crucifix which is surrounded by black withered branches. Behind the crucifix we see a Gothic church whose predominantly brown tones blend into the landscape. It is flanked symmetrically by dark brown and dark green fir trees. Though the church is set back between those trees, its spires rise above them. The sky is very close; toward the horizon, if we can call it a horizon, it is shrouded in gray-green fog, but near the top of the picture it brightens into pink, then to a stronger red.

The crucifix is solitary, as the church is deserted. Access to the crucifix is blocked by rocks and water; the church is both hidden and protected by the trees. The water, which springs forth from beneath the cross as a source of life (a time-honored Christian conceit), but for no one's benefit in this wilderness; the cross, which stands in a totally inaccessible spot; the church, to which no road seems to lead—all these are self-explanatory symbols for something that has been removed to a realm of utter solitude, something that can be com-

20

prehended by lonely spirits only. The sky alone, as it glows red through fog and mist, seems to hold a promise of something ineffable, something that might set even the loneliest of men on fire with hope. It hardly seems possible to imagine a deeper loneliness than that shown in this picture. Both the church and the cross seem to stand under a magic spell.

And yet Friedrich could descend to even deeper levels of solitude. As early as 1809 he painted a large picture, now lost, which, according to his own description, showed the interior of a ruined church. What is particularly noteworthy is that he modeled his ruined church after the Cathedral of Meissen, which stands to this day and is in excellent condition. Friedrich's church interior contained no worshipers, only rubble, broken altars, shattered statues. "The splendor of the church and her servants is a thing of the past; a different time, a different yearning for clarity and truth, have emerged from the ruins." Standing on those ruins, he had painted, "the Bible in his left [hand], and his right hand over his heart . . . a Protestant clergyman gazing thoughtfully up at the clouds floating lightly in a blue sky."

This may well have been a regrettable descent into episodic art—as was the "gothic" scene in Friedrich's *Hutten's Grave,* now in Weimar. But the rest of the lost picture may have been as powerfully effective as the Berlin work, *Abbey Amidst Oak Trees* (fig. 11). The oak woods are a thing of the past; all that is left of them in the painting are dark trunks whose bare branches rise above a dense layer of ground fog and stand in bizarre silhouette against a bright sky. These trees surround a ruined abbey. The remnant of the building probably was its facade. Its strictly geometric tracery is still recognizable though no longer complete. Nevertheless we sense the contrast between those geometric forms and the bizarre vegetative shapes of the dead trees. Perhaps it would be going too far to interpret the three circular panes in the window arch as symbolizing the Trinity. And yet such symbolism has been known to crop up in the work of the Romantics, as it had in the Middle Ages. More important, within all the fog and mist, and among the denuded, ghostly trees, a severely geometric configuration recalls a religious reality that has fallen into ruin.

Within the portal of the ruined abbey appears

yet another geometric form: the cross. But it is completely steeped in shadow. Certain religious ceremonies are still taking place in this ruin. But they are only burial rites, and they seem absurdly misplaced. A group of monks is carrying a coffin, presumably that of a dead brother, past the cross in the doorway. But where are they taking it? The interior of the church, if it can be called an interior, cannot contain anything but snow, the same snow that covers the cemetery outside, and disembodied brownish darkness. The grave into which the coffin is to be lowered can be seen in front of the ruin, almost in the center of the picture. The dark crosses marking the graves are so similar in color to the monks' habits that we get the eerie feeling they stand in some deep relationship to each other: the grave markers seem demonic live beings; the monks, creatures of the night. But the sky, above the layer of mist that rests on the snow-covered earth, is high and bright.

Certainly this picture is as different as possible from Carstens's *Night and Her Children* (fig. 5). But when you think about it, isn't there a connec-

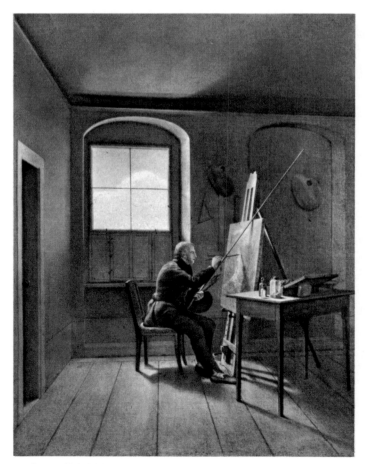

17. Georg Friedrich Kersting. *C. D. Friedrich in His Studio.* 1811. Oil on canvas, 21 1/4 × 20 1/2." Kunsthalle, Hamburg

21

18. Caspar David Friedrich. *Moving Clouds*. 1821. Oil on canvas, 7 1/4 × 9 3/4". Kunsthalle, Hamburg

tion between them after all—a common tendency toward the dark side of life? Each picture symbolizes inexorable fate in its own way. Brought down to essentials, the difference between Friedrich and Carstens is not so great as that between Friedrich and Mengs. But we can see how the difference even between the two last-named artists can be minimized when we study a picture (fig. 13) by Johann Friedrich Weitsch (1723–1803). The picture shows the tomb of Mengs and a female figure representing Art, who mourns the artist's death. The whole composition of this picture, its underlying sentimentality, are "romantic." Of course the footpath leading toward the brightly lit clearing in the background, right, seems destined to end in some quite worldly Elysium or Arcadia.

Both motifs, the ruined monastery and the tomb in a landscape, can be found in Baroque painting. For the former we need only remember the

painting of a monastery by Jacob van Ruisdael, which Goethe describes: the intention of "presenting the past within the present has been most admirably fulfilled. The dead has been brought into closest touch with the living." For the latter motif, we might cite Poussin's *Funeral of Phocion* in the Louvre. A later example is Albert Meyeringh's (d. 1714) Hamburg landscape.

All these pictures have one thing in common: they show the past through the present. In Friedrich's pictures the past can testify only to a surmise of the freedom that reigns on high, of the heavenly power of salvation. What he wished, or perhaps we should say, what he dared to wish, may become clearer when we listen to Johann Georg Sulzer: "To turn our churchyards into burial places is the kind of abuse about which there has lately been much noise." Friedrich can't have thought much of that "noise." His picture rejects it as decisively as

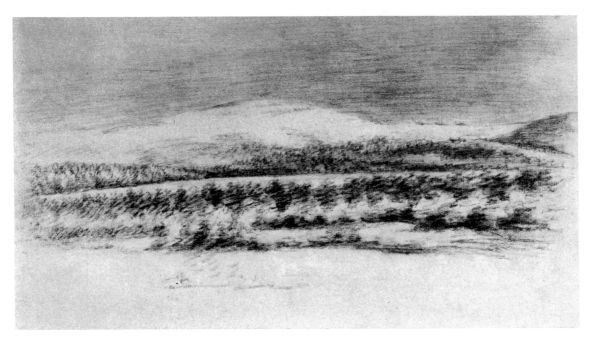

19. Johann Wolfgang von Goethe. *The Brocken.* Goethe Nationalmuseum, Weimar

it rejects all worldly ideas of a "hereafter." This is most impressively shown in his *Monk by the Sea* (fig. 14), which caused a sensation when it was exhibited at the Berlin Academy in 1810.

The foreground shows an inhospitable snow-covered beach with sparse dirty brown grass growing on it. It is washed by the dark, dark sea, streaked with brown, full of uncanny bluish-glinting whitecaps. The horizon is a distinctly defined straight line from which a blackish haze rises upward. The sky is gray, brightening a little near the top of the picture. It takes up three-quarters of the entire picture surface. On the beach stands a monk in brown habit, his back to the viewer. His posture expresses profound worship. It is difficult to imagine a more deserted place than this beach; in the picture it is as if it had been exiled from the earth. The monk, too, seems an exile—no longer human, a mere faceless shadow—a tiny helpless being face to face with the glowering ocean under an endless sky. To become a monk, he had to turn his back on the world. In so doing, however, he had entered into a community with others who had done the same. But here he is alone, despite the habit that bears witness to the community. He is inexorably alone, truly monastic. He has left everything behind: the "world," his brothers, the monastery. And why shouldn't he? Wasn't his monastery in ruins? Wasn't a burial ceremony the only form of worship still taking place there? What was there to bind him to a place where in

former times the never-ending praise of God had been heard and solemn festivals had been gloriously celebrated?

Yet even in this wilderness to which his spirit has driven him, his reverence for the eternal has not deserted him. Deeply moved and profoundly worshipful, he stands before the boundless sea and its mystery, before that vast sky which appears immeasurably greater and mightier than earth and sea. True, its huge expanse is brightened here and there with a light that vaguely promises another world. But that vague promise is all. Thus we cannot imagine the monk turning and going back to the community of worshipers from which he has come.

"It is magnificent," wrote Heinrich von Kleist, who saw the picture at the Berlin Academy exhibition, "to gaze upon a limitless body of water in endless solitude on the ocean shore under a darkling sky. But one must have walked to this place, one will have to go back, one wants to get to the other side and cannot, one is stripped of everything needed for life, and yet one can hear the voice of life in those roaring waters, that rushing wind, those moving clouds, and in the lonely cry of birds."

"Man can stand without fear, if he must/ alone before God, his childlike faith for a shield" (Hölderlin).

There were others who felt quite differently about the picture. We read in the *Berliner Abendblatt* of 1810 that a governess who had brought two

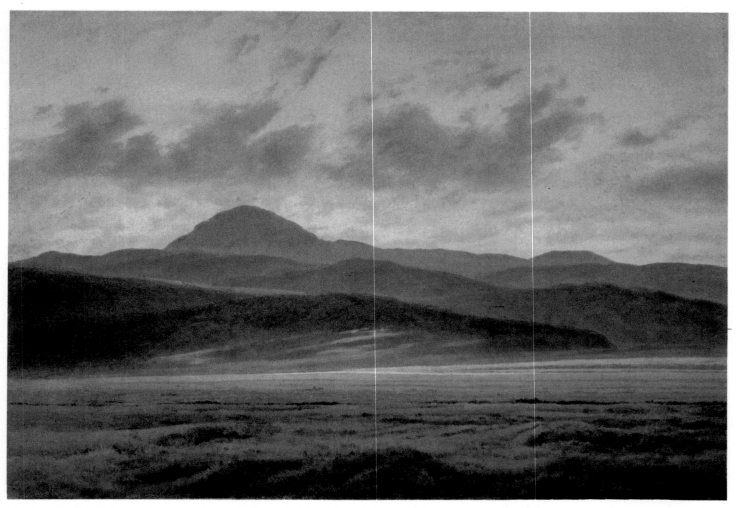

20. Caspar David Friedrich. *Riesenbirge Landscape* (formerly *Harz Mountain Landscape*). c. 1820. Oil on canvas, 14 × 20″. Kunsthalle, Hamburg

young girls to the exhibition remarked, "Wouldn't it have been lovely if he had put some fishermen for amber into the foreground?" But even Helene Marie von Kügelgen, a woman of highly developed artistic and religious sensibilities, disliked the picture. "A huge, endless air space with a light strip of beach in the foreground and a hermit in dark robes or a shroud skulking around on it [!]. The sky is empty and uniformly calm. There is no sun, no moon, no thunderstorm—indeed, a thunderstorm would be a comfort and a blessing to me; it would show some life and movement at least. There is no boat, no ship, not even a sea monster on that eternal ocean, and there isn't a single green blade of grass upon the sand; and the few seagulls that flit about merely intensify the loneliness and horror of the scene." But to depict absolute loneliness had been precisely Friedrich's intention. Recent studies have shown that the artist had originally painted two ships on the ocean. But they had disturbed him while he was completing the picture, and so he had erased them.

THE TETSCHENER ALTAR, THE SISTINE MADONNA, and ART REVERENCE

Shortly before his *Monk by the Sea*, Friedrich had done a sepia drawing which had caused as much controversy in Dresden art circles as his *Monk* was to cause in Berlin. The picture showed a crucifix on a mountaintop, facing the setting sun. The motif was in keeping with "that religious mood which had recently begun to animate our German world in a very special way . . . where it was being subtly expressed and interpreted through pictures of landscapes . . ." (Ludwig Tieck). A Countess Thun was so enchanted by the drawing that she wished to own it. Her husband, who was just then installing a chapel in one of his palaces, asked Friedrich to execute the drawing in oils for the altar of his chapel. At first Friedrich was unwilling to do so, for he would take up his brush only "on his own volition, without externally imposed purpose, [but

24

only] when inspired by a spontaneous inner enthusiasm" (Rühle von Lilienstern). But in the end, the artist and the nobleman came to terms (*Tetschener Ältar*, fig. 15). The sculptor Friedrich Kühn created a frame with eucharistic symbols to the painter's specifications—but not, it seems, to his complete satisfaction. Every day more and more people wished to see the picture before it was to be moved to Dresden. But Friedrich would not allow it to be shown until he had arranged the lighting of his sparsely furnished studio in such a way as to produce a quasi-sacred mood. Frau von Kügelgen saw it in such a setting: "It made all who entered the room feel as if they had stepped inside a temple. Even the greatest loudmouths . . . spoke softly and earnestly as if in church."

There were others, however, who voiced strong objections to the picture, notably the Kammerherr von Ramdohr, who fancied himself an expert on art. His criticism of the picture, published in the *Zeitung für die elegante Welt*, culminated in the remark that it was "truly presumptuous for landscape art to insinuate itself into the churches and onto the altars." Actually he rejected all Friedrich's work on the general principle that it disregarded the boundaries of art. The slice of nature represented in the *Tetschener Ältar* was unworthy of landscape art, he said, because it lacked variety, and with its subject matter limited to a single mountaintop and an overly large sky, it was of a truly provocative simplicity. Friedrich, he said, presented harsh contrasts instead of harmonious transitions. He hadn't the slightest idea of the laws of distance and perspective and was ignorant of the basic rules of optics. A mountaintop, indeed! Impossible to say where its base was, and it was seen at such close range that the viewer had no point of reference by which to judge distance. As a result of this close confrontation, he said the viewer was being robbed of his pleasure because his freedom was curtailed. There was no distance in which foreground and middle ground could merge, but directly behind the peak that took up the foreground there was an abyss from which light came up in red and yellow glowing rays! Friedrich, Ramdohr maintained, was defrauding the viewer in every way of the chance to enjoy the world. In Ramdohr's view only the habitable world could satisfy the senses. It was the only "aesthetic" world; it alone could produce that "aesthetic emo-

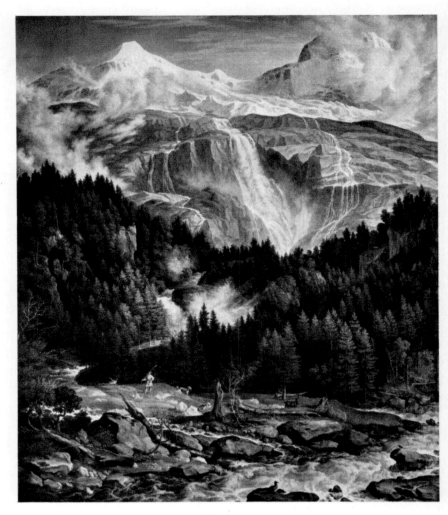

21. Josef Anton Koch. *Schmadribach Falls*. 1821/22. Oil on canvas, 52×43″. Neue Pinakothek, Munich

tion" which constituted the meaning of a work of art.

In a different context, Ramdohr declared that art is "only for the educated who are entitled to the enjoyment of social talents and amenities by reason of their wealth and leisure."

That attitude is pure Rococo epicureanism. The Enlightenment began to question such views, usually for moral reasons. But sometimes there were other criteria as well. Johann Georg Sulzer, in his *Allgemeine Theorie der Schönen Künste* (General Theory of the Fine Arts), is an interesting case in point. His article "Erhaben" (The Sublime) begins: "It seems that in works of art we generally call sublime that which in its own way is far greater and stronger than we would have expected; which is why it amazes us and elicits admiration. That which is merely beautiful and good, in nature as in art, pleases us, is agreeable and charming; it makes a gentle impression which we enjoy with equanimity; but the sublime affects us with powerful blows, it carries us away and irresistibly stirs our

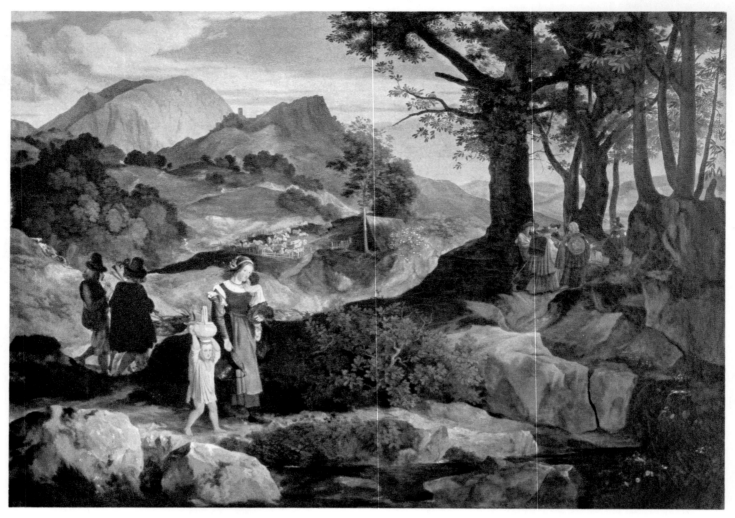

22. Carl Philipp Fohr. *Mountain Landscape*. 1817. Oil on canvas, 38 5/8 × 53 1/8″.
Collection of HRH the Prince of Hesse and the Rhine, Darmstadt

soul. . . . As a gently rolling landscape is to the amazing sight of towering mountains . . . so is the beautiful to the sublime. Therefore it is the highest form of art and must be applied where the soul is to be violently attacked, where admiration, awe, urgent desire, high courage, and even fear and terror are to be aroused."

It is possible that Ramdohr would have considered these remarks an invitation to "pathological emotion." At any rate, he accuses Friedrich of trying to supplant "aesthetic emotion" with "pathological emotion." Friedrich, he says, tries "to put the viewer into the kind of state he might experience at the sight of the thing itself, when viewing it in nature, rather than on canvas." Thus Ramdohr's chief criticism is that Friedrich disregards the rules of art and approaches nature directly; not, it must be added, a familiar, habitable nature, but an inhuman, superhuman nature, because he wishes to achieve not mere empty aesthetic enjoyment but an emotion that resembles religious reverence, if not actual religious reverence. It is interesting to note that the only human figure in the picture is a symbolic one; not a living figure

at all, it is a crucifix facing the mysterious light from the depths, which, with its trinity of rays, is meant to represent the "image of the eternal life-giving Father," as Friedrich himself has said.

Friedrich once remarked of a painting he saw at an exhibition that "though it is shown as a landscape, it would be well suited for a church, for which it seems to have been intended." This shows that Count Thun's commission could not have struck Friedrich as unusual, and that he was not the only person who felt that landscape painting could be worthy of being used on the altar of a church. But somewhat later he changed his opinion and said of that same unidentified picture that "the artist lacked the dedication for that sort of thing. He had neither the inner light nor the religious warmth and reverence." Perhaps that unnamed artist had not gone beyond the cool, detached quality of Chodowiecki's *Enlightenment* (fig. 7). One other thing worth mentioning is Ferdinand Hartmann's defense of Friedrich's altar picture. Hartmann writes that the picture was, after all, not intended for a public church but for the private chapel of a lady, "on whose sense of delicacy Herr

Friedrich . . . could surely rely." No doubt the picture was meant to appeal to the "subtle discernment of a chosen few." Perhaps this attempt at a defense shows where the limits of this type of altar painting had to be drawn—a limit of which Friedrich himself might not have been fully aware.

But the *Tetschener Altar* is not the only example of art with which we can characterize the striving for religious-aesthetic experience that prevailed during that period. A work dating from a much earlier period is equally significant in this respect—Raphael's *Sistine Madonna*. Raphael's picture had come to the Dresden Galerie in 1754, a year after Tiepolo had completed his fresco and a year before Winckelmann published his manifesto about the imitation of Greek art. Almost exactly at the same time at which Friedrich was creating his *Tetschener Altar*, Gerhard von Kügelgen completed a copy of the *Sistine Madonna*. It was "considered equivalent to the original at the time." The painter refused to sell it. Wilhelm von Kügelgen reports that his father wanted the picture to "become the palladium of his house." "Therefore," writes Frau von Kügelgen, "we turned our ballroom into a *temple*. The Madonna . . . stands in the center, in a very fine frame," raised on a mahogany-colored platform. "A gray silk drapery covers the picture, which is surrounded by the Stanze of Raphael, engraved by Raffaello Morghen. The entire effect is so tremendously solemn that even the children only talk in whispers when they enter." In 1813 some Cossacks, billeted in the Kügelgen house, treated the picture with utmost reverence. "They made the sign of the cross and said their prayers in front of it as if they were in a church. Then they spoke in whispers about the miraculous work of art." A year earlier, however, there had been a French general billeted in their house; he "had smirked at the picture and said he would like to find a cook who looked like Raphael's Virgin."

It would be hard to find a more irreverent way of scoffing at the art reverence that can build a "temple" of art in a private house. Such reverence was completely incomprehensible to the Frenchman. But art reverence was to vanquish both the pure hedonism of the Rococo and the vacuity of academic-classicistic dogmatism. Ever since the young Goethe had confessed his enthusiasm for the Strasbourg Cathedral and its architect, Erwin von

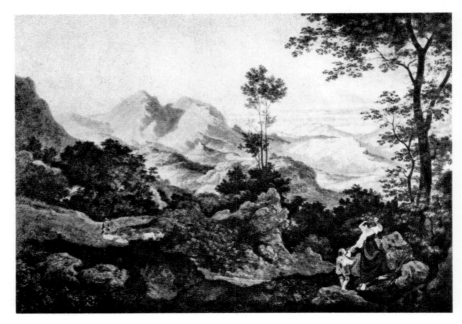

23. Ludwig Richter. *Morning in Palestrina in the Apennines, 1829.* Oil on canvas, 30 1/2 × 39 3/8". Staatliche Kunstsammlungen, Dresden

Steinbach, ever since Wackenroder had published his *Confessions of an Art-Loving Friar* (1797), this reverent attitude had established a new relationship with art. In 1775 Goethe even went beyond his manifesto *Von Deutscher Baukunst* (Of German Architecture) with his *Dritte Wallfahrt nach Erwins Grabe* (Third Pilgrimage to Erwin's Grave). The different sections of that enthusiastic effusion are entitled: "Preparation," "Prayer," "First Station," "Second Station," "Third Station." It would be impossible to make the idea of a pilgrimage any more explicit than that. But it is a pilgrimage to a work of art in a religious spirit—shortly before the French Revolution was to have its profoundly detrimental effect on all religious pilgrimages.

Following in the young Goethe's steps, Wackenroder writes: "I have succeeded in building a new altar to the glory of God." What he means is the altar of art veneration which he erected at a time when the French Revolution was toppling church altars everywhere and even Friedrich painted demolished altars to show his faith in the dawning of a new era.

Like Goethe, Wackenroder still talks of the "enjoyment" of art. But he "compares the enjoyment of a noble work of art to the act of praying!" Artists were to be "looked up to like saints in their glory by the world of today. Unbelievers and scoffers who deny the divine aspect of art reverence and make fun of it" are not worth talking to. And

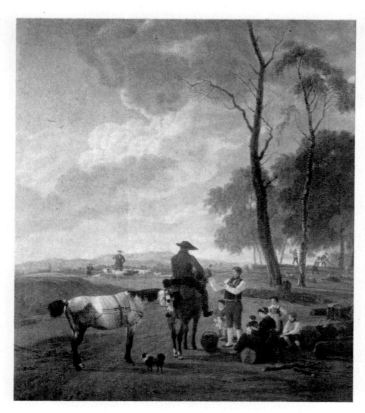

24. Wilhelm von Kobell. *At the Edge of the Woods*. 1800. Oil on canvas, 17 1/2 × 15 1/2". Kunsthalle, Hamburg

Friedrich, to quote just one of many possible witnesses, is convinced "that art . . . should be the true language of our emotions, our mood, even our piety and our prayer."

The origin of this kind of art veneration is generally credited to Romantics such as Wackenroder. Nevertheless the young Goethe had expressed it before Wackenroder—in fact, Wackenroder's own *Confessions* . . . were first believed to have been written by Goethe. And even Goethe cannot be considered the true originator of art reverence. The real originator, for Germany and most of Europe, was that "pagan" Winckelmann. We remember the religious tone in which he talks about Cardinal Albani's antiquities, and his unhesitating comparison of the cardinal's villa with Saint Peter's Cathedral. It is very much in Winckelmann's spirit when Novalis, a profoundly Christian "romantic," says: "The works of classical antiquity compel us to revere them as sacred objects." In 1799 he wrote Friedrich Schlegel that, in the future, it would be a "basic Christian task" to establish contact with "the religion of the ancients, the divinity of classical antiquity." That was exactly what Raphael had done in the sphere of art.

Thus it is not surprising that the first important description of the *Sistine Madonna* came from the pen of that "arch pagan" Winckelmann. In his essay about the imitation of Greek art we find: "Behold the Madonna with a face that radiates innocence and at the same time a greatness that transcends mere femininity. Her posture is calmly serene, she has the kind of stillness the Greeks achieved in the images of their deities. How great and noble is her entire form. The Child in her arm is elevated above mortal children by a face whose childlike innocence seems illuminated from within by a spark of divinity. The female saint kneeling at the Madonna's feet is garbed in reverent stillness of soul but clearly subordinate to the majesty of the main figure . . . the male saint, opposite the kneeling female figure, is a wonderfully dignified old man with features that seem to testify to a lifetime spent in the service of God."

Each sentence is drenched in that reverence for art which the times demanded. In the eyes of the Romantics Raphael's greatness consisted in having revived an ideal of form that originated in classical antiquity. That ideal was still valid and important for the Christian world. It is hard to say how far the "pagan's" reverent description was influenced, if not inspired, by Christian ideals. Somewhat later, in 1794, Fernow went so far as to say that Raphael should be regarded as "the Messiah of artists because he mediates between antiquity and nature, between art and reality, as Christ mediates between God and man." And the "romantic" Wackenroder refers to Raphael as the "luminous sun among painters," and calls him "heavenly," a "holy man," and "divine." He tells about an old priest who studied "every brushstroke with veneration," and exclaimed, "If only I had seen this holy man in life! How I would have revered him!" Wackenroder would also have us believe that Francesco Francia was "venerated as a god."

It is interesting to note that Johann Georg Sulzer talks of an "inner sanctum where Apelles and Raphael had been initiated into every secret." But even more remarkable is the fact that after visiting a gallery in Bologna during his journey through Italy, Goethe expressed himself vehemently against the "generally senseless . . . horribly stupid objects" of Christian art, calling them "works that cannot be sufficiently degraded by any known epithets; things that are maddening to one who . . . would like only to venerate and adore."

28

But after seeing a picture ascribed to, but definitely not by, Raphael, he is "instantly restored to health, and glad . . . I have committed the figure of Saint Agatha to memory and I shall read my Iphigenia to her in my mind. And I will not let my heroine say anything that saint would not be able to say." This not only constitutes a victory for Raphael, it is a victory for the aesthetic church in which the saint and the priestess of antiquity reach for each other's hands—safely removed from martyrdom and blood sacrifice. But even in this limited space we would be remiss if we failed to point once more to Tiepolo's Apollo (fig. 2). He is the Baroque forerunner of art reverence. He actually symbolizes it. And the object in his hand, on which his eye is fixed with such deep devotion, is a work of art; but it is also an idol, a sacred image, and as such it must not be regarded from a merely aesthetic point of view.

It was Adolf von Menzel who, in 1855, dared

to disenfranchise Raphael with *Make Way for the Great Raphael*, a fascinating little picture (fig. 16). It shows the *Sistine Madonna* as it is being brought to Dresden and its title makes it seem an homage to Raphael. "Make way for the great Raphael!" is what August III is said to have shouted when the picture was brought into the king's throne room and he decided that it belonged on the throne. Menzel presents the scene in a very lively impressionistic style. The ongoing activity is more important to him than the Madonna, who is only half seen, while the saints appear as mere shadows. This is the end of art "reverence." Even before this picture was painted, in 1826 Schopenhauer wrote of Raphael's Madonna, "She says nothing to me." In 1870 Dostoevsky wrote in *The Possessed* that he had sat in front of the picture for two hours, only to "walk away, disappointed. . . . Nowadays we see nothing in it. . . . It was the older people who created that picture's reputation."

25. Philipp Otto Runge. *Morning*. From ·*Times of Day*. 1803. Etching, 28 1/2 × 19″. Kunsthalle, Hamburg

26. Philipp Otto Runge. *Noon*. From *Times of Day*. 1803. Etching, 28 1/8 × 18 7/8″. Kunsthalle, Hamburg

27. Philipp Otto Runge. *The "Little" Morning*. 1808. Oil on canvas, 42 7/8 × 33 5/8". Kunsthalle, Hamburg

28. P. O. Runge. *Oil sketch for "Noon."* 1803/04. Oil on cardboard, mounted on wood, 12 1/2 × 10 1/2". Kunsthalle, Hamburg

THE TEMPLE OF INDIVIDUALITY

"Friedrich's studio . . . was absolutely bare . . . there was nothing in it except an easel, a chair, and a table. A solitary ruler was the only wall decoration. No one could figure out how it had attained that honor. Even the necessary paintbox with its oil bottles and paint rags was banished to the next room, for Friedrich felt that all extraneous objects disturbed his interior pictorial world."

This description of Friedrich's studio by Wilhelm von Kügelgen stands in open contrast to his own father's studio, which "contained a world of the most diverse objects," in addition to all his books, the reading of which he left to his wife and friends. Kügelgen *père* maintained "that empty walls and a tidied-up room would stunt my imagination."

Kügelgen's studio, as painted by Georg Friedrich Kersting (1785–1847), however, does not look quite so mundanely colorful. On the other hand, Kügelgen's description of Friedrich's studio

tallies almost "word for word" with Kersting's painting of Friedrich in his studio (colorplate 16). The only difference is that Kersting shows not only a ruler but also two palettes, and a wooden triangle hanging on the wall. The triangle is however partially hidden by the easel that stands upon a table in the center of the picture. Table and easel practically form a single unit. Friedrich stands, leaning against a chair in front of his easel, holding his palette, his brushes, and his maulstick. He is not painting but is deep in contemplation of his picture. We cannot tell at what stage of completion it is, for all we see is its back, the easel, the table full of painting utensils—and the artist himself.

Thus we cannot even venture a guess at what kind of picture Friedrich might be painting. Any hint at a definite visualization seems to have been deliberately avoided. For how can a bare room with its floor, walls, and ceiling differentiated from each other only by their color tones—how can the geometric shapes of table, easel, and picture frame give rise to any speculation in that respect? The sober geometry of these objects is so strongly stressed that one feels it may be intended as the

chief content of the picture. And then there is the window in the rear wall and that window, too, is divided geometrically, into four perfectly identical squares. The dividing lines make us think of a reticle.

But the window also is the source of light which illuminates the room and creates the various color tones of walls, floor, and ceiling and casts dark shadows on the floor and on the back of the picture on the easel. The darkness contrasts vividly with the bright window, so that the longer we look, the more we feel that these two elements are related to each other. And the window does not show merely light: through it we see bright white clouds in a light blue sky. What else, therefore, can possibly have taken shape on that invisible canvas but that sky and those clouds? Has the picture been painted by the firmament itself, or by the artist? The painter's thoughtful, contemplative gaze reflects the indissoluble union of his work with that firmament—the fact that art and nature are one. What strikes us as strange at first glance, the empty formality of those severely geometric forms, turns out, upon longer contemplation, to be a means of conveying the essential point with con-

vincing clarity: the relation of the sky, of heaven, to the picture. To realize this and to express it in a picture, the artist must be steeped in profoundly reverent contemplation. "It seems to me," writes Wackenroder, "that I can see you standing, deep in thought, in front of the picture you have begun— that the imagined scene you want to depict is hovering vividly before your soul"; and, we might add, because it has come to you as a gift of heaven.

Nothing must interfere. No doubt Friedrich's studio had a door. But Kersting not only did not paint it, he has made a door practically unthinkable —by choosing this particular segment of the room, by closing the second window, at right, and last but not least, by showing a large, completely empty wall behind Friedrich. The artist must be completely by himself; the room in which he works —deep in reverent thought—must be inaccessible to outsiders, a veritable "temple of individuality." Friedrich refers to such a temple in his brief essay *Über Kunst und Kunstgeist* (On Art and the Spirit of Art). "Art teachers! . . . beware of forcing your rules and your instructions on everyone, for in that way you might easily . . . destroy the temple of individuality without which man cannot achieve

29. Philipp Otto Runge.
The Huelsenbeck Children. 1805/06.
Oil on canvas, 4'3" × 4'7".
Kunsthalle, Hamburg

30. Philipp Otto Runge. *The Artist's Parents and Children.* 1806.
Oil on canvas, 76 × 51 1/2". Kunsthalle, Hamburg

greatness! . . . Your rules may be good, but they
do not fit everyone . . . only the laws of God are
valid for all." Is he pondering those laws of God
as he stands before his easel, so deep in thought?

Like a preacher exhorting his congregation,
Friedrich defends the uniqueness and invulnera-
bility of the artist's creative subjectivity. He can
do it only "in his innermost self, in the center of
his being, and only through spiritual contemplation
—or not at all," says A. W. Schlegel. In his earlier
years Goethe placed creative subjectivity above
everything else. The slavish adherent of rules, the
imitator of others, seemed to him an "evil genius"
no less, who "murders genuine human beings in
the outer court of the sacred mysteries"; and he
terms such a person an "assassin" and a Haman.
Later, in the *Tag und Jahresheften* (diaries) of his
early years, he recalls his "absolute desire to cut
across all boundaries"; and he adds, "All that . . .
was deeply and truly felt."

Friedrich's tone is more priestly. But, like

Goethe, Friedrich was convinced that a true artist
has no need of "the cumbersome splendor of tem-
ples and sacrifices." The artist's studio is his
"temple of individuality." For God reveals himself
to the true artist ". . . wherever he may be; in his
quiet room or in the open field." Kersting's picture
shows Friedrich in just such a quiet room where
God reveals himself. And now we can understand
why the studio is so bare of any objects that might
create a diversion—though the spittoon on the
floor, most of it is hidden behind the easel, is rather
profane—and why the picture on the easel and the
"heavenly" window have been placed in such a
close relationship, and why Friedrich is shown with
such a reverent expression on his face.

Kersting had painted Friedrich in his studio a
year earlier, in 1811 (fig. 17). The room in the
earlier picture is similar, but here Friedrich sits at
his easel and is painting a mountain landscape that
has a waterfall in its center and reminds us of Koch
(see colorplate 3). We do not know whether
Friedrich ever actually painted such a Baroque
landscape. In this earlier picture the table with the
painter's utensils stands next to, not under, the
easel. And there is a door—unimaginable in the
Berlin picture—in the left foreground. This is a
room which anyone might enter without hindrance
in order to watch the painter at work. This studio
is not the "temple of individuality" of the Berlin
picture. Nor is there an inner correlation between
the picture the painter is painting and the window
illuminating the room. No matter what we imagine
the unseen picture on the easel of the Berlin paint-
ing to be, we know that the sky and clouds we see
through the window must somehow determine its
form and essence. Of course we can hardly assume
that Friedrich is here painting one of the cloud
paintings Goethe had requested of him in connec-
tion with his cloud studies of 1815 and 1816. At
that time Louise Seidler wrote to Goethe that
Friedrich would have "nothing to do with those
clouds." But later on he must have changed his
attitude as we can see from *Moving Clouds* (fig.
18). And if our guess about the picture in the
Berlin painting is correct, there must have been a
forerunner to Friedrich's Hamburg cloud picture.

In his letters about landscape painting Carl
Gustav Carus said: "We can see everything that
moves the human heart—brightening or darkening,
building or dissolving, shaping or destroying—we

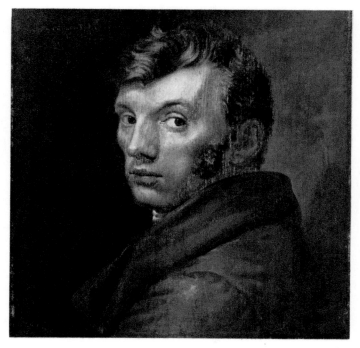

31. Philipp Otto Runge. *Self-Portrait.* 1809/10. Oil on oak panel, 19 1/8 × 18 7/8". Kunsthalle, Hamburg

32. Caspar David Friedrich. *Self-Portrait.* c. 1810. Pencil and chalk, 9 × 7 1/4". Staatliche Museen, Berlin

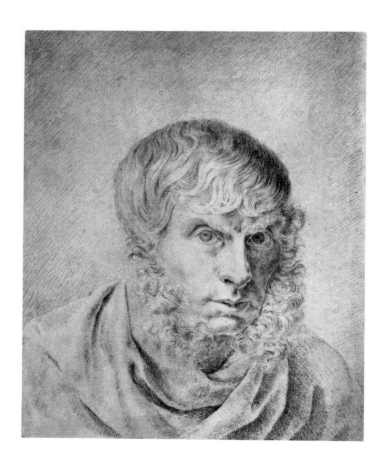

can see it all in the graceful shapes of clouds." Johann Christian Clausen Dahl, Carl Rottmann, Georg von Dillis, and Adolf von Menzel have painted clouds, too. These pictures seem to establish the opposite of the classical ideal of form, for they combine the appearance of corporeal form with the fact of corporeal formlessness and continuous change. And that is exactly why they symbolize both, the essence of earthly-heavenly form and the intangible yet very real states of the human soul. Artistic discipline, indispensable even in the face of the disembodied, is symbolized in Kersting's picture by its geometric structure. Peculiarly enough, that "square cupboard style" of his furniture was called Greek at the time. But the cloud pictures— all cloud pictures—are the very opposite of Greek. They can be taken as direct expressions of the ideas voiced by Wackenroder, Friedrich, Runge, and others, that art is of "heavenly" origin; that it is a "heavenly art." It remains a moot question whether Friedrich's idea of a "temple of individuality" was inspired by 1 Corinthians 3:16 f.: "Do you not know that you are God's temple and that God's Spirit dwells in you? . . . God's temple is holy, and that temple you are."

THE EARTH-LIFE PICTURE AND THE HUMAN FIGURE

In discussing pictures of the sky we have prematurely turned away from earth. While sky pictures are "landscapes," too, they are mostly the kind of landscapes in which earth takes up very little space. The main interest of the times, of course, resided with earth landscapes. The sky in such an earth landscape might well take up two-thirds of the picture, as we have seen in *Monk by the Sea* (fig. 14). Carus felt that "landscape" was a "trivial" name for the kind of pictures Friedrich, Dahl, and others were painting. He felt they should be more properly called "pictures of earth life," "earth-life art." The new name was not meant to denote vast motifs. It did not mean that only "descriptions of huge mountain ranges, of storms at sea, of great forests, volcanoes, and waterfalls were to be the motifs for such earth-life pictures." Of course, those subjects, properly executed, might well "consti-

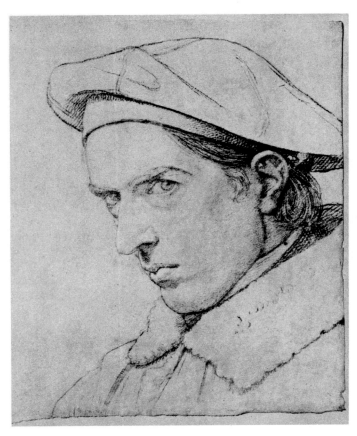

33. Friedrich Overbeck. *Self-Portrait*. c. 1843–44. Brown pencil, 13 1/4 × 11″. Museum für Kunst und Kulturgeschichte, Lübeck

34. Friedrich Wasmann. *Head of a Dead Woman*. c. 1842. Pencil, 9 1/4 × 7 3/4″. Kunsthalle, Hamburg

tute what is loftiest in earth-life art." However, "every aspect of earth life, even the very humblest and simplest, becomes a worthy and beautiful subject of art as long as its essential meaning, the divine idea concealed within it, has been truly captured." In each case the landscape can testify to that "eternal and infinite unity which our language designates with the word God."

Indeed, the landscape art of the period discussed here tried to be the art of earth life, to represent, as Goethe said, "the passive-active fate of earth." The descriptions that accompany the colorplates in the next part of this book are an attempt at showing the various creative approaches to earth-life art. Unquestionably that form of art was the period's most important creative achievement. As to the human figure, even an artist like Carstens, with his beautiful cartoon of *Night and Her Children*, somehow falls short of complete fulfillment. There were significant attempts at monumental painting, notably the works of Peter von Cornelius (colorplate 35). But even he did not succeed in effecting a genuine renascence in that field. It soon became abundantly clear that the drive

toward monumental art was hampered by a lack of subjects that truly expressed the spirit of the times and that could appeal to any but the educated few. Goethe said: "Man is the highest, the essential subject of art," for, "we know of no other world but the world of man; we want no other art except that which expresses this idea." But the expression of this idea could be many different things, for Goethe as well as for his contemporaries. On December 10, 1777, after he had climbed the Brocken, Goethe wrote these lines from Psalm 8 in his diary: "What is man that thou art mindful of him?" And in his *Harzreise im Winter* he says: "Aber abseits, wer ist's?/ Ins Gebüsch verliert sich sein Pfad,/ hinter ihm schlagen/ die Sträuche zusammen,/ das Gras steht wieder auf,/ die Öde verschlingt ihn." (Who is he, walking alone?/ His path is lost in the bushes;/ branches close behind him/ the grass rises up again,/ the wilderness swallows him up.) These verses have their visual counterpart in Friedrich's *Monk by the Sea*.

The verses, as well as the Biblical quotation in Goethe's diary, also find expression in one of Goethe's own most "romantic" drawings (fig. 19).

34

In it the snow-covered Brocken mountain rises behind several rows of trees which are shrouded in drifting fog. The trees themselves become cloud-like in shape. At that time there was no other German who drew in this manner. Goethe's drawing anticipates Caspar David Friedrich, not in style, for Goethe's is quite sketchy, but in composition and in the feeling for nature that manifests itself perfectly without the addition of human figures. Compare this with Friedrich's Hamburg picture (fig. 20), *Riesengebirge Landscape* (formerly called *Harz Mountain Landscape*). Not only are there no human beings in Goethe's drawing, we cannot even imagine any in that landscape. But if there were to be any human figures, they would surely be as distorted and vague in shape as the trees. The question "What is man that thou art mindful of him?" seems profoundly justified. The older "classical" Goethe, on the other hand, could not conceive of a picture that did not include human figures. As he says in his *Winckelmann*, ". . . as man has been placed upon the summit of nature, so he in turn regards himself as a whole nature which must produce a summit from within itself."

It is always easier to pose a goal than to achieve it. Joseph Anton Koch, Peter von Cornelius, Gottlieb Schick, Julius Schnorr von Carolsfeld, and the Olivier brothers tried to realize Goethe's goal in various ways, yet none of them quite succeeded. Carstens's *Night* and Friedrich's paintings can be shown to be creations of the same period because of the way they depict man's fate. But there is a considerable difference in form. No direct line leads from Carstens's *Night* to the spectral figure of the *Monk by the Sea*, nor can the *Monk* ever become a monumental figure. If we agree with Philipp Otto Runge that "the artist's feeling is his law; the true wellspring of art and beauty lies in his feelings,"

35. Johann Heinrich Wilhelm Tischbein. *Goethe at the Window*. Pen and ink. Goethehaus, Frankfurt

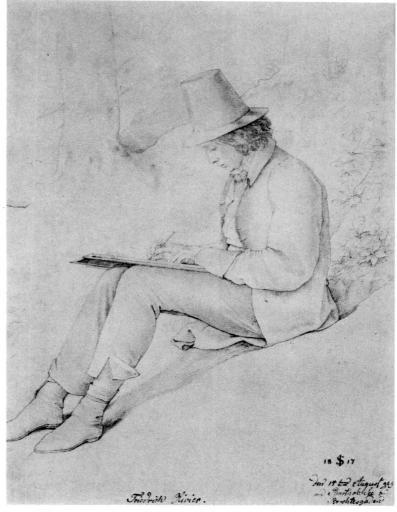

36. J. Schnorr von Carolsfeld. *Friedrich Olivier*. 1817. Pencil. Albertina, Vienna

35

37. Carl Philipp Fohr. *Friedrich Overbeck*. 1818. Pencil, 6 1/2 × 5 5/8". Kurpfälzisches Museum, Heidelberg

38. Carl Philipp Fohr. *Peter von Cornelius*. 1818. Pencil, 6 1/2 × 5 5/8". Kurpfälzisches Museum, Heidelberg

then mere formal differences become unimportant. But if we side with Cornelius, for whom landscape painting was "a kind of moss or lichen on the great trunk of art," they seem important. This is the exact antithesis of the ideas of Friedrich, Carus, and most other landscape painters represented in this book. The split in opinion results in a polarity often referred to as the difference between "Classicism" and "Romanticism." But in making such a distinction, we must not forget that "Classicism" never did produce a figure that could have been said to be "a whole nature . . ." that could produce

"a summit from within itself. . . ." The mere emphasis on the human figure does not create a human form in the sense postulated by Goethe. There was more genuine greatness in that "moss or lichen on the great trunk of art"—even when it was only a matter of placing the human figure in harmony within the landscape, as in the works of Joseph Anton Koch, Carl Philipp Fohr (fig. 22), and the Olivier brothers. Interestingly enough, the harmony tended to be the more convincing the smaller the format of the picture (colorplate 27).

The experts on art and artists were convinced at that time that art had gone into a decline. "Art, which placed the ground under the feet of the ancient Greek and formed a heavenly vault over the Christian's head, is now being frittered away on snuffboxes and bracelets." In order to counteract that decline, Goethe and his friend Heinrich Meyer felt they must renew the old faith in academic art. Here is a quotation from their newly founded journal, *Die Propyläen* (1798): "The state of art at the present time . . . seems to us to be in urgent need of control and rules. We must not stray from the main road by so much as a hair's breath. For the stronger and more perfect art becomes, the

39. Peter von Cornelius. *Boy's Head*. c. 1811–18. Pencil, 7 5/8 × 6 7/8". Collection Dr. Winterstein, Munich

further its power reaches, the more daring can it be, the bolder may it become. But while it is weak and poor, it must retrench and restrain itself." Did Meyer write those words with Goethe's approval? He too was convinced that he was endowed with "a view of art that spanned whole millennia," as Goethe was to say of himself later, in one of his conversations with Eckermann. By contrast, Runge decried all rules and deplored clinging to ancient ways. He wished for "a lovely judgment day" in which everything that had so far been created would perish, to make a truly new beginning possible.

Runge himself made what must be considered the most remarkable attempt at bridging the gap between earth-life art and the art of the human figure. Runge and Friedrich are often mentioned in the same breath, as if their artistic goals had been identical. Actually, there are more differences than similarities between them. Parallels exist, of course, quite apart from their common geographic background. But anyone who refers to both men as Romantic painters—which is quite possible—should bear in mind exactly how flexible the idea of Romantic really is. Friedrich and Runge have in common an absolute faith in the "temple of individuality." "I see," says Runge, "that if I want to achieve anything in art, I must build entirely upon myself, and work from within myself; that is the only essential truth for me."

When Runge came to Weimar in 1803 Goethe —even though he obviously had taken an immediate liking to him—tried to intimidate him by "speaking gruffly and stressing his own enormous reputation." But Runge stood his ground against the Olympian so that "he could see how very serious I am about my work and how very much it is my own." Though Runge, a pious man, immediately modified his remark with "—not my own through myself but through God from whom all things come," he still felt and saw himself altogether dependent on himself. For he saw the history of Western art as a steady process of demythification. While this process necessarily leads to greater abstraction, it also makes more stringent demands on the individual artist. "How can we even consider a return to the art of the ancients? Of what use can the ancient myths still be to us? What good is anything that has been said before? What's been said is over and done with." Runge was, like Friedrich, a strict Protestant. But he

40. Johann Christian Reinhart. *Path in the Woods.* Etching

believed that "we have arrived at the end of all religions stemming from Catholicism." Therefore "everything is directed toward the landscape." In this he and Friedrich were in complete agreement. But Runge's landscape is a very different one from Friedrich's. He feels that "no real artist has yet appeared" to create the kind of landscape he envisions. His *Times of Day* (Tageszeiten), begun in 1801 and published as etchings in 1803, were meant to exemplify demythification and a direction toward the landscape (figs. 25, 26; colorplate 33). But they are neither landscapes in the traditional sense nor earth-life pictures in Carus's sense. They are "arabesques" (as Runge himself called them at first) composed of flowers, leaves, clouds, stars, and human figures, children and women. Where a traditional landscape motif occurs, as in *Noon*, it does not determine the over-all composition. What Runge aspires to is a complete union between nature motifs and the human figure. For, since men do not yet really understand the language of trees and flowers, grasses and stones, clouds and stars, nature must be made to speak through the human figure.

Runge's ambition was to eliminate all traditional mythology. He wanted to invent a com-

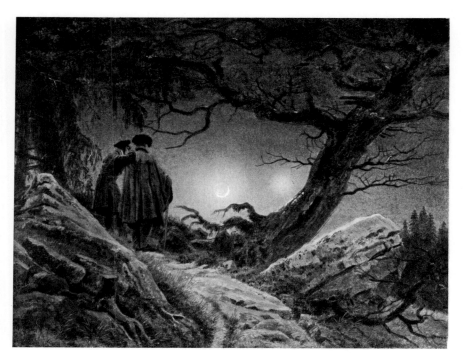

42. Ferdinand Kobell. *Moonlit Landscape.* Etching

41. Caspar David Friedrich. *Two Men Contemplating the Moon.* 1819.
Oil on canvas, 13 3/4 × 17 3/8″. Kunstsammlungen, Dresden

pletely new mythology, a kind of nature mythology which he wanted to present, in Goethe's words, in a "natural-human" way. We can see that this is his very own invention. In fact, though, it remains on the level of allegory, if for no other reason than the multiple meanings that have been spirited into it. The pictures are meant to symbolize morning, noon, evening, and night, but at the same time, they also stand for the seasons of the year, for human life as it begins and grows, wanes and ends; for the revelation of the infinite within the finite; for the experience of eternity within the passage of time. Nor would we be very remiss if we added yet one more interpretation. The artist is saying, "I want to represent my own life in a series of pictures."

There are other works by Runge besides his *Times of Day*, but these were his main *oeuvre*. His imagination wrestled with them unceasingly until the day of his very untimely death. The drawings were to be made into oil paintings, but *Morning* is the only one that was ever executed (fig. 27; colorplate 33). While Runge may originally have thought of his arabesques as wall decorations— Goethe actually used them as such—his visit to the Cathedral of Meissen (the same cathedral which Friedrich painted as a ruin) gave rise to the desire for a chapel to be built for them outside Hamburg. The chapel should, he felt, be in the style of the

Meissen Cathedral, for, he said, the cathedral had "really led him back to himself." What was or even could be the purpose of such a chapel? Runge himself, on one occasion, has called his drawings "an abstract pictorial fantastico-musical composition with chorus." In other words, he sees them as a "total work of art," and as such they must, of course, have their own architecture, too. What would have been the end result but an aesthetic church? No amount of Christian symbols Runge might have added and no architectural features copied from the Meissen Cathedral would have altered that fact.

The style in which the figures are drawn is unthinkable without the influence of Classicism. In some respects it is a continuation of Carstens's style. We must call it "classicistic" if we insist on such classifications. But it contains important elements of abstraction which are most apparent in the geometric arrangement of the whole. In 1809 Steffens wrote Goethe that he felt Goethe would no doubt note "with pleasure the great clarity, the unself-conscious simplicity and the well-ordered, if I may say so, poetic geometry" of Runge's approach.

In the final version of *Morning* the earth-life aspects of the picture have been greatly strengthened. Still, isn't the figure of morning really a variation of Eos, a Greek goddess? Perhaps Runge

38

had been impressed by Jakob Böhme's poem "Aurora." The fact remains that his approach to the human figure is related to that of the ancient Greeks and must be seen from that viewpoint. An early sketch of *Noon* in Hamburg, which may date from 1804 (fig. 28), is painted in oils on a gold ground. Here the landscape elements are completely subordinated to the human figures. The group of a mother and her children has the character of a holy picture, and not because of the gold background only. It brings to mind the compositions of Raphael's Madonna pictures. This is not to say that Runge ever imitated any specific picture. But the comparison does arise, and it is quite possible that Runge meant it to. For, like other Romantics, he too was profoundly impressed by the *Sistine Madonna*. "I must confess that his [Raphael's] Madonna has moved me to the depths of my soul. . . . The picture makes you realize that a painter can also be a musician, an orator. You have a greater feeling of reverence before that picture than in church." Runge's *Noon* is a secularized Madonna, however, and thus she has more than one child. Both figures, the secular Madonna and the pagan goddess of *Morning*, essentially belong in an "aesthetic church." The artist would not have objected to its architecture being Gothic.

There are additional examples for the close connections between Runge, the romantic, and Classicism (*Bacchanal, Triumph of Amor, Nightingale's Lesson*, and others). But while they may be important pictures, his portraits are more important. In them Runge developed an amazing, extremely personal realism (figs. 29, 30; colorplate 32). Friedrich also painted portraits, but they are an unimportant part of his work, though his self-portrait, now in Berlin, is one of the truly great portraits of the period (fig. 32). Lean of face, with his hair combed forward in long waves right down to the bushy eyebrows; with a beard that stands about his cheeks like so many curling flames; with eyes whose power and reverence of vision seem equally forceful—large, dark, luminous eyes—that is how he drew himself when he was about forty years old: stirred by what he saw, lonely in what he thought.

Runge, on the other hand, looks like a dreamer in his self-portraits of 1801 and of 1802/03 (frontispiece). Call these self-portraits Romantic if you like. That word describes a certain style, but it no

43. Christoph Nathe. *Village Street*. Staatliche Museen, Berlin

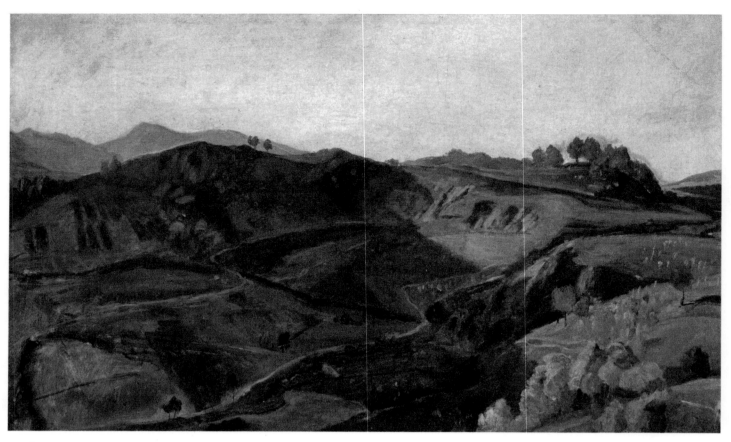

44. Friedrich Wasmann. *Light and Shade*. Kunsthalle, Hamburg

more explains the palpable realism of the artist's face as it gazes out at the world with steady scrutiny than the word "Classicistic" explains Gottlieb Schick's wonderful portrait of Heinrike Dannecker (colorplate 34). By the same token, we may classify Overbeck's late *Self-Portrait* sketch (fig. 33) as Nazarene and Carl Philipp Fohr's *Friedrich Overbeck* (fig. 37) once again as Romantic. If we insist on classifications, we would have to call *Peter von Cornelius* (fig. 38), also by Fohr, Classicistic because of its impressive clarity of structure. Isn't it better to concentrate on artistic individuality instead of clinging to such vague, hard-to-define categories? And isn't it more enlightening to keep in mind how many different artistic individualities there were? How would we classify a portrait like the one Runge painted of his parents (fig. 30; detail of children, colorplate 32)? Is it Romantic or realistic? Certainly the latter. It was a great rarity for simple tradespeople to be portrayed full length in such a large picture, and it remains a rarity. Thus one may well call Runge's picture historically revolutionary. He shows his parents as they are taking a walk. The mother is holding on to her husband's arm. To the right are their grandchil-

dren, playing with a fire lily blooming by the wayside. The compositional line moves up from the head of the mother, who is smaller and frailer than her husband, culminates at his head, and then descends through his hat and cane to the children. The old people are walking, and they look out of the picture at the viewer. Of the two small children, one looks at the lily, the other at his grandparents. There is a strong sense of up and down, and back and forth in this picture. The old man, who holds himself very straight, has doffed his hat as he walks past. He greets the viewer in a manner that expresses respect and self-respect at the same time. A man of honor, he gives honor where honor is due. He knows what he is and what he has. The ships and the landing place we see behind a fence near the house belong to him. But he is not putting undue importance on that. A man's dignity is more important than his property. "The dignity of man reposes in your hands," was Schiller's admonition to the artist. We may well ponder the fact that the century which began when these venerable old people and their grandchildren were painted produced very few portraits that looked at the viewer with such rectitude and such respectful self-respect.

THE NAZARENES

On July 10, 1809, just about the time Friedrich was painting the *Tetschener Altar* and his *Monk by the Sea*, "a small band of budding artists" assembled in Vienna. They were repelled by what went on at the academies and "wanted to lead art back from its present excesses to the road of truth; and they felt qualified to do so." They called themselves the Guild of Saint Luke. Their "high priest" was Friedrich Overbeck, their "master," Franz Pforr. For them artistic and religious truths were one, the former attainable only through the latter. Friedrich and Runge also saw a vital relationship between art and religion, but they would have considered it sinful to try to mix the two. "Religion is not art; religion is God's highest gift, but art can glorify it and bring it closer to our understanding" (Runge).

In 1810, though not exactly expelled from the academy, the members of the Guild of Saint Luke became involved in so much controversy that they decided to secede. In addition to Overbeck and Pforr they were Johann Konrad Hottinger, Joseph Wintergerst, Georg Ludwig Vogel, Joseph Sutter. And where else but to Italy, to Rome, would their road lead them? Except for Wintergerst, who went back to his native Swabia—not as a simple returnee but as "the first apostle to be sent out"—they all wandered toward Italy, "truly a heaven-sent piece of . . . land" where one could find "the golden age

more than once" (Pforr), to Rome, of which Fernow had said, in an aesthetic paraphrase of the Sermon on the Mount: "Blessed are they who live in Rome." The artist Mengs, whom Winckelmann had once praised so lavishly, was no longer playing his part there. He had died in 1779. A decade earlier the landscape painter Jakob Philipp Hackert (colorplate 1) had settled in Rome, and he lived there until 1786. In 1781 Johann Heinrich Wilhelm Tischbein had come to Rome for the first time. He became Goethe's companion in 1786. In 1789 the landscape painter Johann Christian Reinhart (colorplate 2; fig. 40) arrived in Rome; when he wanted to leave again, Fernow warned him, "Germany has produced great artists, but her soil is not nourishing for them. Let the German artist live, strive, and create in Italy." In 1795 Joseph Anton Koch (colorplates 3, 4) had settled in Rome, and in spite of his gruff eccentricity quickly became an "art leader" among those German artists who liked to meet at the Caffè Greco near the Piazza di Spagna. Sometimes they displayed their drawings and paintings there. The caffè was considered "a special kind of art temple." In 1797 the sculptor Bertel Thorvaldsen decided to go to Rome. He was generally thought of as a great pagan, but to everyone's surprise he found a "great love in Christ" awakening in his heart—with the help of some feminine inspiration. Later he wrote: "I know very well that when I am dead, people will say of my Christian figures that they are Greek . . . and of my Greek ones . . . that they are Christian." In 1792 Carstens arrived in Rome. Koch and Thorvaldsen became his friends. But unlike them,

45. Georg von Dillis. *Willow Across a Brook.* Etching

46. Carl Wilhelm Kolbe. *Dead Oak.* Etching

47. Caspar David Friedrich. *Leaf Study*. Staatsgalerie, Stuttgart

48. Philipp Otto Runge. *Silhouette*. Cut paper. Kunsthalle, Hamburg

he remained an avowed pagan. Among those who called themselves, or were called, Hellenists were Reinhart and Koch. The latter not only put shepherds and Greek temples and even the god Apollo in his landscapes; he also found room in his generous heart to populate them with saints, monks, and pilgrims. To continue the list of those who made the pilgrimage to Rome—a list here confined to those artists whose pictures appear in this book—we note the arrival of Gottlieb Schick, a student of Johann Heinrich von Dannecker's, in 1802. His first Roman works were portraits done for the Humboldt family. But in 1805 he exhibited his *Sacrifice of Noah* at the Pantheon. August Wilhelm Schlegel expressed his enthusiasm for it in his *Letter to Goethe:*

"What a rich and important picture of human life this Noah emerging from the Ark represents. Here is the end of a natural cataclysm that marks the beginning of history everywhere; here is family life and, with it, the beginning of the State, in which the father's kingship on earth is a reflection of God's kingship in heaven; here is an altar—the first human edifice; prayer and sacrifice—the foundation of religion; and here, in the beckoning apparition of the Godhead, is a symbol of revela-

tion. . . . I can give no greater praise to the artist than when I say he has well realized the dignity and symbolic wealth of his subject . . . we see here, for once—to our delight—a kind of religious reverence that has so totally disappeared from contemporary art. . . ." This renascence of religious reverence—questionable though it may appear to us today—did not prevent Schick from painting an *Apollo with Shepherds* three years later (Staatsgalerie, Stuttgart). When that picture was exhibited in the Palazzo Rondanini, the residence of the Bavarian ambassador who was, of course, a monsignor, its success in the papal city exceeded even that of Schick's *Noah*. Neither of the two pictures follows the style of painting which then prevailed in Rome —it was far too traditional to attract followers. Artists in Rome were more likely to emulate the French, especially since the great success of Jacques-Louis David's *Oath of the Horatii*, which had been shown there in 1785. Before going to Rome Schick had been in Paris with David. Anyone who came from there was bound to be a painter of the human figure, and that, indeed, was what Schick intended to be. But although he also took Michelangelo and Raphael for his models, he never produced anything to equal Carstens's *Night and Her Children.*

Like Carstens, Schick died young (1776–1812).

Thus when the Guild of Saint Luke arrived in Rome in 1810, it found a great many artists there, some intent on landscape, others on the human figure. It seems, though, that the landscape painters were in the majority, and continued to be—at least among the German artists. When Ludwig Richter "stepped upon the soil of the holy city like a worshipful pilgrim who has reached a long-desired goal," he had a Roman travel permit in his pocket on which he was called "il Signor Landscape" (see fig. 23).

Having divided the artists into Christians and pagans earlier in this book, we might easily have led the reader to conclude that the landscape painters were the Christians whereas the pagans devoted themselves to figure painting. But a glance at the works of Reinhart, Koch, and Thorvaldsen shows that no such clear-cut division can be made. Nevertheless there was a great deal of partisanship, and it was thrown into sharper relief on the arrival of the Guild of Saint Luke, especially when the members moved into the monastery of San Isidoro, which had been abandoned by Irish Franciscan monks. Overbeck declared that the Guild of Saint Luke wanted to "work quietly among themselves in the tradition of ancient sacred art." His "desire to be a monk" made him long for the "delights of solitude and renunciation of the world." Here too it is well to remember Friedrich's *Monk* and his abandoned monasteries. Having seceded from the Vienna academy, the Guild now seceded a second time by fleeing into monastic seclusion. And of course the pagans quickly made fun of them, coining the nickname "Friars of San Isidoro."

Reinhart and Friedrich Müller (1749–1825), the painter-poet who was called the "Devil's Miller" (Der Teufelsmüller), were the Friars' most outspoken enemies. But they found a few friends too, notably Koch, Thorvaldsen, and Schick. Later Ludwig Richter was to declare that "the respectable old pagans . . . who had utterly immersed themselves in antiquity" were unable to see the difference between "Christianity and clericalism." Actually neither Reinhart nor the Devil's Miller was all that respectable. Nor must we imagine the Friars as utterly innocent and harmless. On December 21, 1810, the old Lukas academy reopened in Rome, "to the detriment of art," as Pforr wrote. When its first exhibition opened in 1811, the gentle Overbeck announced that they would ". . . do their level best to destroy the artistic horrors [of the academy] and bring home a number of heads as trophies."

The Friars' prestige rose sharply in 1811 when the promising Peter von Cornelius arrived

51. Carl van Bergen. *Still Life*. 1821. Oil on canvas, 24 3/8 × 19″. Kunsthalle, Hamburg

in Rome and promptly joined them. But though he was a Catholic, Cornelius refused to move into the monastery. The two leaders of the Friars, Overbeck and Pforr, were Protestants. Pforr remained a Protestant until his untimely death in 1812. Overbeck converted to Catholicism for artistic-religious reasons. Franz and Johann Riepenhausen, the brothers whose drawings for Ludwig Tieck's *Genoveva* had brought them much undeserved attention, had turned Catholic as early as 1804—for the same reasons. Goethe's review in the *Jenaische Ällgemeine Literatur-Zeitung* in 1806 had greatly contributed to their fame. But later on he felt he had to make a stand against the "neo-Catholic sentimentality" and against the friarizing (this was meant for Wackenroder) and Sternbaldizing (a dig at Tieck's novel *Franz Sternbald*), mischief which was more detrimental to art than all the Calibans clamoring for realism could be. The Riepenhausen brothers brought a vogue for German old masters and Pre-Raphaelite artists to Rome. There was such a rise in conversions to Catholicism that the Catholic Cornelius felt

impelled to drink the health of Jupiter with the Prussian ambassador, Niebuhr, remarking, "If you fellows won't stop turning Catholic, I may have to become a Protestant."

The growing division into partisan groups was also expressed by names and symbols. "I Nazarei" became a nickname for the Friars because in 1812 Overbeck let his hair grow long and parted it in the middle in order to give himself "a resemblance to the head of Christ" (fig. 38). This was not unprecedented: in his Munich self-portrait Albrecht Dürer had painted himself with a Christlike appearance, and Raphael's contemporaries had maintained that his head resembled that of the Saviour. The Nazarenization of the artist's own person is especially remarkable as Overbeck, in his Emmaus picture of 1808 (Lübeck), had created a Christ type to which he stuck all his life. Its influence remained in effect long into the nineteenth century—which did not greatly further the cause of art. Back in 1798 August Wilhelm Schlegel, in his essay *Die Gemälde*, had profoundly questioned the possibility of creating a really convincing image of Christ. Friedrich had similar qualms. As for Runge, we will get back to him presently.

In 1816 the young Fohr introduced a "Teutonic" coat of his own design to Rome. It soon became the favored garb of all German artists. Even Crown Prince Ludwig wore it when he came to Rome in 1818. It was a kind of outward symbol of German patriotism. Before long, though, it fell into disrepute as a "demagogue's cloak." Friedrich, in whose pictures the coat frequently appears, remarked about the one in Dresden (fig. 41) which shows two "Teutonic" friends contemplating the moon: "They are hatching a demagogic plot." Strange, what power the moon has over the Germans!

The combination of patriotism and religion provoked Goethe's second attack on those tendencies he disapproved of. In 1817 he published an article in the magazine *Über Kunst und Altertum* called "New German Religious Patriotic Art." It is directed chiefly—though not exclusively—against J. J. Meyer who was known as "Kunscht-Meyer" (Art Meyer). It is a kind of stern warning addressed to the Nazarenes and to all those who professed a "passionate love for the honorable, naive, though rather coarse taste" of the German masters of the fourteenth and fifteenth centuries.

Meyer replied in a letter to Goethe that was even more sharply worded. Schadow, while he "pretends to be against the lovers of Gothic art . . . is so foolish—no, that's not strong enough: is so impertinent—still not strong enough—so bestial as to . . . prefer Holbein's Dresden Madonna . . . to that of Raphael."

Goethe himself could be just as vehement. Though he had praised Friedrich earlier, he now declared that Friedrich's pictures might "just as well be seen upside down." In his fury against "that sort of thing," he went so far as to smash the hated pictures against the side of a table and to shoot books to pieces. "That sort of thing must not be permitted to exist," he exclaimed "with inner fury," as we can read in Sulpiz Boisserée's diaries. Two years before, Goethe had seen Boisserée's collection of German and Dutch old masters in Heidelberg; he had even gone back to see it a second time. And at that time "even the old king of pagans paid homage to the German Christ Child" (Boisserée). Indeed, when he saw the *Death of the Virgin* by the master who is named after that picture, Goethe confessed, "Here is a picture from which truth leaps at us with clenched fists." And of the Saint Christopher, formerly ascribed to Dirk Bouts, he admitted, "If I were not such an old heathen, this picture might convert me." Sulpiz Boisserée, a devout Catholic, saw nothing wrong in speaking of the "sacred moments when he sat in front of these pictures." But all that did not prevent Goethe's subsequent attack on the "new German religious patriotic art." In that great controversy, one side saw in the love for Gothic art an "idolization of any old daub," while the other proclaimed that the noble simplicity and strong character delineation of those works spoke directly to their hearts. "Here there was no virtuosity of the paint brush, no extravagance of style. Everything was as simple as if it had not been painted but had grown that way." Wasn't "noble simplicity and quiet greatness" exactly what Winckelmann had praised as the most essential attributes of Greek art? A detailed study would show, no doubt, that those whom Goethe and the Hellenists regarded as their enemies were just as devoted to "noble simplicity" as they were. Except that each side put a different interpretation on the words.

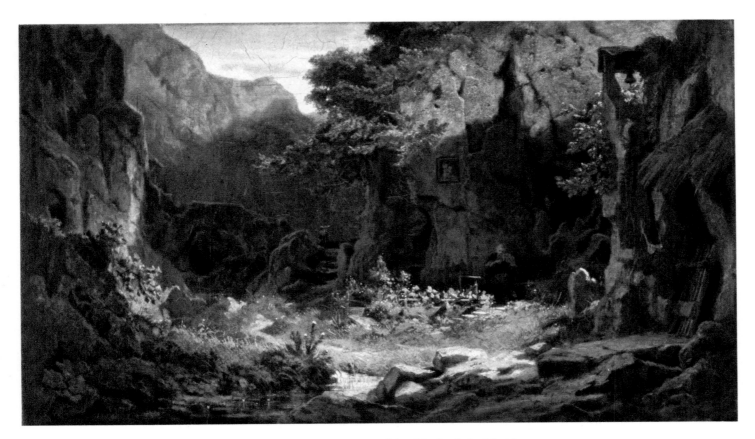

52. Carl Spitzweg. *Hermit Playing the Violin.* Oil on canvas, 12 1/4 × 21 1/4″. Schackgalerie, Munich

DRAWING AND COLOR

The relative importance of drawing as against color underwent several shifts during the post-medieval centuries, as has been pointed out earlier in this book. This shift in emphasis also plays a significant part in the period discussed here. It began with a radical rejection of the coloristic fireworks of the late Baroque and Rococo. Mengs, who had grown up in the coloristic tradition, places himself in opposition to Tiepolo with his *Parnassus.* Carstens, rising above empty formalism, effects a complete victory for drawing. Color is merely an addition in his work. The same holds true for many of his contemporaries and successors. Runge definitely started out as a draftsman. He had originally conceived his *Times of Day* as drawings, to be judged and valued as such, not as mere preliminary sketches. Friedrich too was first of all a draftsman. Only an artist for whom drawing is the chief bearer of form and expression could have painted a picture like his *Abbey Amidst Oak Trees* (fig. 11). No mere colorist could have "drawn" those oak trees so sharply outlined against the sky. On the other hand, to have produced the color tones of mist and fog which Friedrich achieved in the same picture, he had to see the "painterly" aspects of nature. Anyone "whose eyes and senses are dull," and who is not alert to life in nature, "with all its delicate play of colors . . . whose imagination is poor, and who sees nothing but gray when looking into fog . . ." is incapable of creating such a picture (colorplate 13). Yet Friedrich repeatedly objects to those artists who are "under the tyranny of the paintbrush," whose "coloristic skill" is directed only toward "coloristic brilliance." Instead of being true to life, they "exaggerate their colors, putting makeup on trees, rocks, water, and air." Friedrich does not reject their "bold, pert brushwork" as such; he merely does not want it to lead to self-indulgence. That would make of a picture a mere "rag daubed in oil," for "skill and boldness . . . in the choice and handling of color" too often replace the "cleanness and delicacy" of execution. "In the great coloristic extravagance of so many pictures . . . I seem to see our times only too clearly reflected. It is mere empty, sensual play." "No matter how lavish in his use of color," the painter must never become "garish or shrill," he must always be alert to the "most delicate transitions and purest harmony of colors with each other." "The painter shall not project his will, he shall paint." But "the painter shall not only paint what he sees before his eyes, but also what he sees within himself."

All the remarks above were made by Friedrich in front of various pictures he saw at exhibitions. They corroborate his own painting style, but not entirely. While he strove for complete union between drawing and color and for the greatest delicacy of transitions, he was also capable of producing sharp contrasts. The *Tetschener Altar,* the *Meadows near Greifswald* (colorplate 12), the *Plowed Fields near Dresden* (Hamburg), and other of his works are proof enough. From 1810 on, his brushwork became more and more emancipated from draftsmanship, freer, more purely painterly. In some of his pictures, such as the *Enchanted Church* (fig. 10), he has succeeded in combining both kinds of brushwork—the draftsmanlike and the painterly. But among his drawings there are none, as far as we can see, that are purely "painterly," or even as sketchy as Goethe's *Brocken* (fig. 19) or as some of the really amazing drawings by the self-taught artist Christoph Nathe (1763–1808) that anticipate Wasmann's work (figs. 43, 44). Friedrich remained true to his delicate precision even when his subject matter was vast and lofty.

It is characteristic of Runge that he liked to practice a popular amateur art of his period—silhouette cutting—especially in his younger years. He was astonishingly accomplished at it. In silhouette cutting the effectiveness of the outline, the "drawing," is all important. But with the years Runge became more and more interested in color. His *Times of Day,* especially, were meant to become oil paintings. Planned as allegories from their inception, they had to have symbolically significant coloring too. Runge's color symbolism, developed with the help of intense study and high-flying imagination, cannot be discussed in detail here. But it is important to note that Runge regarded the three primary colors as a revelation of the Trinity. He explained his ideas in his letters and in his *Farbenkugel* (color globe), which appeared in 1810, the year he died. Goethe welcomed Runge's studies, and in his own work on the sensual-moral proper-

ties of color he was bound to encounter the painter. But Runge's ideas on the reality and effectiveness of color went one step beyond his color symbolism. That step is reached in the *Child in the Meadow* section of the extant version of his *Morning* (colorplate 33). Here he anticipates the Impressionists' approach to landscape painting. His landscape justifies, or rather demands, the inclusion of such artists as Georg von Dillis, Friedrich Wasmann, and the early Ferdinand Georg Waldmüller in this book—not to mention Karl Blechen, Johann C. C. Dahl, and Johann Jakob Gensler.

In contrast to the last-named artists, the Nazarenes were intent on reinstating the prominence of local color. They were not afraid of becoming harsh or garish. Pforr, in a brief essay *Über den Charakter der Farben*, says: "In most paintings we find a certain sequence of colors which has no other purpose but to flatter the eye and soften the transition from one object to the next, which is what produces the harmony of colors. However, we are striving to emphasize harmony in the person depicted through the colors of his clothing. . . . We have . . . made numerous attempts to express various characters, and we have succeeded rather well." Pforr then goes on to give some examples, such as "Black and purple, black and blue, white and purple, and so on, are best. Colors to go with black hair, that is, they make a good character." Elsewhere he admits that he had followed Dürer's example in this method of characterization through color.

Although the Nazarenes particularly emphasized local color, most of the artists of the period were great draftsmen. Clarity of outline was one of their chief goals. For this reason they preferred to work with pencil or pen; chalk took third place. Ludwig Richter reports that in his early years in Italy he saw the French painters go mountain climbing with huge paintboxes. They "needed enormous quantities of color for their studies; and they applied these colors half a finger thick with large bristle brushes. They always painted things at a certain distance so as to achieve a total effect or, as we said, a 'theatrical effect.' Of course they used up a lot of canvas and paper, for they only painted, they never drew. We, on the other hand, were more interested in drawing than painting. Our pencils could never be hard enough or finely enough pointed for drawing firm, precise outlines,

down to the smallest detail. Each of us crouched over a paintbox no bigger than a small sheet of paper . . . we fell in love with every blade of grass, every graceful twig. . . ."

They did a great deal of walking, and it was important to them that their drawings be accurately dated, to the day. "Always place the date under every poem after you have made it," said Goethe to Eckermann on October 29, 1823. "I gave him a questioning look, why should that be so important? 'Then you can use it as a diary of your feelings at the same time,' he added." How deeply they could concentrate on their work is shown very charmingly in a drawing by Schnorr von Carolsfeld (1794–1872) of Friedrich Olivier (fig. 36). Schnorr was a marvelous draftsman, as his portraits show (portraits of Freiherr von Stein and of Victor Emil Janssen, in Hamburg; *The Painter Carl Mosler*, at the Akademie, Vienna). His preliminary sketches are much more appealing than most of his finished historical paintings; some are truly brilliant (fig. 50). A study of a piece of cloth on a chair looks almost like an abstract composition (fig. 49). No less important than Schnorr's portrait drawings are those of Carl Philipp Fohr (figs. 37, 38). They are preliminary studies for a large picture that was to have included all those artists who frequented the Caffè Greco, so that, on paper at least, their split into factions should be healed. The group picture was to be etched in copper so each artist could be given a copy.

The Nazarenes also did some excellent watercolors and drawings with watercolor (Dillis, Koch, Fohr; Lucas: colorplate 8). In these works drawing and color are brought into convincing, often truly enchanting, harmony. Etchings are more scarce. Most important among them are landscapes, no doubt all of them examples of earth-life art. *Willow Across a Brook* (fig. 45), by Dillis, may have been inspired by the Dutch painters of the seventeenth century, but it shows an imaginative quality entirely its own. The surface of the picture is almost totally covered by a network of tiny leaves. They shimmer in the hovering, sparkling interplay of light and shadow which is broken only by the shadows themselves and by a few white spots of sky. But even these shadows are in motion, and it is impossible to determine where they merely touch on another form and where they completely absorb it. For Reinhart, too, who drew with greater defi-

nition, a tree could become a symbol of earth-life (fig. 40). A highly imaginative counterpart of Reinhart's *Forest Path* is the *Dead Oak* (fig. 46) by Carl Wilhelm Kolbe (1757–1835). It brings to mind the writings of E. T. A. Hoffmann. Kolbe himself confesses:

"What has always attracted me most in nature are trees and leaves . . . and the sun that gives them light and warmth. Everything here moves and tempts me, the beautiful green color, so beneficial to the eye; the infinite variety of form and the difference of expression inherent in each; but above all, it is life which inspires them, which joins their world to mine . . . all that . . . touches my alerted imagination as with a magic wand . . . trees have made me an artist. . . ." He adds that if there were no trees in paradise, he would not give a penny for his eternal life. Behind the dead oak tree in the foreground stand the mighty forms of its neighbors in the fullness of their sap and growth.

53. Peter von Cornelius. *Frau Elisabeth Malss.* 1811. Pencil, 7 1/4 × 8 1/4″. Kunstmuseum, Düsseldorf

48

COLORPLATES

JAKOB PHILIPP HACKERT (1737–1807)

Italian Landscape

Signed and dated 1778
Oil on canvas, 25 5/8″ × 34 3/4″
Private collection, Munich

Hackert, a painter's son, was born in 1737 in Prenzlau. He began his studies in Berlin, where he had his first success with two pictures of the Tiergarten (zoo) in 1761. To further his education he strove to associate with such men as J. W. L. Gleim, K. W. Ramler, and especially J. G. Sulzer (see p. 25). He never lacked commissions, and so he was able to travel to Stockholm and Paris, Normandy and Italy. On December 18, 1768, he arrived in Rome, which was to become his second home—along with Naples, which he first visited in 1770. In 1786 the king of Naples appointed him court painter. Goethe visited him in 1787. "He is always drawing and painting, yet he remains gregarious and has a special talent for attracting people by making everyone his disciple. He has quite won me over, too" (*Die Italienische Reise*). After Hackert's death Goethe wrote a monograph about him, based on their friendship. Hackert had made some advantageous contacts in Rome. In 1771 his fame soared in meteoric fashion when Catherine II of Russia wished to have the victory of the Russian navy over the Turks commemorated in a series of paintings. Hackert was approached. He promised to paint six pictures but there was one problem: the artist wanted to be "true to nature," and he had never seen a ship on fire. The victorious admiral, Count Orloff, obligingly had a frigate blown up before Hackert's eyes, in the harbor of Livorno. Now the painter could be "true to nature," and in his patron's opinion, he was. Joseph Anton Koch, an artist famous for his sarcasm, remarked in 1834: "The good ship in its demise contributed more to Hackert's fame than his artistic accomplishments. His pictures are bad but famous." Many people still think so today, though they express themselves more moderately. But a letter dated Rome, 1783,

placed Hackert "first among all the landscape artists here," and that was no exaggeration. As a matter of fact, Hackert is one of the painters who succeeded in overcoming the Italian prejudice against landscape. "Landscape is regarded as something secondary here—people scarcely give it a thought," Goethe wrote to Charlotte von Stein in 1787. And Ludwig Richter remarked, "The Italians generally have very little feeling for landscape; it doesn't speak to them, or else they do not understand its language." Hackert contributed greatly to Italy's reputation ". . . as a new Jerusalem of the *truly cultivated* whose minds and hearts are perennially drawn there . . . ," as Goethe remarks in his *Italienische Reise*. Some of the Hackert landscapes sent to Weimar gave Goethe "a pleasant morning." "They are extraordinary works" which, as he observes elsewhere, "could not be imagined more perfect in their practical recreation of reality." While we might not go quite so far in our praise, there is much to be enjoyed in Hackert's best landscapes. The work shown here is a case in point. Hackert began drawing from nature at an early age, and as the years went by his work became increasingly more idealized—or perhaps we should say, more "romantic." His treetops stand against the light sky like a great cloud of green and brown leaves. They attest to the artist's earnest industry (which Albrecht Dürer would have called hair-splitting). But behind their impenetrable shadows the hazy distance appears delightfully transfigured. "Whenever I want to write words, I keep seeing pictures—of the fertile land, the open sea, the fragrant islands, the smoking mountain, and I lack the power to describe it all" (Goethe in Naples). At his best, Hackert had that power.

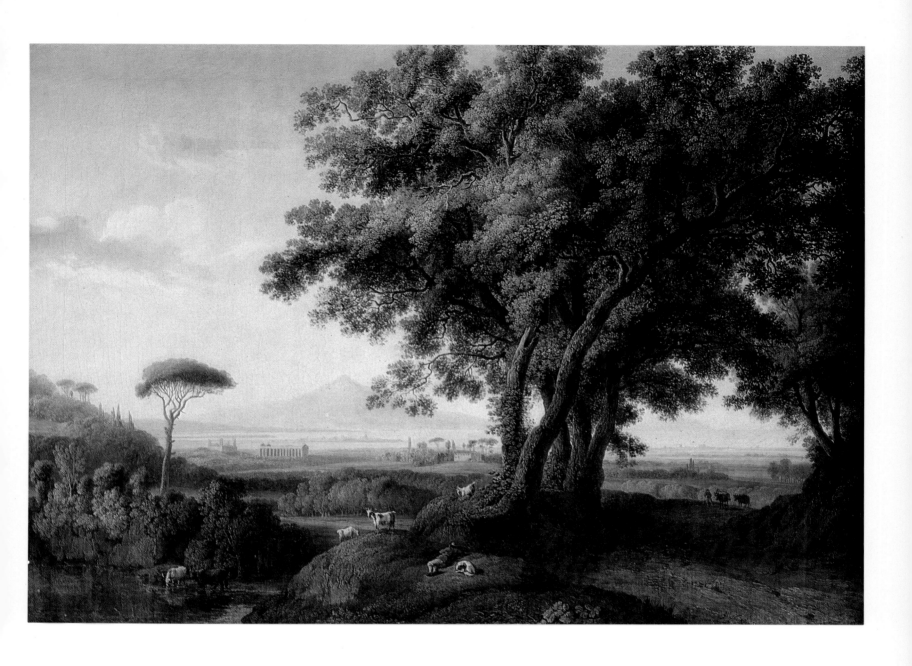

JOHANN CHRISTIAN REINHART
(1761–1847)

View of Tivoli

Dated: Roma 1813
Oil on canvas, 29 7/8 × 22 3/4″
Collection Georg Schäfer, Obbach

Reinhart studied in Leipzig under Adam Friedrich Oeser, who was also the young Goethe's teacher. Johann Christian Klengel taught him engraving. In 1789 Reinhart went to Rome, where he was to become the "certified immortal," the patriarch among German artists. He survived the crusty Joseph Anton Koch by eight years, perhaps because he enjoyed using the hunting rifle as much as he did the paintbrush. The Nazarenes retreated whenever he extolled the pagan Mount Olympus above the Christian heaven, which he did with special zest in the Chiavica tavern on the Piazza Barberini— a very un-Olympian, dark little place. Yet he was the son of a parson and he had studied theology before becoming a painter. In 1787 he had made an engraving of a traveler kneeling before a roadside crucifix. His first landscapes were rather formal, but in 1785 he painted a small picture of *Saint John in Bohemia* (Germanisches Nationalmuseum, Nuremberg) which showed how independent he could be in his composition and use of color. Later he abandoned the painterly style of that picture and began to put more emphasis on his drawing, so that he is now considered, next to Hackert, one of the "classicists" of landscape art. A series of "picturesque engraved views of Italy by Albert Christoph Dies, Reinhart, and Jakob Wilhelm Méchau, presently residing in Rome," was published in 1792. Certain of Reinhart's paintings and engravings follow Poussin's example with their clear symmetrical composition and well-balanced sequence of planes. These pictures are peopled, as a rule, with idealized figures stressing that "noble simplicity and quiet greatness" which Winckelmann extolled in Greek art. Yet Reinhart never really quite abandoned the "realistic" quality of his earlier works. In those days "foliage" was an important criterion by which an artist's closeness to nature was judged —a criterion that may strike us as somewhat peculiar today. One would have to read Richter, who, in his memoirs, describes Adrian Zingg's way of differentiating between the "jagged oak style" and the "rounded linden-tree style," and who says of Klengel's style that it "had to make do for all of Linné"—in order to understand that, when August Wilhelm Schlegel says of Reinhart that "his forte is foliage, and he gives it an accurate definition that almost doesn't exist in nature," this is meant as high praise indeed. Reinhart clung to that accuracy of definition even when painting lofty views, as in the picture shown here. There is a certain Baroque loftiness in those steep rocks flanking the scene—heavier on the left than on the right—and in the way the house at the upper left appears at the top of these rocks, half-hidden by trees and bushes—and in the tall, narrow arch that spans the river and allows the viewer a glimpse of Tivoli. Yet the picture has a strong individuality. The deliberate asymmetry of the composition is particularly effective. Not only are the two halves of the rock wall different from each other: each irregular mass is topped by a piece of architecture, a small, ruined building on the right and a large house on the left, its straight walls forming a vivid contrast to the heavy rock masses below. Of course house and rock are connected through color. The arch is in an asymmetrical position, too; it is off center in relation to the house and to the entire composition. The entrance of the house is partly hidden behind a wall and some shrubbery. We get the impression that it is closed. This in turn places the house in contrast to the arch, which opens on a vista of waterfalls and buildings. The many little houses we see through the arch form yet another contrast with the one large house in the foreground; and the tall, solid arch stands in contrast to the flowing, falling water. The blue sky has its "asymmetrical" counterpart in the darker blue of the water in the foreground. The figure of a hunter, busy with his dog and paying no attention to the rocky cliffs or to the waterfall, has an old-fashioned eighteenth-century quality. Nor is it a "classicistic" practice to show bright distances and heights across a gorge and through and above an archway. As Hackert (in the preceding picture) holds the viewer's eye with his group of trees, so does Reinhart with the wealth of shapes in the foreground; his rock formations, however, lend weight to the scene, which is lacking in Hackert's. The engraving of a forest path (fig. 40) shows that Reinhart was an impressive creator of forest scenes. The forest was an important subject of that period, as was the single tree (compare colorplate 14).

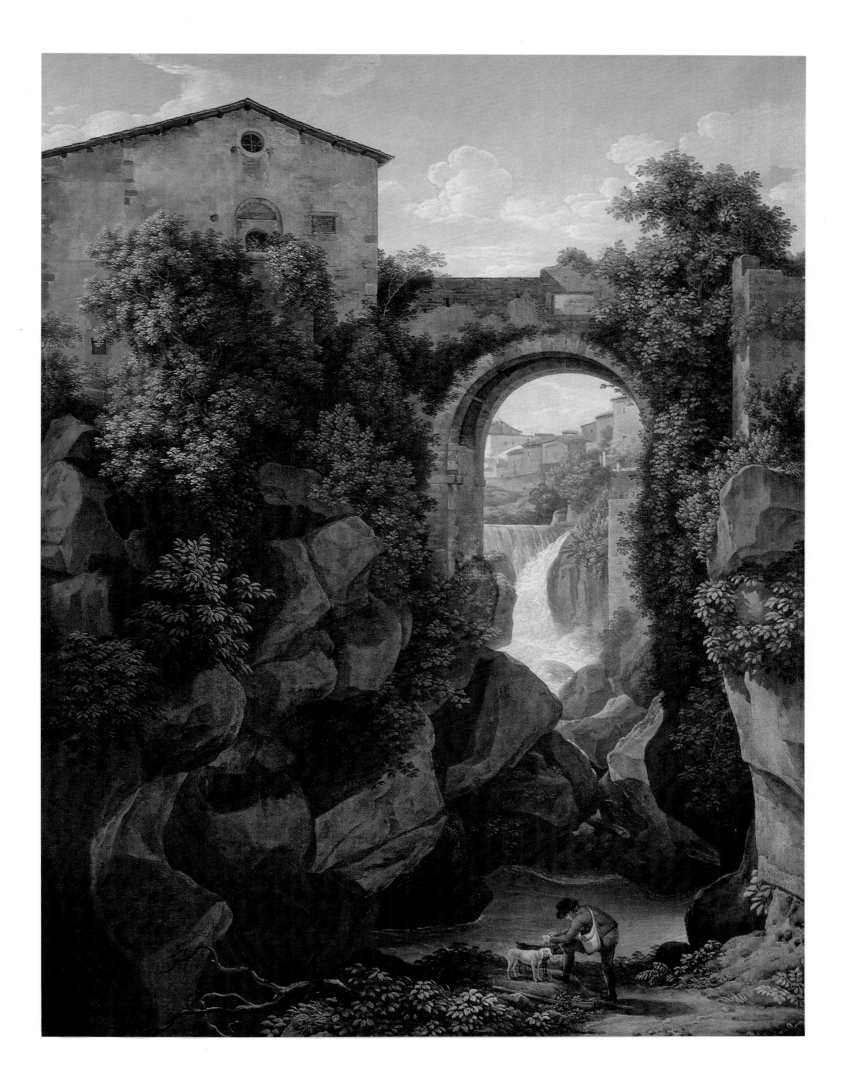

JOSEPH ANTON KOCH (1768–1839)

Waterfall

Signed and dated: Koch 1796
Oil on canvas, 39 3/8 × 29 1/2″
Kunsthalle, Hamburg

Joseph Anton Koch was born in 1768, the son of the poor laborer in Obergibeln in a remote valley of the Lech River. He received his first instruction from a hermit. A pilgrimage to a wonder-working image made a profound impression on the boy. Around 1782 he attended the Dillinger theological seminary; in 1785 he became a student at the Karlsschule in Stuttgart, which was, or aspired to be, an academy of the arts and sciences. But "this nature boy who shows so much promise" could not adjust to either institution. Imbued with the ideas of freedom the French Revolution had engendered, he fled to Strasbourg in 1791. In a letter dated 1805 he writes: "I came to Strasbourg, stayed there a few weeks with De la Vaux, but since I didn't want to be a Jacobin without a source of income, I said good-bye to that republican company—having energetically danced around that barren tree with my red cap on my head—and went on to Basel. I stayed there almost a year, until I came under suspicion of being a dangerous person and was expelled. I got to Bern, but I wasn't wanted there, either; went to Biel, where they decided to tolerate my presence." His own modest earnings plus some outside help made it possible for him to set out for Italy. "But first I went into the Bernese Alps, where I gobbled cream with cheese roasted over an open fire, and stalked across the mountains like a chamois hunter." He arrived in Rome in the spring of 1795, and except for a few years' interval during the Wars of Liberation, he remained a Roman. Soon he had established himself as the "chief" of German artists in Rome, a position which in no way diminished his republicanism. He was straightforward, direct, and aggressive, though personally very sensitive. It is noteworthy that one of his favorite writers was Abraham a Sancta Clara. He liked to read his work out loud in Tyrolean dialect. Incidentally, he did the same thing with the *Nibelungenlied*, which was just then being rediscovered. Koch was not always easy to live with, "for he was full of strange whims and crotchets" (Ludwig Richter). He did not fit into the well-groomed salons of Rome.

The *Waterfall*, shown here, is one of Koch's earliest paintings extant. He had made a drawing of the Falls of the Rhine at Schaffhausen in 1791 (Graphische Sammlung, Stuttgart). Violent motion fascinated him, as the Hamburg picture clearly shows. Here Koch has the water racing down a narrow rocky gorge. The entire composition is based on the sharp contrast between the jagged brown rocks and the silvery gray-white water foam. The brown tones on the left deepen to a blackish gray; on the right, the green trees are tipped with warm yellow-green highlights. Yet Koch shows great restraint in his use of color. Even the shepherd at the lower right, with his reddish-brown skin and gray-brown garment, almost blends into the background. It is hard to know just what the shepherd is doing, or trying to do. He seems to be moving toward the water, but is he afraid to cross? On the other side, lower left, lies a dead tree, like a monster, reminiscent of Kolbe's work (fig. 46). Apparently Koch's intention was to make the menacing aspects of a gorge and the elemental power of falling water as impressive as possible; this is why the composition is arranged at such a steep angle, with everything crowded threateningly into the foreground. There is a mere hint of sky and distance at the uppermost edge of the

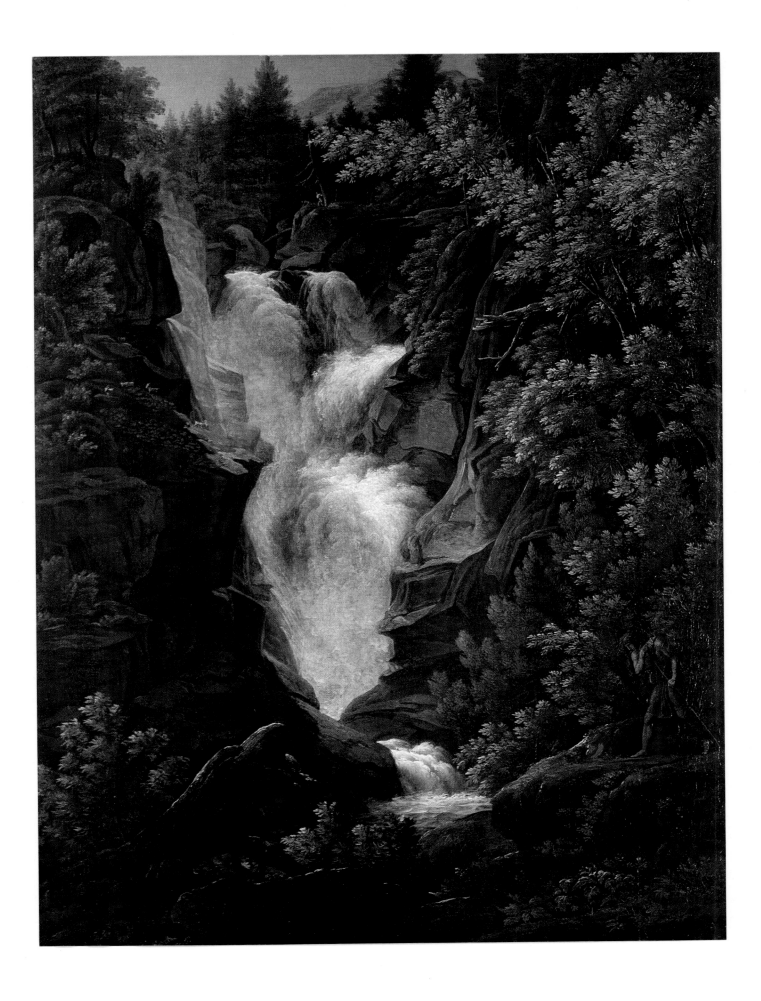

JOSEPH ANTON KOCH

Landscape with Rainbow

Dated 1805
Oil on canvas, 45 3/4 × 44 1/4"
Staatliche Kunsthalle, Karlsruhe

picture. By comparison, Reinhart's Tivoli painting (color-plate 2) seems much more articulated, both in depth and in height. But Koch was intent on showing how narrow, menacing, and inescapable the gorge is. He has not completely succeeded, however, for the huge waterfall ends rather harmlessly at the bottom of the picture.

Landscape with Rainbow (previously described on pp. 14–15) dated 1805, shows how quickly Koch had mastered the problem of wide, articulated space with distant depths and a big sky. Koch's intense preoccupation with geology does not show here quite so clearly as in his *Schmadribach Falls*, the first version of which (Museum, Leipzig) he began in 1805 but did not finish until 1811. Koch was very industrious. When he was fond of a subject, he repeated it. There are repetitions of his *Schmadribach Falls* (fig. 21) and of his Karlsruhe landscape in the Neue Pinakothek in Munich (1821/22 and 1815 respectively). But both these second versions are inferior to the first. The *Schmadribach Falls* is one of the most grandiose alpine landscapes of the nineteenth century. Richter was fascinated by the "poetic interpretation" of that "magnificent alpine painting." "It gave me immeasurable delight to see that mighty mountain torrent pour down from snow-covered cloud-shrouded peaks and come boiling through the dark pine forest, and especially the frantic speed of those wild waves in the foreground, gushing over tree trunks and stones. The shepherd boy with his alpenhorn and his few goats, standing so quietly, almost forlornly, amidst that grandiose scenery and watching the tempestuous, roaring

waters, is a truly delicious idea." Looking at that picture, we understand that Koch, as Richter states, was firmly opposed to all sentimentality, "for he was by nature more classical than romantic."

As important as his *Schmadribach Falls* is Koch's *Wetterhorn*, dating from 1824 and now in the Reinhart Collection in Winterthur. Both these pictures, however, do not really show the "poetic interpretation" Richter felt. Rather, they make visible the history of the earth. Carl Gustav Carus says in his *Nine Letters on Landscape-Painting*: "How clearly and powerfully the history of these mountains speaks to us . . . how tellingly that history is expressed in certain layers and formations, so that even the ignorant are bound to get a sense of history from them." Shouldn't the artist therefore be permitted to "emphasize these features, and thus create landscapes that are historical in a deeper sense?" Koch did, from memory or by a combination of unusual methods. When he painted the Scheidegg, long after his stay in Switzerland, he utilized "the very unimportant watercolors of a young Swiss painter," as Richter, who visited him while he was working on the picture, reports. "But he composed the whole thing in his own way, and since he asked me to, I painted in a piece of the foreground for him. 'I can't paint those little plants,' he said. 'I've got a damned heavy paw and it needs something light and delicate here.' So I painted the little plants. While I was busy doing that, he told me the story of his childhood, when he had herded goats high up in the mountains and had drawn, with coals from his goatherd's fire, great stories and landscapes on the smooth rock walls—

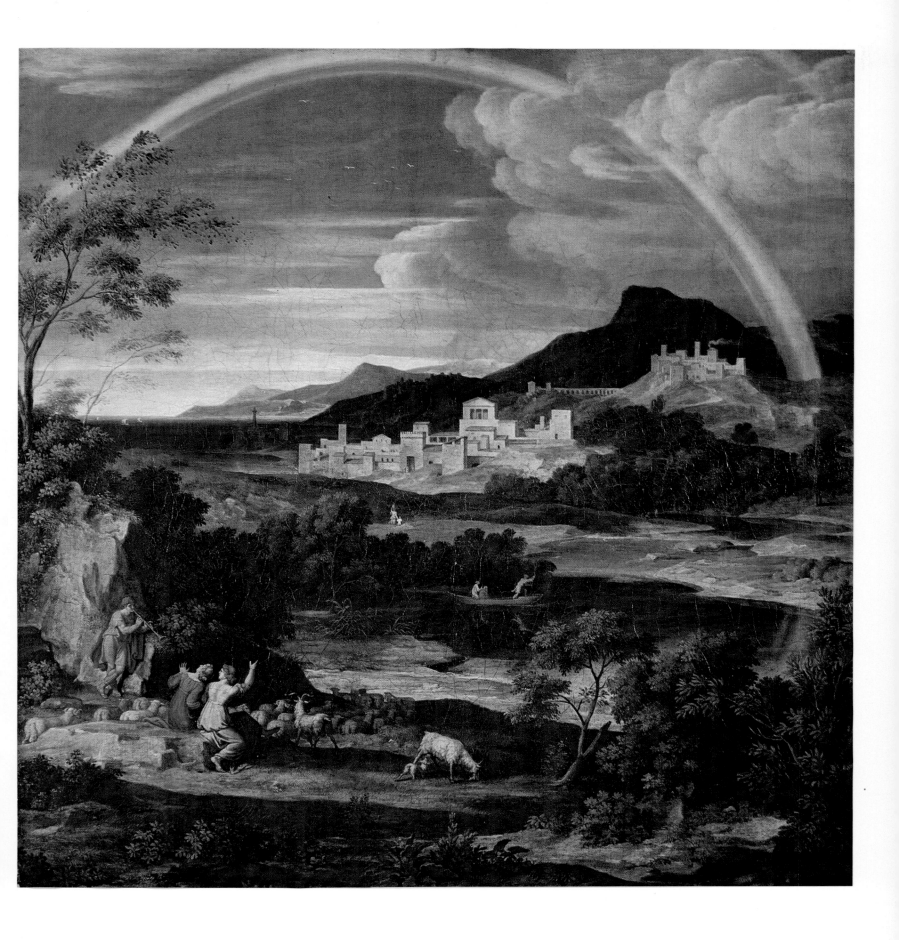

Colorplate 5

JOSEPH ANTON KOCH

Landscape with Men Returning from the Promised Land

Signed and dated: J. Koch T. 1816
Oil on canvas, 28 3/4 × 39"
Wallraf-Richartz Museum, Cologne

mainly stories from the Apocalypse. There was a sense of greatness, of power, of the fantastic in him even when he was just a young goatherd."

Among Koch's paintings of religious subjects, we have chosen this one showing the men returning from the promised land. There can be no doubt that the luminous landscape is far more important in this picture than the human figures are. Yet religious motivation obviously meant a great deal to Koch. In this he agreed with Friedrich Schlegel, who had expressed his views to his stepson, the painter Philipp Veit, in 1816 and 1817. Like Runge and Friedrich, Schlegel wanted landscape painting to serve religious art. At that time Veit was working with Peter von Cornelius and others on the Casa Bartholdy frescoes (colorplate 35), and Schlegel wished him "the best of luck" with the project, "which will surely prove a valuable experiment and will enlarge [your] artistic thinking, purpose, and knowledge."

But then he expressed "a thought, or rather a wish" which he had long entertained. "I really wanted you to learn landscape painting from our own Koch; it is definitely an important element of historical painting and one in which one can still accomplish a great deal and be quite new and different. But one must first learn the special techniques, preferably from a painter like our Koch, who practices the great art of sacred painting and whose interpretation of nature does not conflict with it. . . . Oh, what a pity that [he] never saw the ancient sacred pictures at Sulpiz [Sulpiz Boisserée's collection] in Heidelberg! There are pictures by Hemmeling [Memling] among them, sacred

landscapes, especially one showing Saint Christopher crossing the water with the Child on his shoulders—they surpass anything you can find in the way of landscapes. It would have meant a new period and a new step in the development of Koch's art." (The reference is to the same picture which nearly "converted" that "old heathen" Goethe, p. 45.)

In 1817, when Veit was toying with the idea of becoming a clergyman, Friedrich Schlegel once again brought up the subject of his "ideas on landscape painting," but unfortunately he confined himself to a rather general remark about ". . . the way a painter can interpret and represent nature in a Christian way, thus glorifying the mysteries of religion from a completely new viewpoint, insofar as it is possible in the visible world." Schlegel's wife, Dorothea, felt that Friedrich would have to "produce some very special statements" in order to convert her to his ideas. For the time being she remained on her son Philipp's side, to whom Christian painting meant the painting of human figures only.

The question remains whether Friedrich Schlegel, in presenting his ideas in concrete form, would actually have pleased the artist Koch, whom he praised so highly. Koch was a sworn enemy of aesthetic theorizing. In a letter dated 1805, mentioned above, he says: "There is a crazy race of people who keep coming here across the Alps. They call themselves aesthetes; they wear eyeglasses; they languish, they are filled with a sense of beauty, and they cannot look at anything without immediately pulling some writing materials from their pockets and writing down their clever observations. The curators and guards tend to mistake them for notaries."

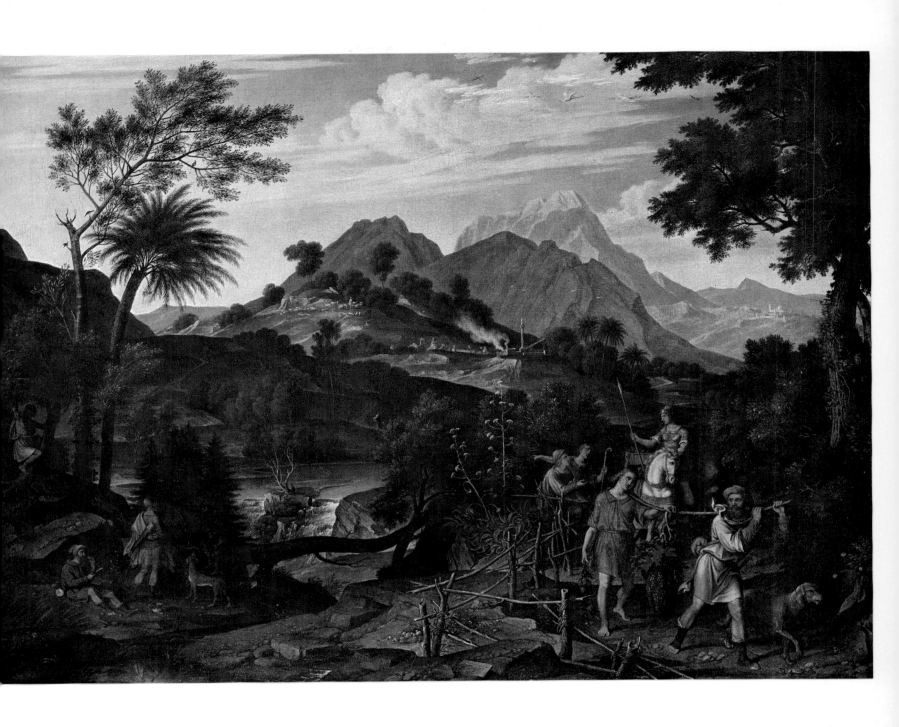

CARL PHILIPP FOHR (1795–1818)

Mountain Landscape (detail)

1818
Oil on canvas, 38 5/8 × 53 1/8″
Collection of HRH the Prince of Hesse and the Rhine,
Darmstadt

This landscape (fig. 22) was painted near Rocca Canterano, not far from Subiaco, and it was done in the last year of the artist's life. Although it is not completely finished, it is one of the most important examples of German landscape art. Fohr was twenty-two when he painted it. He was born in Heidelberg, the son of Jakob Fohr, a teacher and cantor in the French-reformed community. He went to the local gymnasium (high school), where his studies were overwhelmingly unsuccessful. "Every scrap of paper," wrote P. Dieffenbach, his first biographer, "was utilized for drawing or painting. During classes he took great pleasure in committing funny scenes he had seen in the street to paper and in portraying his teachers in a manner that made the other pupils laugh. This not only led to unpleasant scenes whenever he was found out; it also made his intellectual development lag noticeably behind that of many of his fellow students." His spelling alone was, and remained, horrible. But he was so obsessed with drawing that his father apprenticed him to Friedrich Rottmann, who taught drawing at the university and was Carl Rottmann's father (colorplates 24, 25). Through a lucky coincidence the fifteen-year-old Fohr met Georg Wilhelm Issel (fig. 12), a painter and privy councilor to the prince of Hesse, who persuaded him to move to Darmstadt. But there, it seems, he received no further instruction in art, in spite of Issel. "Thus," writes Dieffenbach, "he was thrown back upon himself, became his own teacher. Without any outside instruction, he made excursions into the surrounding countryside to pick out objects he wanted to draw or sketch. He was particularly fond of trees and often found some near Darmstadt—ancient oaks, sturdy beeches, old willow trunks, and so on—which he used for studies. In his later paintings one can find certain trees whose originals might still be standing in the so-called Buchwald. He did not mind walking for several hours to find a beautiful tree."

His illuminated landscapes, drawn from nature, earned him the favor of the Grand Duchess Wilhelmine Louise, who became his generous patroness. She enabled him to enroll at

the Munich academy in 1815. It did not do much for him. The director, Johann Peter von Langer, was a pedantic person who adhered rigidly to the rules of Classicism. The new interest in the German past, in medieval myths and knightly epics, in the *Nibelungenlied*, were anathema to him. But these ancient tales were just what attracted Fohr, though landscape fascinated him even more. He used his first vacation from the academy for a journey across the Alps to Venice. He spent forty extremely happy days drawing and painting watercolors. Langer had spoiled Munich for him. In 1816 he went to Heidelberg, where he became a member of the Teutons, an organization of patriots who hoped that a new Germany would emerge from the Wars of Liberation. Fohr portrayed the members of the group, which was to play an important part in the history of the German students' associations. It became apparent even then that Fohr was not only a born landscape painter, but equally gifted as a portraitist. Fohr wore the Teutonic coat he had designed, as did all the members of the group (p. 44). He wore it in 1816 when he set out for Rome. It would have been unthinkable for him not to be attracted by that "sun of European art." On November 21 he arrived in Rome. The Germans there quickly became acquainted with each other. For young Fohr, the encounter with Koch, who was many years his senior, became most important. And Koch, in turn, felt drawn to Fohr. Richter, who came to Rome in 1823 and was "intoxicated with delight" by the young man's nature studies, was of the opinion that Fohr "could have given a new direction to landscape painting." Fohr himself wrote: "I don't think I am overly confident if I believe that I will soon outdo even the most famous landscape painter, Koch." He was not to reach his goal. One day, having worked on a sketch of Hagen, the Nibelungen hero, addressing the Rhine maidens, Fohr went bathing in the Tiber with his friends. Exhausted from having worked all day, he was overcome by an attack of weakness, or else there was a sudden drop in the river bottom—the water spirits claimed him. (Several other artists whose work appears in

CARL PHILIPP FOHR

Pergola

Pen-and-ink and watercolor, 11 1/8 × 8 1/2"
Collection Georg Schäfer, Obbach

this book also died young.) Fohr's untimely death is a major loss in the history of German art.

Fohr learned from Koch. One might actually call him a student of Koch's. Koch conveyed to him his own sense of grandeur in landscape, of the loftiness of mountains, of the structure of the earth. But no matter what Richter might have said, Koch's landscapes—when he stuck to reality—remain more geological and thus more historical in the sense in which Carus used the word: more concerned with the history of the earth. By contrast Fohr is more poetic, more musical. How melodiously the contours of hills and mountains rise and fall in the *Mountain Landscape*. It is truly an "earth-life picture." Koch, too, strove to place his figures harmoniously in his landscapes, and in his Karlsruhe picture (colorplate 4) he succeeded. But it may not be unfair to say that Fohr surpassed Koch in this respect. In his *Mountain Landscape* (fig. 22; colorplate 6) the woman and her children walking toward the spring, the piping shepherds wandering downhill, the pilgrims resting beneath the trees—all belong inextricably to this multiform landscape. Only someone who has wandered himself along many long roads and experienced them fully could invent such a wonderfully varied landscape. It is not accidental that there are pilgrims in this picture. The musical shepherds wandering down the hill are truly enchanting, like figures from a fairy tale, real and unreal at the same time. And as for the woman walking to the spring, her bright red apron, contrasting with all the greens and browns, definitely becomes the focal point of the picture—a truly inspired use of color. While the others step along cheerfully and blithely, she takes her children to the spring, deep in thought, for water is refreshing, one of the good things of this world. Fresh water and springs play an important part in the pictorial world of Runge, too.

We have mentioned Fohr's magnificent draftsmanship earlier (p. 47). His watercolors are no less important. One of the most "modern" of these is the wonderful rendering of a pergola shown here. One is tempted to speak of a geometrical sketchiness—and while the term is self-contradictory, it does seem to apply here.

It has been said that Fohr, unlike Koch and the Nazarenes, never introduced religious scenes into his landscapes. But that is not quite so. A watercolor destroyed by fire showed Saint Benedict in a landscape near Subiaco, in the manner of Koch. A pen-and-ink drawing with watercolor depicts a procession in Saint Peter's cemetery in Salzburg. And *Mountain Landscape* contains some pilgrims. There are some Madonna studies extant, too. The story goes that Bunsen, the Prussian legation secretary, read to Fohr from the works of Martin Luther while he painted. But Fohr's pictures show no trace of that. By contrast, a Hamburg artist who also died young, Carl van Bergen (1794–1835), confessed his Lutheranism in a delightfully colorful *Still-Life* (fig. 51), for the placement of Luther's translation of the New Testament in the "religious" center of the composition, and the way in which it is done, certainly have to be interpreted as religious testimony. Still-lifes had become rare in that period, in both Germany and Italy. Van Bergen's picture is specifically signed and dated "Rome 1821." It calls to mind a passage in *Italienische Reise* that Goethe wrote on his birthday in 1787 about Johann Gottfried Herder's *God*—a "little book filled with fine thoughts of God. I was comforted and pleased to read them—so pure and beautiful—here in this Babel, this mother of deceit and error; and to think that now is the time when such ideas and such ways of thinking can and may spread." It also calls to mind Richter's stories about the beneficial effect of the brilliantly voluble Richard Rothe, who preached from 1824 to 1828 at the chapel of the Prussian legation. But the Protestants in Rome had only one chapel at that time, and they had to bury their dead after sundown outside the city. Fohr was buried near the Cestius pyramid in the Protestants' cemetery where, among others, Carstens too had been laid to rest.

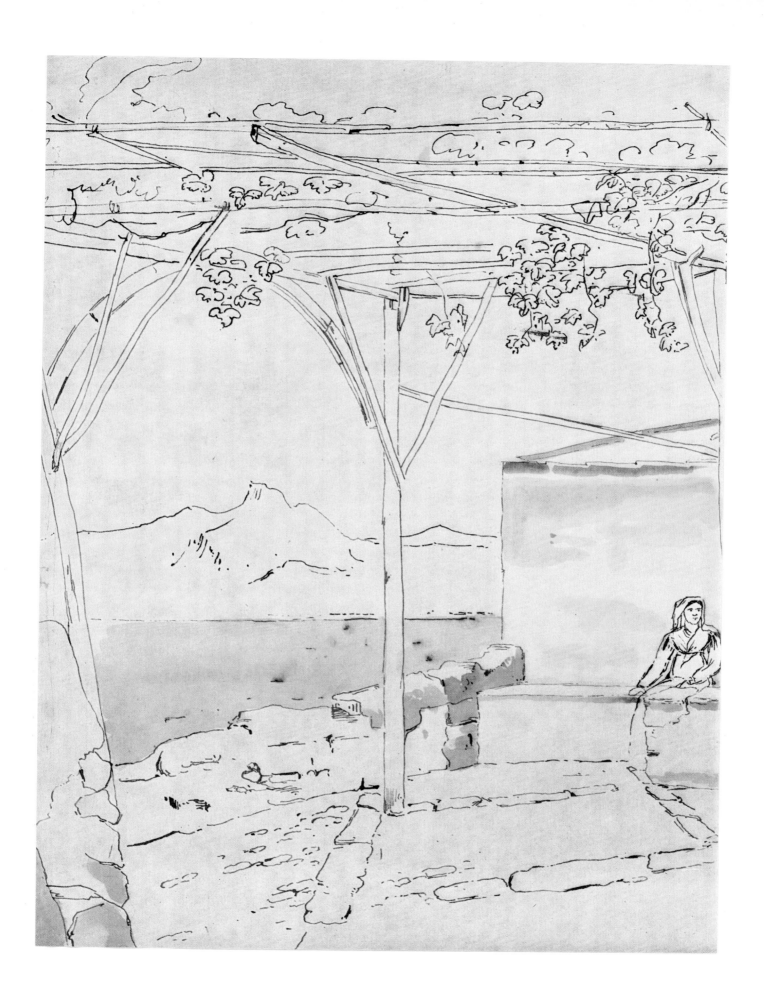

GEORG FRIEDRICH AUGUST LUCAS
(1803–1863)

Landscape near Rome

Signed: A. Lucas fecit.; c. 1830
Drawing with watercolor, 18 3/4 × 25 1/8″
Kurpfälzisches Museum, Heidelberg

August Lucas was born in Darmstadt. His first artistic inspiration was G. A. Primavesi, an Italian born in Heidelberg whose enthusiasm for the Heidelberg landscape and the picturesque ruin of its castle resulted in numerous pictures. Later Lucas came under the influence of Fohr, whose work made an even deeper impression on him than Primavesi's. In 1825 and 1826 he worked with Cornelius. He traveled to Italy, 1829–34, where he was especially attracted by Koch. He lived in Darmstadt in the years that followed, doing portraits as well as landscapes. Later he worked briefly in Heidelberg, where he made friends with Carl Philipp Fohr's brother Daniel. Except for a second stay in Rome in 1850, he spent the rest of his life in Darmstadt. His work is uneven, but he had inspired moments, as the drawing reproduced here proves. The muted browns, greens, and grays almost make one forget that the landscape is in sunny Italy. But all German painters living in Rome tended to stress the "proto-character" of the Roman landscape. Some of that can be felt in this picture. The articulation is superb, the arrangement of trees particularly effective. Leafy and leafless trees are juxtaposed. The leafless trees stand along a narrow footpath that leads back into the depth of the picture. Those farthest away stand out against the sky, delicate as cobwebs. The dying tree in the foreground, right, could be an ancestor of the trees of Van Gogh. And doesn't the entire composition really point to Van Gogh? "Rich soil," wrote Carl Rottmann in 1826, "is by no means typical for all Italian landscapes. The most beautiful spots I have seen had very little luxuriant vegetation. They usually had scorched grass on sandy, rocky soil with heather, hawthorn, and wild fennel showing in the foreground." And in a review of paintings by Karl Blechen exhibited at the Berlin Academy in 1830 the art critic of the *Spenersche Zeitung* had this to say about such a landscape: "These pictures may be invaluable as faithful renderings of the Campagna, since they are undoubtedly true to nature. But it is questionable whether those wastelands with their white volcanic soil almost devoid of vegetation can be considered suitable subjects for painting, especially when, as in this case, the whole thing remains completely without aesthetic value." The critic does not tell us what he means by "aesthetic value" and, needless to say, we do not agree with his judgment.

However, one might remember the writer Heinrich von Kleist's observation in connection with Caspar David Friedrich's *Monk by the Sea*. The poet was "convinced that with his [Friedrich's] spirit, a square mile of sandy marshland could be rendered by a single barberry bush with a solitary crow sitting upon it, fluffing its feathers. Indeed, if that landscape were painted in its own chalk and with its own water, it could make the foxes and wolves howl." Lucas does not go quite as far. But he does convey a sense of desolation, and while he has not placed any crows in his landscape, he indicates a pair of human figures beside a cleft in the rock which, despite its proximity to a few leafy trees, seems no more hospitable than a barberry bush in Kleist's sandy marshland. This piece of Italy is obviously not "the new Jerusalem of the truly cultivated," as Goethe called it. But the composition of those rocks and stones somehow anticipates the compositional methods of Cézanne.

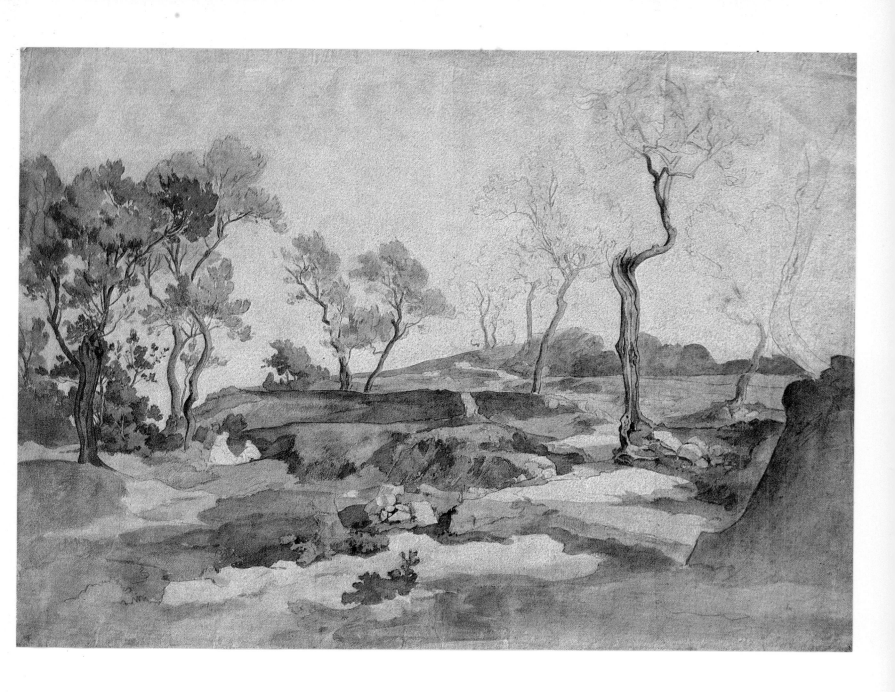

GEORG VON DILLIS (1759–1841)

Prater Island with View of the Gasteig Infirmary

After 1800
Oil on canvas, 8 × 10 3/8"
Staatliche Kunsthalle, Karlsruhe

Johann Georg von Dillis was born in Grüngiebing near Wasserburg, the son of a game warden. After graduating from the gymnasium in Munich, he studied philosophy and theology in Ingolstadt and was ordained a priest in 1782. But he managed to get himself released from all pastoral duties. In school he had studied drawing with Johann Jakob Dorner the Elder; later he studied and copied mainly from the Dutch old masters. Even when he first attended the academy, he was confined to copying pictures. But he had a great urge to get out into the countryside. Thus he was one of the first artists to discover the landscape of northern Bavaria. In 1785 he had some success with his watercolors. In 1788 he went on his first big journey, to Alsace and then to Switzerland. In addition to being a creative artist, he had a profound interest in art history; thus he was made inspector at the Hofgarten Galerie in Munich, which was later transferred to the newly erected Pinakothek. His responsibilities as inspector included not only the old pictures in the gallery's collection but also the development of all young artists who studied there; he was utterly devoted to that task. His travels broadened his knowledge. In 1794 he visited Rome for the first time, and he returned to it repeatedly: in 1817–18 with the crown prince and again in 1830 and 1832 with King Ludwig of Bavaria. In 1822 he was named Central Director of Collections of Paintings and Other Art in Munich, and he became the king's most important adviser on acquisitions for the Pinakothek and on the arrangement of its collections.

Nowadays a museum director is usually an art historian rather than an artist, for it is hard, if not impossible, to meet the museum's intellectual demands while at the same time enjoying the necessary freedom of an artist's life. But Dillis's success must be ascribed to pure genius. Of course he had the spirit of the times on his side: critical art history was still in its infancy, and so was the museum "business." Nevertheless Dillis's ability to combine art historianship, art expertise, and art instruction with a genuinely modern creative talent of his own is a most impressive accomplishment.

He began his artistic career by drawing *vedute* (views).

But he soon managed to free himself from the constraint of topographic representation. He was familiar with the art of the seventeenth and eighteenth centuries, and its painterly qualities attracted him. Though an excellent draftsman, he really came into his own with watercolor and watercolor technique, as the small picture of Prater Island illustrated here shows. It has such painterly immediacy that one is tempted to see it as a forerunner of Impressionism. The group of trees in the right foreground is a masterpiece in itself: in a wonderful series of transitions it dissolves from the definite to the vague and to pure, if muted, color. The footbridge whose straight lines mark the middle ground all the way across, spanning the irregular shape of the river; the rising bank on the other side, receding into the distance in a diagonal line; the white infirmary with its red roof, a half-hidden but very decided presence—all this bespeaks the experienced artist who knows exactly what he is doing. The light blue-gray sky is a most delicate background for the clouds of foliage, and is reflected in the waters of the Isar, where its blue is paler and flows into gray and pinkish-brownish tones. The figures under the bridge are pure splashes of color, yet their motions are perfectly recognizable. It is a bright world that seems to rest within itself. Yet this restfulness does not rob it of mystery. The group of trees holds and bears witness to the secret of earth life. Dillis loved trees and experienced their essence, as we can see in his etchings, too (fig. 45). And some of his city views, of Rome for instance, can hold their own beside those of Corot.

It is quite remarkable that this man, a Catholic priest, painted so many landscapes and genre scenes yet never did a single "Christian" picture. And he refused to accept a teaching post at the Academy for Landscape Painting—though not for the same reasons as Cornelius. Dillis considered a teaching post "utterly superfluous" because he felt that students should "go to nature" directly, since nature "gives the landscape painter all the education he needs." He added that, after all, "today's landscape painters have earned their high reputation by diligently studying Nature herself."

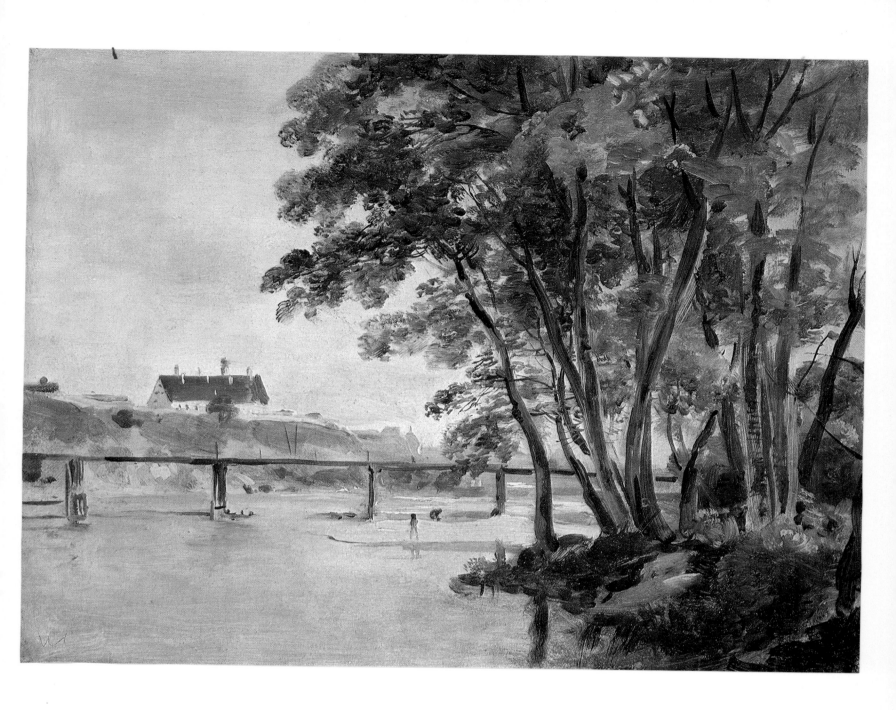

WILHELM VON KOBELL (1766–1853)

View of the Valley of Kreuth

c. 1810
Oil on paper, 8 5/8 × 13 1/4″″
Staatliche Graphische Sammlung, Munich

"Anyone who wants to follow his own road, alone, on his own two feet, without holding on to the pedantic apron strings of artists and professors, is putting his hand into a wasps' nest." These words were written in 1793 by Ferdinand Kobell (1740–1799), Wilhelm von Kobell's father, who had indeed attempted to go his own way, out of the Baroque style that dominated his time. One of Ferdinand Kobell's etchings (fig. 42) anticipates a composition by Caspar David Friedrich (fig. 41) in a remarkable way. Like Friedrich, Ferdinand Kobell refused to believe "that, in order to become a great landscape painter, a man absolutely had to go to Italy—I am so stubborn that I simply will not be induced to go there." His son studied at the Zeichnungsakademie (drawing academy) in Mannheim, which was under the directorship of Verschaffelt; but he also learned from his father. In 1786 father and son worked together on the famous Aschaffenburg landscapes, whose "realism" is considered seminal to German landscape painting. In 1793 Wilhelm moved to Munich, and later his father followed him there. Here again Wilhelm turned to landscape painting. But he had also studied the human figure and painted animals in Mannheim, and he continued to do so in Munich. He was inspired by early Dutch painting and also, it has recently been shown, by the English artist George Stubbs. The painting *At the Edge of the Woods* (fig. 24), dated 1800 and now in Hamburg, is a beautiful, warmly colored example. It consists of a genre scene placed within a landscape. The main figure, a horseman, is seen from behind. To his right, a family of woodcutters forms a convincing group from which we see a young man walking toward the horseman to hand him a refreshing drink. But the horseman does not reach for the drink. This kind of suspended action is very typical of Wilhelm von Kobell: we encounter it again and again in his pictures. It adds to the sense of quietness pervading the entire scene.

In 1806 the king of Bavaria commissioned Kobell to paint some battle scenes. Their realism moved Crown Prince Ludwig to commission another set of pictures on the same subject. From 1808 to 1815 Kobell did twelve large battle paintings destined for the walls of a ceremonial hall. They were to glorify the exploits of the Bavarian army in the service of Napoleon Bonaparte. Georg von Dillis (p. 66) served as adviser to the crown prince. The most famous of Kobell's pictures is, and deserves to be, the *Siege of Kosel*. In it we can see the break with the Baroque tradition most clearly. The supreme commander is not shown at a moment of heroic action, but stands, surrounded by his staff, on a hill in the foreground. There is a tense stillness around this commander-in-chief, General Raglovich. The fact that most of the figures are seen from behind might be termed a Romantic device. But what really dominates the picture is the size and depth of the wide landscape—it seems to affect these soldiers more powerfully than the siege itself. Fog and gun smoke, hovering above the ground, hide the battle action from view.

It is not too farfetched to think of Friedrich when looking at the *Siege of Kosel*—with its spacious, seemingly limitless vista on either side, its vast sky, and its quiet action. Even more reminiscent of Friedrich is Kobell's *Valley of Kreuth*, illustrated here. It almost could be a companion picture to Friedrich's *Harz Mountain/Riesengebirge Landscape* (fig. 20). Kobell's work, to be sure, is more concrete, more varied in its forms. Yet both compositions are based on the contrast between a large plain and the mountains behind it, with their highest peaks on the left, descending in melodious contours to the right. Kobell, of course, interposes a line of trees between his plain and his mountains. And the group of trees in the left foreground, warmly lit by the sun, makes the plain seem not quite so endless in that direction as the one in Friedrich's picture. Nevertheless, the similarities of composition and expression are incontestable. Kobell's mountains and meadows also have something mysterious in spite of the solidity of their presence. In the very center of his picture Kobell has placed—stippled in delicate blue-greens—a figure seen from the back, facing the mountains. "What is man that thou art mindful of him?" The question may be asked here, too, in full view of the extraordinary might of these mountains.

Kobell's further artistic development shows fewer and fewer instances where a comparison such as the one above could be made. The sense of quiet never left his pictures—it became even stronger. He painted figures in landscapes, both adults and children, usually in Bavarian national costume. He particularly liked to depict men on horseback, as well as all sorts of animals, with a "neat brush and a clarity of coloring" which Goethe praised and which has remained quite popular to this day.

In 1814 Kobell became professor of landscape painting at the academy in Munich. When he was pensioned in 1826, the post was discontinued. Like his father before him, Wilhelm von Kobell never visited Italy. All his love was concentrated on the Bavarian landscape.

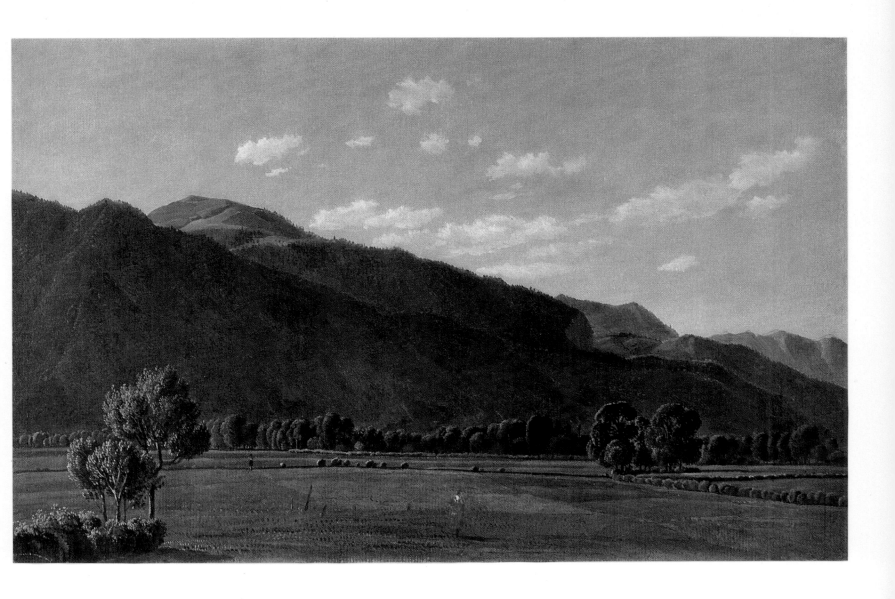

CASPAR DAVID FRIEDRICH
(1774–1840)

Ships in the Harbor of Greifswald

Before 1810
Oil on canvas, 35 3/8 × 27 5/8"
Staatliche Museen, Berlin

"In the year of our Lord, 1774, on September 5, on Monday morning at three-thirty, born into this world," says the entry for Caspar David, made by his father in the family Bible. He was the sixth child. His father owned a soapworks and chandler's shop in Greifswald. One event in Caspar David's childhood, the death of his brother, produced a memory that was to haunt him all his life. The parish register of Saint Nicholas contains these lines: "On December 8, 1787, the chandler Friedrich's son (Johann Christoffer), aged twelve years, drowned while trying to save his brother who had fallen into the water." The children had gone boating on the town moat; their boat had overturned and the tragedy had taken its course.

We do not know who discovered Caspar David's artistic talent. Probably it was a friend of Gotthard Ludwig Kosegarten's, namely, Johann Gottfried Quistorp, who became an "academic drawing master" at the University of Greifswald in 1788. Quistorp also had worked as an architect, and in 1812 he became a professor for civilian and military architecture. It is possible that Friedrich's many portrayals of architectural structures, even though they are mostly of ruins, can be traced back to Quistorp's influence. In 1794 Friedrich moved to Copenhagen. It is hard to say in what way he profited from his four years at the academy there; undoubtedly he acquired technical skill from Jens Juel and Nicolai Abraham Abildgaard. But at the same time he also discovered Ossian, and this confirmed in him certain moods and ideas toward which he had always inclined. From Copenhagen he moved to Dresden, a city that was to attract such men as as Runge, Dahl, and the Oliviers in later years. At first he seems to have made a good living as a painter of *vedute*. He seems not to have established especially close contact with other artists in Dresden such as Zingg, Klengel, Méchau, or Crescentius Seydelmann—all landscape painters of some renown. But even then he knew what he was to write to his brother somewhat later: "Figures are not quite my *métier* . . . and I don't really paint the human figure; I paint landscapes." He did draw and paint portraits, but with certain rare exceptions (such as fig. 32), they do not tell us anything essential about him. Anton Graff, who became an important influence on Runge when the latter came to Dresden, made no impression whatsoever on Friedrich.

In 1801 and 1802 he went back to his native region. Italy did not tempt him. In his remarks about paintings by contemporary or recently deceased artists he considers those as "honest men who have not been to Rome and who have sound eyes and who paint nature from nature, not from pictures." "This could have been accomplished at home, too, from etchings; it would not have been necessary to travel to Rome for it. But it seems to be the rule of the day, in religion and in art, that one should deny one's own common sense and feelings, and lie to oneself and others." "The gentlemen who judge art are not satisfied with our German sun, moon, and stars, our rocks, trees, and grasses, our plains, lakes, and rivers. Everything has to be Italian if it is to have any claim on greatness and beauty." "If X had not gone to Rome, he

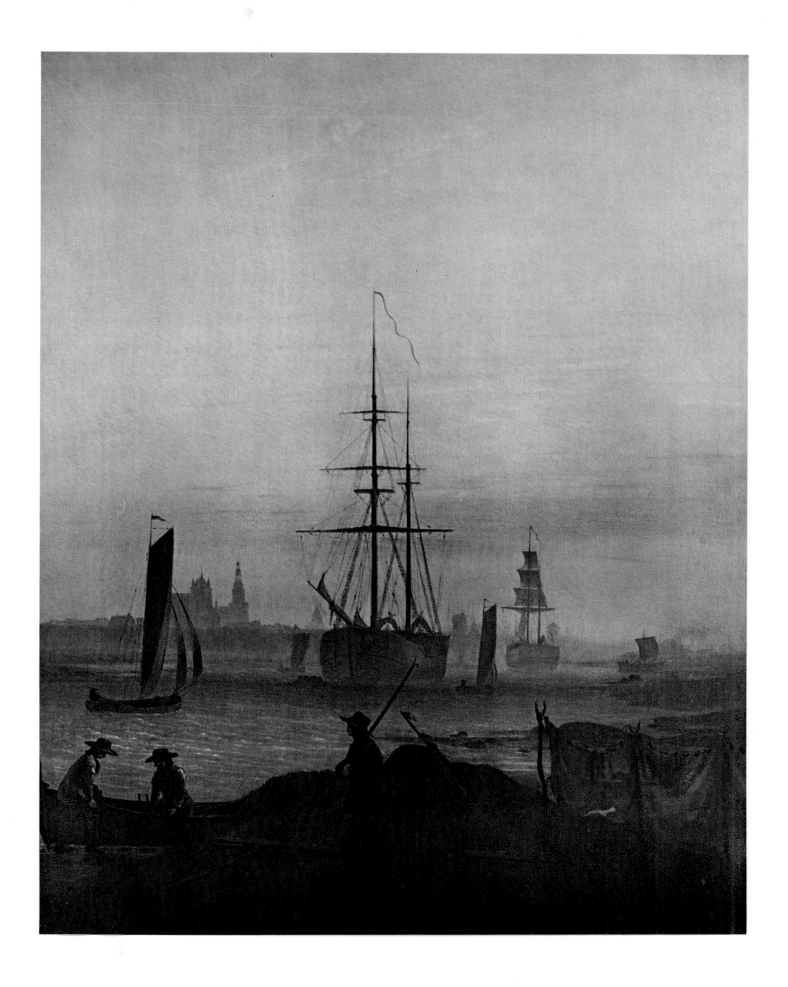

CASPAR DAVID FRIEDRICH

Meadows near Greifswald

After 1820
Oil on canvas, 13 3/4 × 19 1/4″
Kunsthalle, Hamburg

would have gone much further as an artist. Since he has come back from Rome, he has improved. In Rome he paid homage to the fashion of the day and became a disciple of Koch's, no longer a student of nature." "His friend X, on the other hand, who lived in Rome at the same time, has remained Koch's obedient servant."

What attracted Friedrich in his native landscape has been impressively described by his friend G. H. von Schubert, a physician and naturalist and the author of *Aspects of the Nightside of Science* (1808). "The quiet wilderness of the chalk mountains and oak forests of his native island of Rügen was always his favorite place in summer, and even more so in the stormy days of late autumn and in early spring. When the storm was at its peak and foam-crested waves rose up and rolled over, he would stand—drenched by the spray or a sudden downpour—and gaze upon those wild waters as if he were overwhelmed with joy, and then he would mutter in a low voice, 'How great, how mighty, how magnificent. . . .'" But it was Blechen (p. 106), not Friedrich, who painted this.

In Greifswald Friedrich had met Runge, and the two men got along well together, though each went his own way artistically. Returning to Dresden, Friedrich made several more friends. He was extremely shy, but he was capable of great warmth when he felt his friendship was reciprocated. He had a charming way with children, and was always ready for all sorts of games, as Wilhelm von Kügelgen writes. From Kügelgen we also learn that "the melancholy gravity of his

brow was lightened by the childlike, trusting gaze of his blue eyes; a gentle trace of humor hovered about his lips."

In 1805 Friedrich took part in a contest arranged by the Weimarer Kunstfreunde (W. K. F., or Weimar Friends of Art), that is, Goethe and Heinrich Meyer (p. 112). Unlike Runge, who lost, he earned a citation and half the prize money. Goethe was fascinated by Friedrich. In 1810 he visited him in his studio. He wrote in his diary: "Went to see Friedrich. His wonderful landscapes. A churchyard shrouded in fog; the open sea." That same year Friedrich had another show in Weimar, and in 1811 he visited the poet. But by then the reservations Goethe had always had, regardless of his admiration, had got the better of him, and Friedrich became a victim of the W. K. F. in that previously described battle between "pagans" and "Christians" (pages 17 and 37 ff.).

Goethe had especially admired Friedrich's mastery of sepia drawing, and Friedrich really had no equal in that medium, which was in fairly widespread use at the time. In 1807 he began to paint in oils. Later he would sometimes recall "the time when color was altogether ignored and oil paintings rather looked like sepia drawings, for brown was the predominant color in them. Later on, brown was replaced by blue and, later still, by purple; finally the color green—which had almost been excluded from landscape painting although it is so predominant in nature—came into its own. At the moment we are using all colors at the same time." This sequence is not really historically accurate, but nevertheless, in the

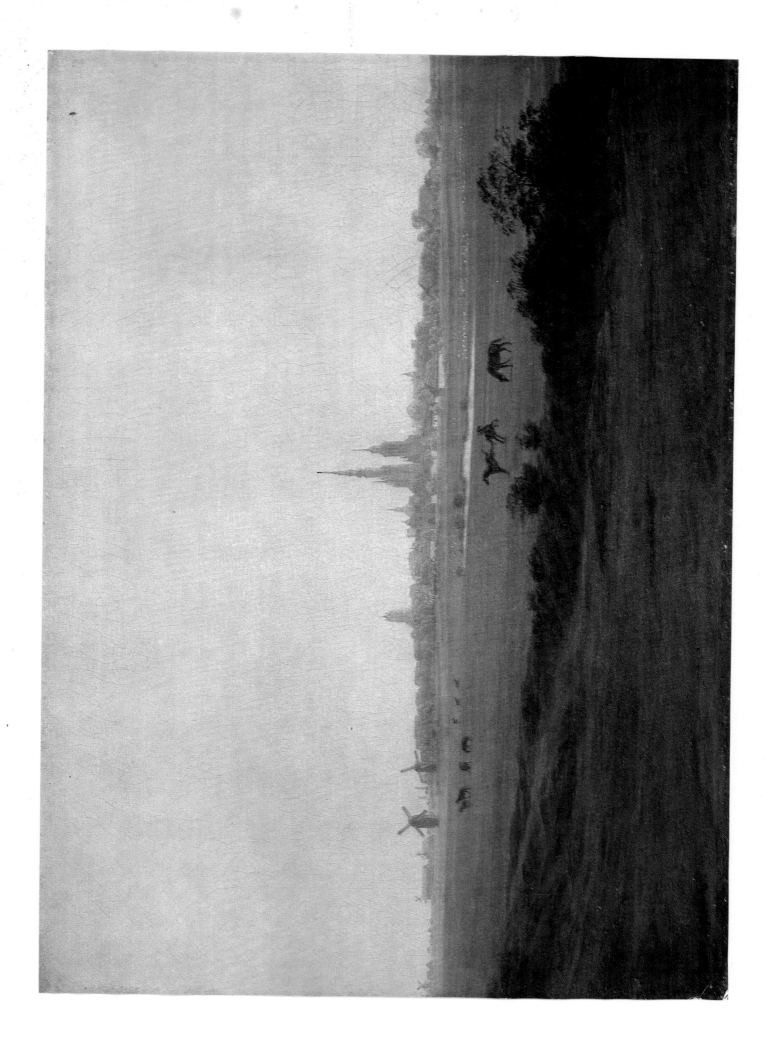

CASPAR DAVID FRIEDRICH

Trees in Moonlight

c. 1824
Oil on canvas, 7 3/4 × 10″
Wallraf-Richartz Museum, Cologne

three decades of which Friedrich speaks, painting became more and more colorful, and not only due to the Nazarenes' enthusiasm for local color.

Friedrich himself started out with a very muted palette. His painting of Greifswald Harbor (colorplate 11) is proof, as is his *Monk by the Sea* (fig. 14). The harbor picture is done in green and grays, light blue and yellow shading into orange. Its exact date is extremely difficult to ascertain: similar harbor pictures in Berlin and (formerly) Hamburg are believed to date from 1810–12, but there is no way of knowing exactly when they were painted. The picture with the thickest forest of ships' masts was destroyed in the Munich Glaspalast fire. Its masts had poked into the sky like lances. In the Berlin picture the ships' masts have been concentrated on either side, leaving open a central view into the depth. The painting illustrated here has some sailors and fishermen in the foreground, all steeped in brown shadows, and in the middle distance, beyond the water, we see the skyline of Greifswald with the churches of Saint Martin and Saint Nicholas. There are only a few ships in the harbor, the largest in the center. Its masts and spars stand like landmarks against the sky, and a layer of mist is separated from the light blue at the top by a band of orange shading into yellow. We are inclined to regard this as the most balanced of the three pictures as far as composition is concerned, but that may be a subjective judgment. Undoubtedly Friedrich was influenced

by Dutch marine paintings. But he succeeded in combining the hovering color tones with his amazing linearism. To draw the masts and spars, he may well have used the very same ruler which Kügelgen says constituted the only wall decoration in his studio.

In the harbor picture, only the very top region is light and bright. The painting reflects Friedrich's tendency to brood, and yet it would be totally wrong to think of him as only a melancholy spirit. His early Munich landscape with lovers (1807/08), the spacious landscape with rainbow in Weimar, the really magnificent watercolor in the Winterstein Collection in Munich showing the source of the Elbe, a drawing of the Riesengebirge in the Reinhart Collection in Winterthur, the Harz/Riesengebirge landscape in the Hamburg Kunsthalle (fig. 20) dating from the twenties, and, finally, the *Meadows near Greifswald*—are all proof that Friedrich's eye was open to the bright side of the world as well.

While in the last-named painting the meadows are dark green in the immediate foreground, they brighten toward the middle, and the town above the horizon stands in magical outline against a wide golden sky which turns delicate blue near the top of the picture. It is truly a transfigured world. No people are in sight, but there are horses, some grazing quietly, others in vigorous leaping motion. The artist's delicate sense of rhythm has placed the churches slightly off center. There are none of the signs of devastation that we so often see in

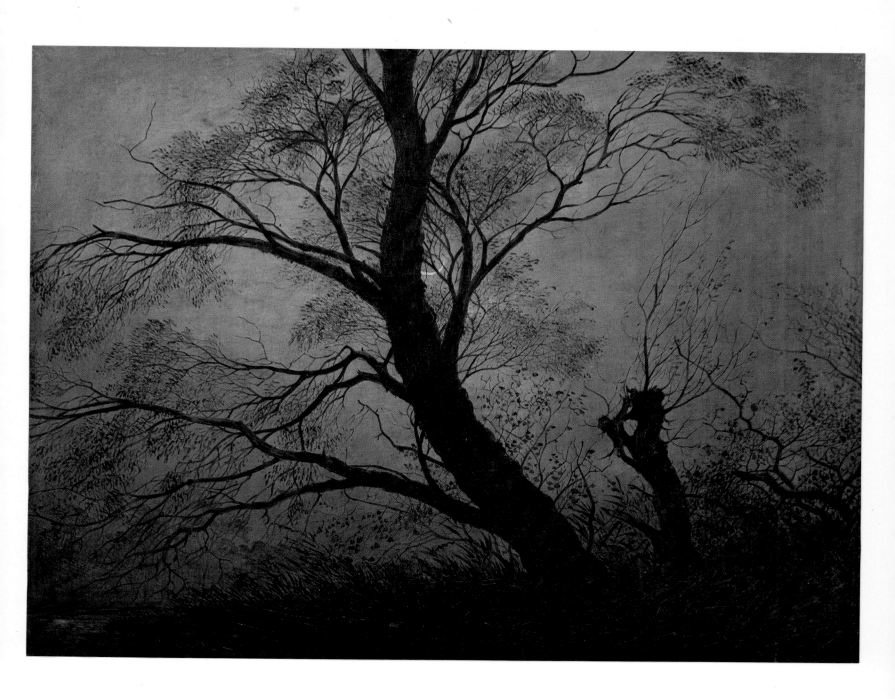

CASPAR DAVID FRIEDRICH

Lone Tree

1823
Oil on canvas, 21 5/8 × 28″
Staatliche Museen, Berlin

Friedrich's pictures of churches and monasteries (for instance, fig. 11). On the contrary, the town silhouette culminates in the steeples of Saint Mary's and Saint Nicholas's, and the spire of Saint Nicholas especially becomes a beacon for that which lies above the world. But it is the marvelous delicacy of execution that lends such a feeling of truth to the whole picture.

We know, in Friedrich's own words, that he was not always subject to melancholy. "I had just stepped out of a dark, sinister forest and found myself on a fairly high hill. Before me, in the valley, lay the lovely town, surrounded by fertile hills, and the newly shingled steeple glinted in the evening light. The Elster River wound its way through lush meadows strewn with flowers—a charming sight. And there were mountains behind those hills, and behind the mountains were crags and rocks; and rock followed upon rock all the way into the airy distance. I stood there for a long time, filled with tremendous joy, and gazed out into that airy distance. . . ."

For the sake of contrast to this attitude we have chosen to illustrate a small picture from Cologne, *Trees in Moonlight*. Here, bare trees stand black-brown against a dense gray sky. Behind the web of branches hangs, half-hidden, a yellow sickle moon. One might say that this picture shows Ossian's influence, but we can say with equal justice that Friedrich's picture prophetically anticipates the style of East Asian art that was later so widely emulated. This is a more mature picture than his drawing of a maple tree, dated March 20 and

21, 1812, in the Kunsthalle in Bremen—which, of course, is merely a preliminary study.

Like so many of the other artists in this book, Friedrich had drawn and painted trees from the beginning. A sepia drawing in Weimar of three oak trees near a cairn by the sea probably dates from 1810. The trees in it exude more personal power than Friedrich's human figures do. In German mythology people are descended from trees, and ancient Norse poetry has men and women named after trees. A hero might be called "Tree of Armed Assault," for instance. Wouldn't that name also fit the *Lone Tree* (colorplate 14) devastated by lightning and storm, in Friedrich's magnificent Berlin painting of 1823? Such a metamorphosis of the imagination occurred even to the Classicist Winckelmann. His famous description of the Belvedere Torso shows a true visionary attitude: "Just like a splendid oak tree that has been felled and stripped of its branches with only the trunk remaining, just so do we see the hero's likeness mistreated; head, arms and legs and the upper half of the chest are missing." The hero was Hercules. Of course Winckelmann's description and Friedrich's picture do not correspond exactly, but they do have in common the fact that Winckelmann sees his hero as a tree, while Friedrich's picture shows the tree as a hero. Friedrich was a passionately patriotic German, and like many other artists of the time, he suffered deeply under the French occupation. But he expressed his grief through peculiarly nonpolitical pictures of landscapes, trees, tombs (such as *Chasseur in the Forest* or *Hermann's Tomb*).

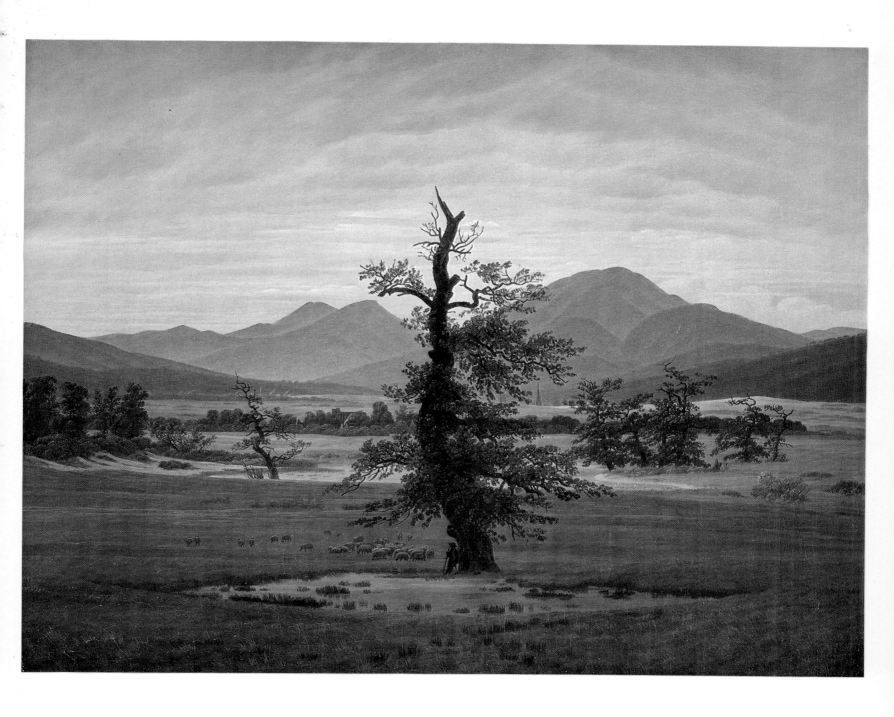

CASPAR DAVID FRIEDRICH

Woman at the Window

c. 1818
Oil on canvas, 17 3/8 × 14 5/8"
Staatliche Museen, Berlin

From Friedrich's figure paintings we have chosen to illustrate only the small Berlin picture of *Woman at the Window*. The woman most probably is Christiane Caroline Bommer, whom Friedrich married in 1818 "to the great surprise of all his friends." "No one had believed that this shy, melancholy man was capable of making such a decision." She was, Carus goes on to say, "a simple, quiet woman who bore him several children without altering his personality or his life in any way." The little picture may have been painted shortly after their wedding. It is hard to think of anything more peculiar than a man's painting his young wife with her back turned—and this in a finished composition, not just a quick sketch! Of course Friedrich often shows figures with their backs to the viewer, and this picture of his wife is probably the most important. One can almost imagine it enlarged to monumental proportions. The room seems sliced off in the foreground, and has no depth; in its strictly geometric form, it merely serves as a frame for the figure. The room isn't livable at all: the wall with the large window merely separates it from the bright outdoors with ships' masts, delicate trees, and large, bright sky. That outdoor world, all earth and sky, is what the woman is seeing, yet she is not really looking at anything. Her glance has become a motionless gaze, an inner awareness of something, which does not so much embrace the ships as their soundless passage—not the trees in their solid stance but the way they shimmer in the light. Most of all, the woman's awareness encompasses the great sky and the clouds sailing across it like ships, even though she is not looking up at the sky but at the ships in the water. The strictly geometrical rigidity of the room is contrasted to the mobile painterly quality of the figure; nevertheless, the figure's potential mobility is very slight and indefinite.

Friedrich's painting has an interesting forerunner: a pen-and-ink drawing by Tischbein of the young Goethe looking out a window (fig. 35). Goethe had moved into Tischbein's apartment in Rome. On July 5, 1787, he writes in his *Italienische Reise:* "Tischbein has gone, his studio has been tidied, dusted and washed, so that I can now enjoy being there." He describes his "home" as a "hermitage." He is doing everything there in his own "contemplative way, and there is no one to whom I open myself." Tischbein has captured some of that in his drawing. But somehow Goethe's figure seems less immobile than Friedrich's. Like Friedrich's young woman, Goethe is looking thoughtfully at the bright outdoors, but one feels he is concentrating on what he sees.

To complete the particulars of Friedrich's life: his meager existence was somewhat improved when he joined the Dresden academy in 1816 and was made a lecturer there in 1824. But the academy paralyzed his creative impulse. In 1834 he painted one more great picture, the *Lonely Cemetery Gate in Winter*, now in the Georg Schäfer Collection, Obbach. It is the only one of his pictures known that is dated on the canvas. Not long after he had completed it, Friedrich suffered a stroke and descended into mental illness, as did Karl Blechen a few years later.

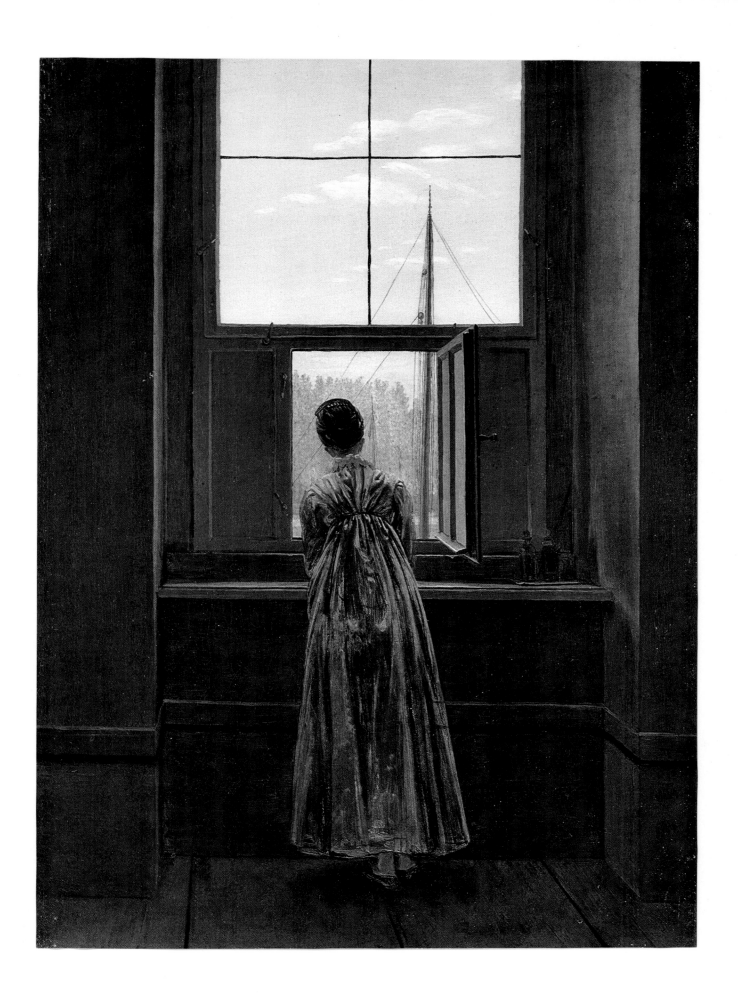

GEORG FRIEDRICH KERSTING
(1785–1847)

Caspar David Friedrich in His Studio

c. 1811
Oil on canvas, 20 1/8 × 15 3/4"
Staatliche Museen, Berlin

A description of Kersting's portrait of Friedrich has been given earlier in this book (p. 30 ff). Here follow some remarks made by Friedrich himself on various occasions: "Every true work of art is conceived at a hallowed moment and born in a fortunate hour, often without the artist's conscious knowledge, out of his innermost heart." "When a painter cannot do anything except imitate dead nature, or rather, imitate nature dead, then he is not much more than a conceited ape." "The task of the artist is not just to represent air, water, rocks, and trees accurately: his soul, his sensibility, must be reflected in them." "Man's deepest enjoyment of a work of art derives from the fact that it immediately reveals itself as having been created by human hands and does not try to pretend to be the work of nature, of God." "Oh, sacred Nature! How often are you pushed aside by fashion and the laws of men!" "A human being, an artist, must rely on his own spiritual self. That is what gives this picture individuality and unity. In the solitude in which X lives, he is ignorant of so many things that have been made into law by pride and presumption; and so he cannot be taught those things, or tempted by them. The spiritually gifted are often fortunate in not receiving any instruction." "An artist should not just paint what he sees before him, but also what he sees within himself. And when he sees nothing within, then he should also refrain from painting what he sees without."

Carl Gustav Carus became more closely acquainted with Friedrich in 1818, and he reports: "It was very significant to me to learn about Friedrich's way of planning his pictures. He never made sketches, cartoons, or color studies for his paintings because, he said (no doubt with some justification), these devices always had a dampening effect on his imagination. He never started a picture unless it stood fully alive before his mind's eye; then he drew the whole thing on the neatly stretched canvas—first quickly in chalk and pencil, then neatly and completely in pen and ink; then he began with the underpainting. This is why his pictures always looked well defined and orderly at every step of their development. They always bore the mark of his individuality and of the mood in which they had first appeared to his mind. 'A picture should not be invented; it must be found,' was his motto, and one may well say that all his pictures took shape in that fashion."

In 1821 Vasily Andreyevich Zhukovsky, a Russian admirer of Friedrich's, suggested that they travel to Switzerland together. "You want to have me along with you," Friedrich replied, "but the I that appeals to you will not be along! I must be alone and must know I am alone in order to see and experience nature completely. I must be able to give myself to that which is all around me, must be one with my clouds and rocks, in order to be myself. I need solitude for my dialogue with nature. Once I lived a whole week in the Uttewalder Grund, among rocks and pines, and during that time I did not see a single living human being. It is true, I wouldn't suggest this method to anyone—it was beginning to be too much even for me. A darkness enters the soul that one cannot seem to prevent. But that must prove to you that my company can't be agreeable to anyone."

Kersting, whose portrait of Friedrich in his studio was an amazing "likeness," was born in 1785. His father was a glazier and the family was very poor. A wealthy cousin helped young Kersting attend the academy in Copenhagen from 1805 to 1808. His teachers were Juel, Abildgaard, and Christian August Lorentzen. In 1807 he won the large silver medal for excellence. In his day Carstens had won only the small silver medal, and since he was extremely sure of his talent, he had been outraged. In 1808 Kersting went to Dresden; in 1809 he returned to his native village, but soon went back to Dresden again. He was a frequent visitor at the Kügelgen house, and he made friends with Friedrich. In 1810 they walked through the Riesengebirge together, a very unusual thing for Friedrich to do, as can be surmised from the remarks above. In 1811 Kersting was extremely successful with his pictures of Friedrich's and Kügelgen's studios, and he had to repeat them several times. He took part in the Wars of Liberation, rose to officer's rank, won the Iron Cross and the Russian Order of Saint George. In 1818 he became manager of the painting department of the Meissen porcelain works. Ludwig Richter was to be active at the art school there from 1828 to 1835.

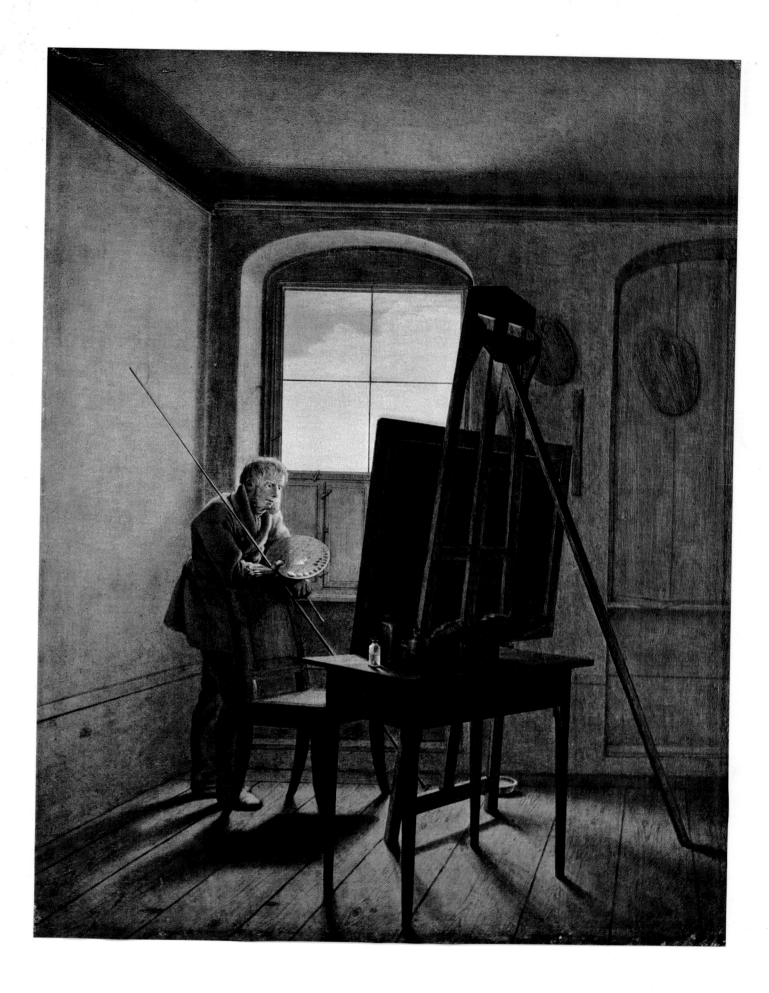

GEORG FRIEDRICH KERSTING

Couple at a Window

1817
Oil on wood, 18 1/2 × 14 3/8"
Collection Georg Schäfer, Obbach

Kersting's best works are pictures of interiors. Goethe praised them too. At the beginning of Volume 15 of his *Dichtung und Wahrheit* he tells of some visits he paid to a noble friend, a Frau von Klettenberg. "She used to sit by the window, neat and clean." One evening he could not help but "try, as far as his meager talent allowed, to make a picture of her person and of the objects in the room—a picture which, in the hands of a skillful artist like Kersting, might have turned out extremely charming." No doubt the picture Goethe had in mind was Kersting's *Woman Embroidering by the Window*, which the court of Weimar had bought. The woman in the picture is Louise Seidler. Kersting's paintings can often be "neat and clean," too, with a Biedermeier tendency that becomes especially apparent in his genre scenes. But *Friedrich in His Studio* is more: it shows a real place where real work is being done. Similarly, the wonderful *Couple at a Window* cannot simply be classified as Biedermeier. The emptiness of the surrounding room is too great, the colors are too delicate, the geometric elements are too strongly emphasized, the absorption of the two young people is too profound for a Biedermeier work. The young gentleman and the lady are not talking at the moment, they are thinking over what has been said. The lady, her back to the viewer, is standing motionless, looking out at the landscape. The man's profile is outlined against the sky, so that his face seems to belong to that sky. Thus one could say that the conversation of these two people is echoing through the landscape outside. And the two young people are very elegantly dressed. There is another picture by Kersting, called the *Elegant Reader*, which Goethe liked. Incidentally we might say of the man's profile that it probably resembles that of the young Clemens Brentano. But when this picture was painted, Brentano was thirty-nine years old; he had just published his *General Confession* and was about to become a Catholic. The young man's head is undoubtedly a portrait, however, and no one can deny that it is a "romantic-poetic" one at that.

The lady's appearance is very different from that of Friedrich's *Woman at the Window*. Kersting's lady is elegantly dressed, but her elegance bears a remarkable resemblance to that of the famous *Nuremberg Madonna* dating from the beginning of the sixteenth century. C. G. von Murr, in his *Description of the Chief Sights in Nuremberg*, published in

1778, called that Madonna a "very good piece." The slender form, the folds of the garments of both figures, even the sphere-shaped head covering are very definitely similar. In contrast to the lady's "melodious" posture, the gentleman's pose seems angular and somehow accidental and momentary, not quite in keeping with the severely outlined profile. To remove the Biedermeier taint from the lady's figure altogether, we might point out its kinship with a drawing of Frau Elisabeth Malss by Peter von Cornelius (fig. 53).

The first to paint a landscape seen through a window—if we confine ourselves to the period under discussion in this book —seems to have been Philipp Hackert (p. 50) in a picture dated 1762 and formerly owned by Ludwig Justi. Friedrich also tried his hand at this motif many times. We know of a drawing reviewed by Goethe in the *Jenaische Allgemeine Literatur-Zeitung* in 1809. It shows "a window of the artist's apartment in Dresden. The lower windowpanes are open, and through them we see the mast of a large ship on the river Elbe and the charming view across the river. The upper windowpanes are closed, and through them we see only air. The simple, well-chosen motif, the skill of execution, and especially the totally convincing way in which our artist presents the difference between the view into the open air and the very slightly diminished transparency of the window glass have earned for this drawing the complete admiration of all who have seen it."

After Friedrich the same motif was used, with variations, by Carus (Staatliche Kunsthalle, Karlsruhe) and Wasmann (Kunsthalle, Hamburg). But to show even more conclusively how far from Biedermeier Kersting's picture is—in spite of the top hat on the windowsill that contrasts so strongly with the castle in the landscape outside—let us refer the reader to the *Sentimental Girl*, by Johann Peter Hasenclever, dated 1846 (Kunstmuseum, Düsseldorf). The girl is seated at the window; her breasts are bare and she is sighing at the moon. The picture of her beloved, in Hussar's uniform, hangs on the wall. On the table and on a windowsill we see, their titles clearly readable, *The Sufferings of Werther* and *Mimili*, by the notorious sentimentalist Clauren. And to top it all off, there is also a letter which begins, "Deeply beloved Fanny."

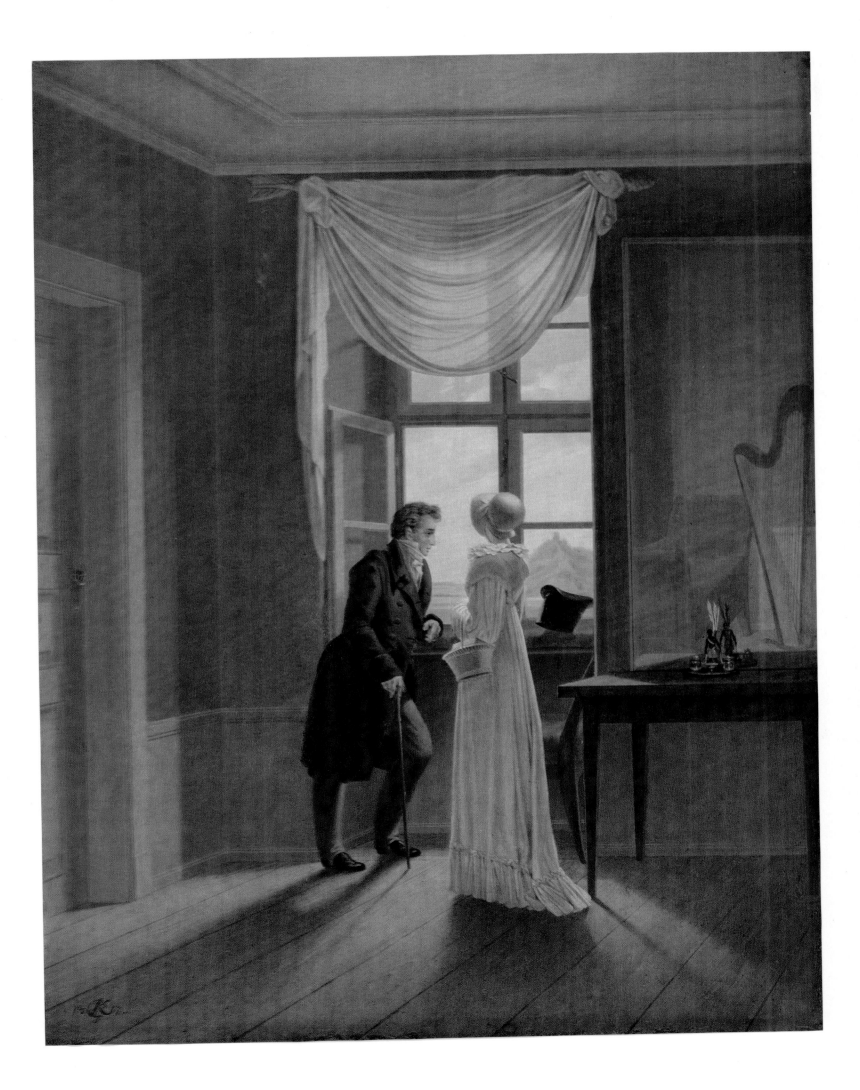

CARL GUSTAV CARUS (1789–1869)

View of Dresden from the Brühl Terrace

c. 1830–31
Oil on canvas, 11 1/4 × 8 1/2″
Collection Georg Schäfer, Obbach

"How often was I able, even in later years, to cleanse my innermost soul of dark depression by painting dark fog-shrouded landscapes, snow-covered graveyards, and similar things. Perhaps these pictures appealed to other souls as much in darkness as my own. As for me, they always brought me relief, nay, liberation." Those words, which might have been written by Caspar David Friedrich, come from the pen of Carl Gustav Carus, a friend of Friedrich's but also a great admirer of Goethe, to whom he "had erected a temple in his heart," as his Goethe books (1843 and 1863) prove. Carus, born in Leipzig, was actually a physician by profession. In 1814 he was made director of the Medical-Surgical Academy in Dresden; in 1827 he became the king's personal physician. He published a large number of medical essays and articles, some of them very remarkable. But in 1831 he also published *Nine Letters on Landscape-Painting*, to which repeated reference has been made in this book; Carus wrote them between 1815 and 1824. But he not only wrote about landscapes, he also painted them. His paintings are the works of a highly gifted dilettante. His somber pictures very definitely show Friedrich's influence. But in 1815 he painted a view of the Rosental (Rose Valley), near Leipzig, in springtime (Gemäldegalerie, Dresden), and this picture shows him remarkably independent as an artist and quite free from melancholy. It brings to mind a verse of Goethe's which Carus himself quotes in his landscape letters: "My eye embraced the world as does a lover/And pure delight did I therein discover."

"The chief aim of landscape painting" was, according to Carus, "to present a certain mood of the soul (meaning) by showing a corresponding mood in nature (truth)." It leads "into the sacred inner circle of nature's mysterious life." To his *Letters on Landscape-Painting* Carus added *Fragmente eines Malerischen Tagebuchs*, which shows how accurately he could observe certain moods even while surrendering to them. He had often stood on the Brühl terrace, shown in the foreground of our picture. Once he had written that it would make "a good picture, with that iron railing." Behind the terrace we see the royal church and palace, their turrets reaching high into the sky. Dusk has descended and has steeped the terrace in deep brown shadow. The city is shrouded in fog. There are gray clouds in the glowing rose-colored sky. This is truly a picture of fading light—the day's light, and man's. On the terrace we see an old man, bent as if his very life were extinguished. His features are blurred. He is steeped in the same brown shadows that cover the terrace. On the left a dog lies beneath the bench. He too is brown.

In his *Fragmente* Carus describes the "characteristic" view of the "great roof of the playhouse and other, smaller, snow-covered roofs nearby; the Catholic church and the palace tower. Smoke was rising, white-gray and thick, from the playhouse. It slanted to the right so that the middle part of the palace tower, behind the graceful gray shape of the Catholic church, was obliterated . . . the sky was concealed by a layer of haze—violet-brown near the horizon, changing to a reddish hue farther up and only above this did the clear yellowish evening sky emerge." While that is not exactly a description of the picture here, it may well be compared with it. And we learn from the description that the central location of the church in the picture probably has no symbolic or religious meaning. Carus's notes do not mention anything of the sort. They merely describe what has been observed. Only the figure of the old man in the foreground, sinking into itself as the day is sinking into night, seems fraught with symbolic significance.

Carus says of Caspar David Friedrich: "He liked a certain free naturalism in my pictures, the result of countless studies made from nature. And it was Friedrich who encouraged me to send a few small oil paintings to Goethe, who, he said, would certainly like them. I did as he had suggested and the old master has mentioned them very kindly in his journal *Kunst und Altertum.*"

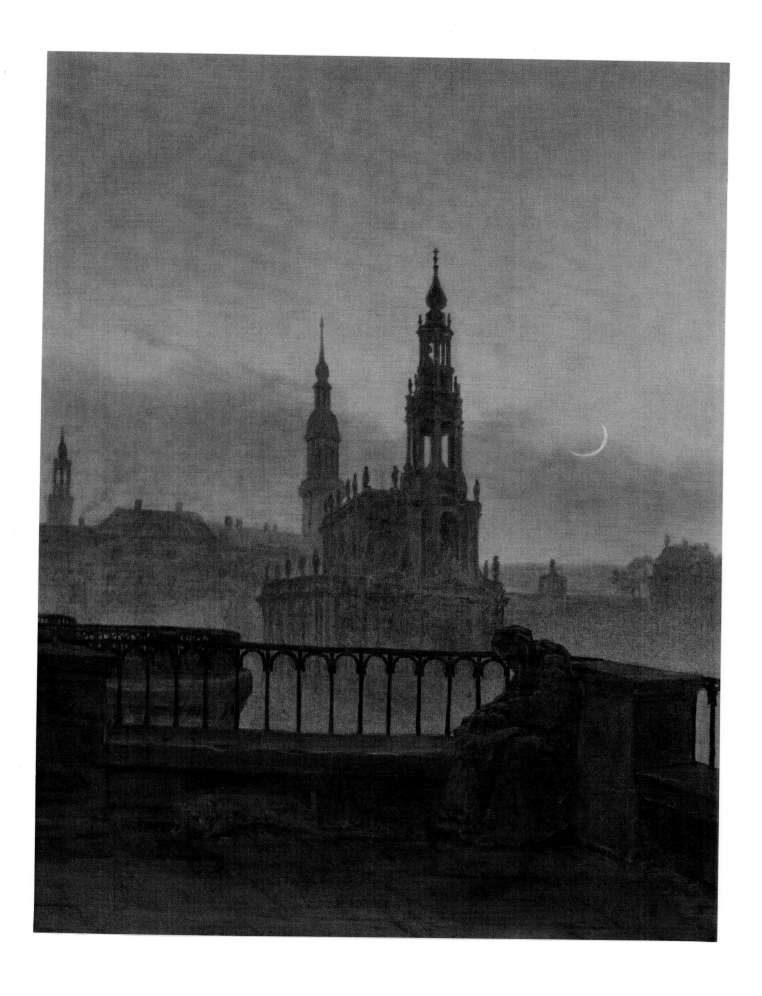

JOHANN CHRISTIAN CLAUSEN DAHL (1788–1857)

Approaching Thunderstorm near Dresden

Signed: d. 22. July 1830 Dahl
Oil on canvas, 7 7/8 × 13 3/8"
Kunsthalle, Hamburg

Dahl was a Norwegian, born in Bergen. He and Allaert van Everdingen are the most important discoverers of the Norwegian landscape. But Dahl discovered it, so to speak, from the German side. He studied at the Copenhagen academy from 1811 to 1818, and he was greatly influenced by Christophe-Guillaume Eckersberg. Then he went on to Dresden instead of returning to his own country. Ferdinand Olivier says in his autobiography: "Dresden, which some were pleased to regard as a German Florence . . . may well be considered the hearth at which the fires of a new enthusiasm for art were kindled and richly nourished." In Dresden Dahl became Friedrich's friend and roommate. In 1820 he was accepted as a member of the academy. He never shared Friedrich's anti-Italian sentiments, and between 1820 and 1821 he traveled in Italy. In 1824 he became a professor at the Dresden academy. Between 1826 and 1850 he was in Norway five times and in 1847 he visited Paris. Thus he saw more of the world than Friedrich, who spoke of his student, for we may regard Dahl as such, "in full appreciation of another's worth" and marveled at "the ease with which [Dahl] produced his pictures almost as if by magic; at his wonderfully foreign-sounding German; and at his strange dreams."

Dahl's dreams did not provide him with so much material, though, as his ceaseless studies of nature. And gradually this estranged him from Friedrich. The more he studied nature, the more he felt the need for a more "painterly" style than Friedrich's—and he pursued such a style. He did not deny that Friedrich's work was true to nature. "Though his style was often a little stiff, it was based on great naturalness and subtle observations," but "borne up by a simplicity of interpretation that often bordered on fussiness or emptiness." The wielder of a swift brush often sees emptiness where a careful brush is applied. Dahl says further: "And more than once Friedrich seems to overstep the boundary between painting and poetry." Still, he defends Friedrich as a "most original, individualistic man and artist . . . who has no equal anywhere." He "knew and felt very clearly that one cannot and does not paint nature as such, but rather one's own emotions, which, of course, must be natural ones." "In a peculiarly tragic way" Friedrich missed some of "what can be done in painting." Thus speaks one who thinks he has discovered and experienced the demand that a painter should be a painter and nothing else.

That was Dahl's aim, and he achieved a great deal. The small picture of a thunderstorm coming up near Dresden (colorplate 19) is fascinating in its purely painterly aspects. It surpasses Friedrich in that respect. And yet there is much of Friedrich in it: the openness toward the sides of the picture; the horizontal, though very animated, organization; the huge sky taking up far more than half the picture. Even the dark strip of brown-green trees in the foreground has its prototype in Friedrich's work (see colorplate 12). But the way in which the houses of the town flare up—white and red, in their brownish environment—shows a purely painterly intensity which Friedrich neither had nor aspired to. The same is true of the sky and its heavy clouds; a comparison with Friedrich's *Moving Clouds* (fig. 18) will show this. Nevertheless, Dahl's work does derive from Friedrich's, but its effect is more explosive, more immediate, more threatening. In these qualities, too, it is not without antecedents. One of the most impressive is probably the sepia sketch by Franz Kobell in Munich's Städtische Sammlungen, showing a mountain landscape. But Dahl's work also points to the future. This would be immediately apparent if we could place side by side Dahl's Hamburg picture and Menzel's *Thunderstorm in the Temple Yard* (Wallraf-Richartz Museum, Cologne).

Dahl has dated his picture to the day. We already know that such precise dating was becoming customary among the poets of that time (p. 47). Heretofore it had not been done in painting. But it confirms Friedrich's admiring remark about the speed with which Dahl produced his pictures, "as if by magic." Here, of course, Dahl's magic contains elements of menace. The sky has been given all imaginable power over the earth. As for the elemental powers lodged in the earth—Dahl has tried to show those in a picture of Mount Vesuvius erupting (Städelsches Kunstinstitut, Frankfurt). It remains an attempt, but a bold one for its time. The artist has daringly covered half the sky with infernal fire and roiling smoke and has placed this against an "infinite" bright, light distance—and yet these two disparate halves of the sky seem to belong together.

Goethe had climbed Mount Vesuvius on March 6, 1787. Tischbein had gone along, though reluctantly. "To this artist who always sought out what was most beautiful in human or animal form—who even humanized the formless, such as rocks and landscapes, by imbuing them with meaning and taste—to this artist the dreadful, shapeless masses continually devouring one another and making war on our sense of beauty will be totally horrifying." Dahl did not shy away from such horror.

JOHANN JAKOB GENSLER (1808–1845)

Beach near Blankenese

Dated: Blknse. Octbr. 8 1842 J. G.
Oil on paper, 13 3/8 × 19 1/4″
Kunsthalle, Hamburg

Of the three Gensler brothers, Johann Jakob is unquestionably the most important painter. After some early attempts under local painters in his native city of Hamburg, he went to study with Wilhelm Tischbein in 1824. Tischbein had established a small art school in Eutin. In 1828 Gensler journeyed through the Harz mountains, by way of Dresden and Nuremberg, to Munich, in order to study at the Munich academy. But he had no use for Cornelius. And he never became a figure painter. Instead he joined Wilhelm von Kobell, who had been pensioned in 1826, and Johann Adam Klein and Heinrich Bürkel. In 1830 he was in the Tyrol and in Vienna, where he visited the academy, though for only a short time. In 1831 he returned to Hamburg and stayed there for the rest of his life.

The small Hamburg picture shown opposite was painted directly from nature on October 8, 1842. We usually think of 1814 as the year in which the first painting was made directly from nature, and Constable is credited with having done it. But the Darmstadt-born painter Georg Wilhelm Issel—the same man who discovered Carl Philipp Fohr—produced some astonishing landscapes which he had painted directly from nature no later than 1814, and perhaps even earlier. But he did not receive much attention, whereas Constable's landscapes nearly caused a riot among Paris artists in 1825. Long before Corot, Issel had the courage to show a sacred edifice, such as Saint Etienne in Paris, with the half-finished Pantheon in the background, in a perfectly sober way in 1815 (the painting is now in the Kurpfälzisches Museum, Heidelberg). We have reproduced Issel's small oil painting, *Gray Winter Day at the Bodensee* (fig. 12), painted around 1816/17, to show the similarity between Issel's composition, meant to be completely "unromantic," and the work of Friedrich. The wintry atmosphere that gives the little picture its inner life—and it really has an inner life, its seeming emptiness and small size notwithstanding—and certain details such as the manner in which the bare trees are drawn, show beyond question that this is a picture dating from the time of Friedrich.

The same can be said of Gensler's *Elbe Beach:* though it was painted almost thirty years later, it still has a strong family resemblance to Issel's Bodensee landscape. Gensler, of course, is much more modern than Friedrich, but his work is unthinkable without Friedrich's. Not that he followed the latter as closely as Ernst Ferdinand Oehme (1797–1855) or August Heinrich (1794–1822): Gensler's artistic relationship to Friedrich can be more accurately compared with that of Blechen (colorplates 29, 30) and Dahl (colorplate 19). But a picture such as Gensler's 1840 *Elbe Beach near Blankenese* (Kunsthalle, Hamburg) can be said to have no direct models but certain very definite antecedents among Friedrich's work which simply cannot be ignored. The symbolic quality of the anchor in the foreground of Gensler's 1840 picture, however, would have been emphasized by Friedrich, whereas Gensler plays it down.

Of course, the landscape through which Gensler wandered was exactly the kind in which one can experience the "infinity" of space. But not every man wandering in a landscape such as the one in colorplate 20 has the experience, not even every painter. The brownish beach in the foreground looks quite inhospitable, and there is something undefined about it which the shallow waves lapping against the shore do not eliminate. Nor does the surface of the river itself represent a definitive boundary, for the colors of the sky, its gray clouds, are reflected in the water. Only the horizon offers a distinct though narrow strip of shoreline—it is the opposite bank of the river. The near bank is on the right, with its dark hills clearly outlined. The contrast between the two shorelines is very impressive, truly a picture of "earth-life." And we see some ships before that horizon—as if on the boundary to another world. The clouds in the sky sweep forward from the depth of the picture, lending a sense of space and height. They consist of nothing and of something —they are "such stuff as dreams are made of," and by no means inferior to the cloud formations of Dahl.

ERNST FRIES (1801–1833)

Neuburg Abbey and the Neckar Valley

After 1827
Oil on canvas, 10 3/4 × 15 1/4″
Kurpfälzisches Museum, Heidelberg

"He was considered the handsomest of the young German artists in Rome, a striking figure, open and cheerful in his manner, skilled at all physical exercise, a good fencer, swimmer, and horseman" (Ludwig Richter). Like his friend Carl Philipp Fohr, he was one of those who developed early, were favored by fortune, and died at the height of their creative powers. His father was Christian Fries, a rich Heidelberg banker and dye manufacturer, who was also a passionate art lover. His house, in Rohrbacher Street, was as great an attraction for visitors from afar as the famous Boisserée Collection that had been in Heidelberg since 1810. But while the Boisserée Collection's fame rested on its German and Dutch old masters, the Fries Collection contained, side by side with seventeenth-century Dutch paintings (among which landscapes predominated), some of the most recent masters, such as Georg August Wallis (p. 96). The elder Fries recognized his son's talent from the moment the boy began to draw. He apprenticed him first to Friedrich Rottmann, then to Karl Kuntz, and in 1818 to G. Moller of Darmstadt. Ernst Fries soon established a reputation as a draftsman, and this reputation may have led people to underestimate his considerable powers as a painter. In 1820 he went to Munich; from 1823 until 1827 he lived in Italy, first in Rome, then moving around. In his obituary in 1833 old Christian Philipp Koester writes that Fries "traveled through all of Italy, as far as Calabria. In a manner of speaking he devoured everything he saw there. Each day he walked for six to eight hours and produced six to eight sketches of a delicacy, sharpness, accuracy, and vividness that would have no equal anywhere. One might say that his eye, finger, and pencil had merged into a single instrument that did his bidding with the greatest of ease." But he painted too. The pictures he sent home were pleasing "because they bore the stamp of *anch'io sono pittore* —'I too am a painter.'" He never ceased to admire. and emulate his childhood friend Fohr because he "knew how to present everything in a poetic way and had a true feeling for what is romantic." Apart from Fohr, Fries did not have many friends. But in Rome he made friends with Ludwig Richter, who says in his memoirs (*Lebenserinnerungen eines deutschen Malers*) that he had "developed a greater sense of color and of painterly technique" than any other landscape painter living in Rome. Richter felt that this was owing to Carl Rott-

mann's influence (colorplates 24, 25) and also to Wallis's. Once when Richter and Fries exhibited together in Rome, Richter's picture was preferred by "the history painters and strict stylists" while "the others favored Fries's picture because of its skillful technique and fine painterly effect. On the whole there is now a greater interest in the painterly qualities." Thus it was not purely accidental that Fries got in touch with the young Corot, the Corot d'Italie. They went hiking together. In Cività Castellana he portrayed Corot very "romantically," in a brilliant pencil sketch.

The small picture of the Neckar Valley (colorplate 21) charmingly demonstrates Fries's painterly talents. He is often called a "realist," as painterliness and realism are often equated. But if that were always so, Rottmann would have to be counted among the realists too. Despite its "like-ness," though, Fries's *Neckar Valley* is no mere likeness. In its likeness, it is truly a dream landscape. The world-transfiguring reflections in the water of the Neckar, which form the core— one might say the "essential" part—of the entire composition, give it that quality. In this dream landscape a boat is seen gliding along in an almost ghostly way; the people in it are barely indicated. The only spot of bright color is a girl's red dress. It seems appropriate to quote from Novalis: "It is not a mere reflection, this image of the sky on the water; it is a delicate act of friendship, a token of neighborliness; and as unfulfilled longing drives toward infinite heights, so does fulfillment like to sink down to fathomless depths" (*Die Lehrlinge zu Sais*). But the "painterly" painters were not the first to discover the effectiveness of images seen in the water. Koch and Reinhart, to name only two, had discovered this long before. In Reinhart's great landscape of 1796, in the Georg Schäfer Collection in Obbach, the blue-green pond in the middle ground shows the reflection of trees with mirror-like accuracy.

Carus writes: "Water, the . . . chief element of life in nature, insofar as all living things on this earth have emerged from it and the infinite sky is reflected in it (so that we might truly call it heaven on earth)—water has a twofold attraction: when it surges and roars with vital might, it awakens and strengthens our sense of life; and its quiet, mirror-like surface, sunlit or dark, produces feelings of infinite longing in our souls."

JOHANN MARTIN VON ROHDEN
(1778–1868)

Waterfall near Tivoli

Between 1800 and 1810
Paper on canvas, 19 × 28 1/2″
Kunsthalle, Hamburg

Rohden was born in Kassel, where he began to paint at an early age. At seventeen he went to Rome. Except for a short period (1827–31) during which he worked as a court painter in Kassel, he lived in Rome for the rest of his life. His artistic education took place in Rome under the influence of Koch and Reinhart. His work is not very extensive because, as everyone knew, he was lazy. Given a choice, he would go out and hunt rather than paint. We cannot say for sure whether he was a greater Nimrod than Reinhart, but there is no doubt that he was the greater braggart. His hunting stories were so extravagant that he was nicknamed "Saint Münchhausen" (after the legendary Baron von Münchhausen). As for his painting, he sometimes had the same picture standing on his easel for a year or two. Richter writes that he painted "very slowly and carefully." "His pictures, firmly drawn and sunny and clear in color, had something dry, almost pedantic about them that was out of keeping with his fiery, good-naturedly boisterous personality." This is a judgment from a fellow artist, and as such must be taken with a grain of salt. The landscape shown here certainly does not seem dry, slick, or pedantic. On the contrary, there is a certain grandeur in the way the rich green meadows are glimpsed behind the warm brown of the multishaped rocks in the foreground and in the way the wooded slope with its waterfall rises behind the meadows. There is grandeur, too, in the delicately gray-blue mountain ranges in the hazy, immaterial distance, set against a yellowish-blue sky. Rohden painted this view of Tivoli over and over again. He obviously shared Goethe's opinion that Tivoli "presents one of the foremost natural spectacles."

"Those waterfalls and ruins, and that entire landscape, are among the most profoundly enriching sights."

There is an earlier painting, now in the Oesterreichische Galerie, Vienna, which has a more restless composition. One feels Koch's direct influence very strongly there. The waterfall is closer to the foreground, and it seems to roar more loudly. This no longer holds true for the pictures in the Staatliche Kunsthalle in Karlsruhe and in the Niedersächsisches Landesmuseum in Hanover respectively. Both are horizontal in format. The one in Karlsruhe was probably done earlier: it shows Koch's influence more emphatically. But we feel that the Hamburg picture is the finest of the existing versions. It is also horizontal in format. All is "classically" serene in it and the color tones have a delicacy that is reminiscent of Friedrich's.

Rohden fell in love with Tivoli—not only as a painter but also as a man. Around 1814 he married the daughter of an innkeeper in Tivoli. And it was probably around the same time that he converted to Catholicism. Richter reports that in his hunting bag this sturdy outdoorsman and hunter, amazingly, always carried the works of Saint Theresa of Avila, "whose depth and brilliance . . . he praised in passionate words." But his art shows neither the influence of the saint nor his own conversion. He remained the landscape painter he had always been. No Italian has ever painted Tivoli as he did— which brings up the fact that the Italians generally left the discovery of their own landscape to the Germans.

JOSEF REBELL (1787–1828)

View of the Gulf of Naples

Between 1813 and 1815
Oil on paper, 9 1/4 × 12″
On the back, in Gothic script: Rebell, Vesuvio
Staatliche Kunsthalle, Karlsruhe

"In Naples a new magical world opened up for me, truly a painter's paradise," writes Ludwig Richter. "Yet it seemed strange that all that beauty did not touch me more deeply and that, in the end, I secretly yearned to be back in Rome: yearned for the grand severity, the lofty silence and solitude of Roman nature and Roman life." Goethe reacted quite differently: "I'll say nothing of the location of the city and its beauties; they have been described and extolled so often! 'Vedi Napoli e poi muori,' they say here, 'See Naples and die.' And you can't blame the Neapolitans for not ever wanting to leave their city, nor her poets for singing the glories of the landscape in mighty hyperboles. Not even several more Vesuviuses standing around in the vicinity would get these people to give up their city. When one is here, one doesn't even want to be reminded of Rome: compared to the wonderful openness of this place, the world capital on the banks of the Tiber seems an old, ill-situated monastery."

And there is yet a third reaction—from Josef Rebell, as his Karlsruhe picture shows (colorplate 23). Rebell's gulf is not paradisaical, it is rather gray. Gray dominates the rocky foreground. The sea is gray-green-blue. The mountains, Somma and Vesuvius, appear in sober, prosaic view; they are green and brown. The sky is gray-blue. There are dark boats on the water, the people in them mere dabs of color or light. The gulf does not appear to be very deep. Nevertheless there is a great feeling of solitude about those boats, nor do the houses at the base of the mountains alleviate the solitude. Gleaming white, they seem to be not buildings but impressions of buildings.

Only a thorough study of Josef Rebell's work will help ascribe the proper importance to this picture as a unique and precious jewel of a painting. It was certainly as unusual a work from an Italianist in 1815 as Issel's Bodensee landscapes are for the north (fig. 12). But to keep the picture within the context of its period, it is advisable to compare its structural aspects with those of Friedrich's *Harz Mountain/Riesengebirge Landscape* (fig. 20) and of Wilhelm von Kobell's *Valley of Kreuth* (colorplate 10). There are more similarities than seems possible at first. While none of those other works has the kind of close-up foreground Rebell creates with the rocks at the lower edge of his picture, we have encountered that kind of foreground treatment in some of Friedrich's work. Rebell's picture has none of the Elysian qualities of Hackert's landscapes (colorplate 1). It seems gray and muted by comparison.

After his descent from Vesuvius, Goethe wrote: "The most magnificent sunset and a heavenly evening restored me when I got back. Yet I realized how confusing to the senses such enormous contrasts can be. Terror and beauty, beauty and terror—each cancels the other out, and the result is a feeling of indifference. No doubt the Neapolitans would be different people if they did not feel so hemmed in between God and Satan." There is no real terror in Rebell's picture. But it makes the viewer realize that even the bright light of paradise can turn gray and dim.

Rebell was born in Vienna in 1787 and died in Dresden in 1828; he is another of those who passed away at an early age. He studied at the Vienna academy, went to Switzerland in 1809, lived in Milan from 1810 to 1811, in Naples from 1813 to 1815, in Rome from 1816 to 1824. In 1824 he became director of the Belvedere Gallery in Vienna. His work, though uneven, definitely deserves more careful study and appreciation.

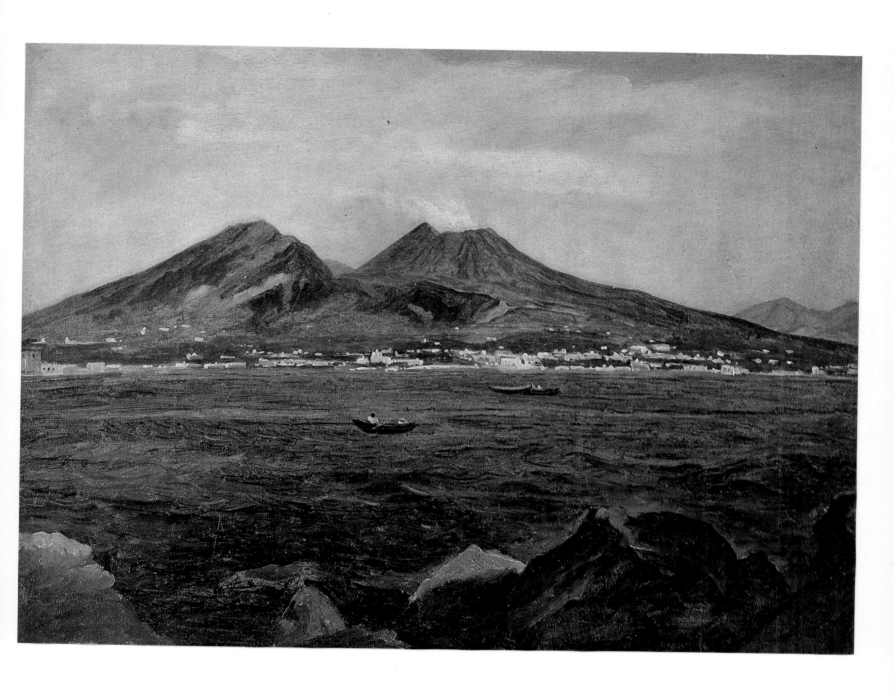

CARL ROTTMANN (1797–1850)

The Inn Valley near Neubeuern

1823
Oil on canvas, 12 5/8 × 18 1/8″
Germanisches Nationalmuseum, Nuremberg

In 1822 Carl Rottmann went from Munich to Berchtesgaden and Salzburg with some friends. It was his first visit to that particular region. From their first stop, in Brannenburg on the Inn, he wrote to his fiancée that he was seated "on a hill, beneath an oak tree" and that "the most romantic landscape he had ever seen, the whole, beautiful Inn Valley," lay spread out before him. Apparently the Inn Valley seemed even more romantic to him than the valleys of the Rhine and Moselle, which he had visited in 1818 in the company of Ernst Fries and other painters, on an assignment from a Heidelberg publisher named Engelmann. That earlier journey had resulted in a series of etchings called *A Picturesque Journey Along the Moselle*. It was published together with a translation of "Mosella," a famous song in praise of the Moselle River and the city of Trier, by the fourth-century poet Ausonius. Such series of views were extremely popular at the time, especially when dressed up in an "educational" manner. Many young artists earned their first fees with them. But instead of doing an etching of the "most romantic" landscape along the Inn, Rottmann created the wonderful earth-life picture shown here. With such forerunners as the *Prater Island* by Dillis (colorplate 9), Rottmann's picture was not anything absolutely "new." But though it was a continuation along the same line, it is so free and fresh that, in its own way, it is innovative after all. The riverbanks can be seen far into

the distance, alternately yielding to the river and pressing in upon it, through vivid stretches of land where brown, green, yellowish, and reddish tones are sometimes sunlit and sometimes in the shadow of a cloud, reflecting a light, partly cloudy sky. The blue-gray mountains on the far bank of the river seem incorporeal and enchanted. Mountains and clouds belong together. The hunters with their dogs, chasing a stag in the foreground, do not diminish the "romantic" quality of the picture. The hunters are having their sport, but the earth in its vastness remains serenely untouched.

Carl Rottmann and Ernst Fries took their first art lessons together, from Friedrich Rottmann, Carl's father, who was an art teacher at the Heidelberg gymnasium (high school). Carl was as poor a student as Fohr had been, and just as indefatigable when it came to drawing and sketching. He also studied under Johann Christian Xeller. And he was profoundly influenced by the Scottish painter Georg August Wallis (1768–1847), an Ossian enthusiast who came to Heidelberg in 1812 and stayed until 1816. Wallis may well have strengthened the young man's innate sense of tonal nuances and atmosphere, for there can be little doubt that Rottmann was born with that sense. Unlike most of his contemporaries, he was not a confirmed draftsman. Color and its tonal values, light and atmosphere, meant more to him than clarity of outline. This may have had physiological causes. At

CARL ROTTMANN

The Island of Delos

1847
Oil on cardboard, 14 × 18"
Staatliche Kunsthalle, Karlsruhe

an early age he began to suffer from a weakness of the visual nerve that makes all outlines appear vague and fuzzy, and his sight deteriorated as he grew older.

Rottmann's contemporaries extolled his vivid imagination. But while he was rich in inner visions, he took fire from what he actually saw. That "visionary talent" came into play even when he was supposed to paint a "view." The biggest commission of his life was a series of landscapes for the arcades of the residential palace in Munich. Begun in 1830, it was a daring project, both technically and thematically. The pictures were to be frescoes. But Rottmann's knowledge of the fresco technique was rather vague, and so he used a mixture of techniques. As for the subject matter of these pictures, they were to be a refutation of Cornelius, who had declared that landscape painting was merely the "moss and lichen" of art. Rottmann wanted to bring landscape art into its own by giving it a monumental quality.

The Munich pictures represented Italian landscapes, but Rottmann had not yet completed them when the king expressed a wish for some Greek landscapes to be added to the series. The king's interest was not exclusively dynastic, although Otto, Ludwig I's second son, had become king of Greece after the Wars of Liberation, in 1832. Germans had long yearned for Greece, as they yearned for Italy. Rottmann shared this general longing, but when he went there, 1834–35, he wrote: "If only the spiritual pleasures of this place were

not connected with so very much physical discomfort . . . it is horribly beautiful." Greece's "wealth of important, lofty sights" offered, he said, "a lifetime of subject matter."

Rottmann had made a whole series of sketches and watercolors on the island of Delos. The picture shown here, now in Karlsruhe, is a repeat version of one of the Greek landscapes painted on stone. The stone paintings had originally been intended for the arcades of the palace, but because of the danger of their not being weatherproof, they were transferred to the Neue Pinakothek. Did Rottmann know the marvelous *Hymn to Apollo* by Homer? It tells the story of the goddess Leto, who had to wander, pregnant, from island to island to find one that would accept the birth of her son. All the Greek islands refused her except Delos, and Delos, too, was fearful of being scorned by the newborn god because of its rocky soil. The goddess had to make a number of solemn promises to overcome the island's objections.

It is not Apollo we see busying himself in the center of Rottmann's picture, but an ordinary Greek who has nothing whatsoever in common with the Apollo of Tiepolo (fig. 2) or of Mengs (fig. 4). But the sunlight that warms the stony land may well be an Apollonic radiance. Nor is this island altogether barren. Shrubbery is growing here and there, and we see a grassy slope in the background. Nonetheless, the chief impression is one of austerity. But it is an austerity that has become luminously transfigured.

FERDINAND OLIVIER (1785–1841)

Landscape Study for "Elijah"

c. 1830
Oil on canvas, 29 7/8 × 22 7/8"
Neue Pinakothek, Munich

Ferdinand Olivier's family was of French-Swiss extraction. His father taught at the famous Philanthropinum in Dessau, which played an important part in the German educational system. Prince Leopold Friedrich Franz had founded it in 1774 and had made J. B. Basedow, who had been called to Dessau in 1771, its director. Basedow was a very difficult man, but extremely progressive in pedagogic matters: the name of the institute was to be symbolic for its educational goals. But Dessau became famous not only for this educational institution but also for its art life. Baron Friedrich Wilhelm von Erdmannsdorff, an architect by profession, who had come to Dessau on a visit, impressed the prince so greatly that he prevailed on him to settle in Dessau. From 1763 to 1765 the prince and Erdmannsdorff traveled together to England, France, and Italy. Then, in 1768, Erdmannsdorff was commissioned to build the banquet hall in the Dessau palace. And in 1769 he built in Wörlitz Park a palace which became an important landmark of German Classicism. In its way it is a more striking example of that style than the prize-winning designs in a contest the Weimar Friends of Art were to set up two decades later. That contest, whose chief purpose was the revival of antiquity, created a great deal of excitement among German artists. In 1773, however, an altogether different building began to take shape in Wörlitz Park. It was the "Gothic House"—begun as a gardener's cottage and completed 1786–87—an art-historical curiosity. The prince, of course, did not regard it as such. Unlike Erdmannsdorff, who wanted to have nothing to do with the Gothic style, the prince sided "with Erwin von Steinbach and the Goths." For many years the Gothic House remained his favorite residence.

Ferdinand Olivier, the eldest of three painter brothers, also became addicted to medieval Gothic. In 1807 he was in Paris as secretary to the German legation. There he saw the art treasures Napoleon had stolen from all parts of the world. There were many German and Dutch old masters among Napoleon's booty. All these works were labeled "old German" at the time, without regard to their actual country of origin. Those pictures made so great an impression on Ferdinand Olivier, as they had on Friedrich Schlegel and on the Boisserée brothers before him, that he began to model his own work after them. His brother Heinrich, who was in Paris with him, followed suit. Ferdinand had had his first drawing lessons from Carl Wilhelm Kolbe (fig. 46), a teacher at the Philanthropinum. Ferdinand had gone to Dresden, and then, renouncing all hope of ever becoming an artist, to Paris.

But the encounter with the old German master turned him into an artist again.

Back in Dessau, he and his brother Heinrich received a commission to copy some original paintings of the "ancient Teutonic school" for the neo-Gothic church in Wörlitz, which had been consecrated in 1809. If only they had been content to copy! Their ambition was not merely to copy but to work independently in the "old German" style, and they failed miserably. Franz Pforr, with his *Entry of the Emperor Rudolf into Basel* (1809–10; Städelsches Kunstinstitut, Frankfurt), is more "old German" than these two untutored dabblers in things medieval.

In 1811 Ferdinand and his brother Friedrich went to Vienna. The Guild of Saint Luke had left that city just the year before (p. 41). The Oliviers seemed destined to follow in their footsteps. But they met Joseph Anton Koch, who came to Vienna in 1812. They learned from him what a well-organized landscape can be. They were confirmed Protestants and, like Pforr, they remained so despite the wave of Catholic conversions among the "old Germans." The Oliviers were probably not among those Protestants who hoped, with De Wette, for a "new church" (p. 16 f.), but rather among those whose Protestantism was influenced by Zinzendorf. To this group belonged the Count and Countess Thun, whose castle was at Dohna. Wilhelm von Kügelgen mentions them often in his *Jugenderinnerungen eines alten Mannes.* The book is a beautiful testimony to living evangelical Christianity—despite the cult with Raphael's *Sistine Madonna* (p. 27) in the Kügelgen household, where the father was an indifferent Catholic almost all his life and the mother a profoundly devout Protestant who had come from the Baltic region.

Ferdinand Olivier's Protestantism did not prevent him from painting such pictures as his *Hapsburg Legend* (1816; Nationalgalerie, Berlin). Of course in this respect he could always cite the poet Schiller as a distinguished precedent. But the best part of the picture is the landscape, and that is derived from Koch. In Vienna Ferdinand made friends with Philipp Veit, who converted to Catholicism in 1810 and moved to Rome in 1815. Ferdinand accompanied him only as far as Salzburg. The Salzburg landscape attracted him greatly; in 1817 he went there again, and probably a third time in 1821. One result of these visits was a series of lithographs called *Seven Views from the Vicinity of Salzburg and Berchtesgaden, Arranged According to the Seven Days of the Week and Connected by Two Allegorical Pages* (1823). This work has been called "epochal," which we find rather exaggerated. The figures are

FERDINAND OLIVIER

Jesus and His Disciples

c. 1840
Oil on cardboard, 9 7/8 × 11 7/8″
Collection Georg Schäfer, Obbach

no less academic because certain sentimental elements have been added. The allegories, especially the motto, which has the words from John 20:29, "Blessed are those who have not seen and yet believe," inscribed beneath a wayside shrine containing a crucifix in the center of the picture, are, artistically speaking, the purest absurdity. The landscapes, however, are almost all very fine.

Ferdinand Olivier has been classified as a spiritual brother of Friedrich and Runge because, like them, he refused to make an art pilgrimage to Rome. This classification may be correct as far as his extra-artistic intentions are concerned, but it is very far from the mark when applied to his artistic ideas. There is no greater contrast imaginable than that between Friedrich's *Monk by the Sea* (fig. 14) and Ferdinand Olivier's *Monk in the Garden of the Capuchin Monastery in Salzburg* (1826; Museum der Bildenden Künste, Leipzig). The former shows the loneliness of the monk who has abandoned, and been abandoned by, the community of men, who sees the divine in the infinite and turns from the viewer in order to worship. The latter shows a fertile, blossoming garden, hemmed in by trees—though we are allowed a glimpse into distant depths—and, right in the middle of it, a good-natured long-beard of a monk who does not turn his back on us but awaits our gaze and returns it calmly. The lofty has given way to the idyllic, the unfathomable to the palpable.

Ferdinand was so charmed by the Salzburg landscape that he tried to persuade his brother Heinrich to join him there. Heinrich became so seriously ill, however, that he was, in Ferdinand's words, "without any hope (except the highest, eternal kind)." But Heinrich unexpectedly recovered, and in 1821 he probably made another pilgrimage to Salzburg. It had become customary to make pilgrimages to certain landscapes for the sake of their "worldly gospel." The third brother, Friedrich, had gone to Rome in 1818 and stayed there until 1822. He saw a great deal of the Nazarenes, who had accepted his brother Ferdinand, in absentia, into their monkish community. Nevertheless Friedrich would not become a Catholic Nazarene—not even in Rome. He sided with the Protestant "Capitolines." Artistically, however, he must be counted—his unquestionable earnestness and zeal notwithstanding—among the perpetrators of a kind of "religious" art that ultimately was responsible for the ostracizing by the churches of all really important nineteenth-century art and

for the artists, in turn, keeping aloof from the church. Goethe had a premonition of this when he remarked to Eckermann on January 3, 1827: "It is strange—I have written so many things, and yet not one of my poems could be printed in the Lutheran hymnal."

Ferdinand Olivier's real achievement lies in his smaller pictures, not in his large, pretentious compositions. And even among his small pictures, those without figures are often more successful than those that have them. At least this seems to be the case with his *Landscape Study for "Elijah"* (colorplate 26). The spacious brown foreground definitely does not appear empty: it is well structured and strongly cohesive in its coloring. The sudden bright area in the middle ground has more expressiveness than the figure which Olivier put into his final version. The big trees stand solidly and effectively on the border between middle ground and background. And behind them we see a veritable surf of treetops hovering above barely discernible trunks. Their movement is passed on to the outlines of the bluish mountains behind them, and the summits merge in the distance with the yellowish-white clouds in a sky that turns bright blue toward the top of the picture.

In the wonderful small picture *Jesus and His Disciples* (colorplate 27), Ferdinand Olivier has achieved true harmony between landscape and figures. It is no doubt subjective to maintain that this little picture is one of the most perfect examples of its time, in its combination of landscape and religious subject. Its most important predecessor is the small version (9 1/2 × 13″) of *Ruth and Boas*, by Joseph Anton Koch (in the Georg Schäfer Collection). In both pictures the subject matter itself suggests the setting. Olivier's composition is based on a story found in greatest detail in Matthew 12:1 ff., according to which Jesus and his disciples were walking through a wheatfield on a Sabbath. The disciples were hungry and began to pluck and eat the grain. When the Pharisees saw this, they accused the disciples of breaking the Sabbath, but Jesus answered them with a reference to David, who had eaten the show bread in the temple without blame. "But I tell you, something greater than the temple is here."

All this action takes place in a beautifully serene landscape of almost "classical" composition and color. It lies quietly in the light and warmth of summer. It does not point to eternity. It is what it is, with its trees, meadows, and fields, its gleaming wheat and the hills along the horizon—a part of the larger

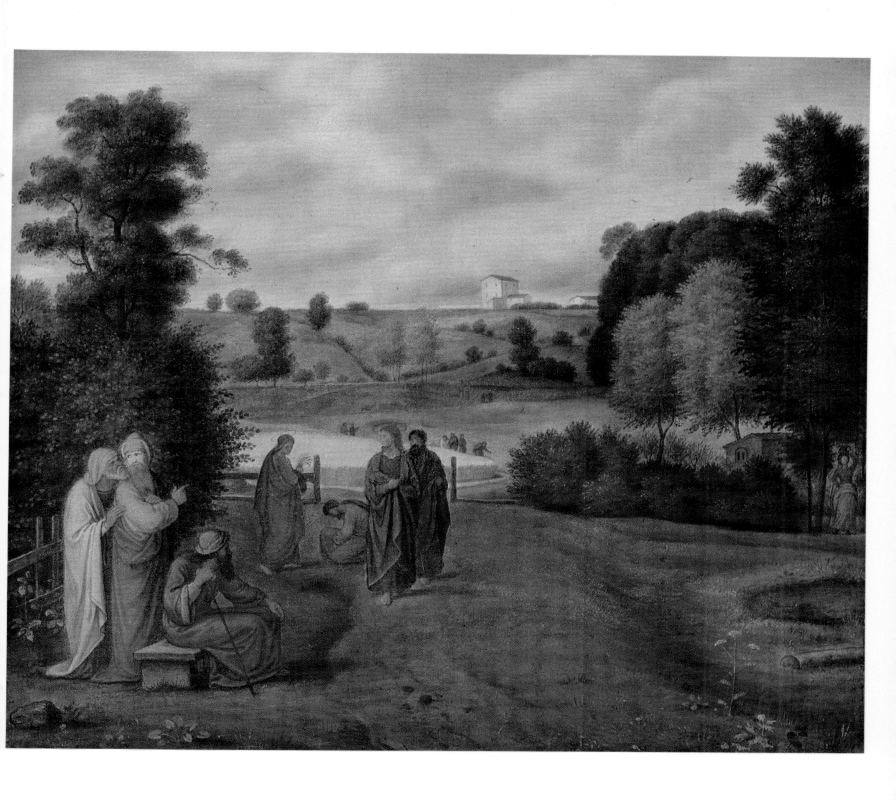

FRIEDRICH OLIVIER (1791–1859)

The Loisach Valley

1842–45
Oil on canvas, 7 7/8 × 11 3/4"
Neue Pinakothek, Munich

world and yet completely self-enclosed. The story begins in the middle ground, where we see the apostles plucking grain from the field; they are so small that we would not know what they are doing unless we had read the Gospel story. Jesus is in the foreground, in a red gown and blue cloak. Here Olivier has put aside the color tones of his landscape and gives free play to the local color. In the immediate foreground there is a group of Pharisees, seated and standing, discussing the event. But the Lord pays no attention to them. His gaze is directed to the side, perhaps at the apostle who may be Saint John, in front of whom another is on his knees. That particular action does not occur in the Gospel, but it fits beautifully into the composition of the picture.

It seems that, by careful design, the Lord is not in the exact center of the picture. And his red halo is so delicately painted that we notice it only when we look very carefully. Furthermore, the dimensions of the human figures are definitely determined by the landscape in which they have been placed. In the devotional pictures of the Nazarenes the opposite is usually the case. But then this is not a devotional picture. By making the landscape the determining factor for the human figures, it proclaims the "worldly" gospel of which Carus had spoken, in a new way. For the same reason Olivier did not feel impelled to place any sort of sacred landmark in his landscape. On the contrary. If we let our gaze wander past the Lord and the apostle directly behind him—perhaps Saint Peter?—into the distance, we come upon a white house and some farm buildings on a hill. We do not know whether Olivier had Jesus' words in mind—"I tell you, something greater than the temple is here"—when he gave such a dominant position to the "worldly" landscape. But we will not go wrong in feeling and thinking that his landscape embodies those words.

Friedrich Olivier never painted anything to compare with his brother Ferdinand's small picture of Jesus and his disciples. In 1815 Goethe showed a *Holy Family* by Friedrich Olivier to Sulpiz Boisserée and said, "There—rejoice in the fruits of your labors!" Whereupon Boisserée, who certainly favored Madonnas and Holy Families, answered with the ready wit for which he was known, "God protect us from such friends—we can take care of our enemies well enough."

Friedrich Olivier was at his best when painting straight landscapes. We have met him earlier in this book, in a pencil sketch which Schnorr von Carolsfeld made of him in 1817 (fig. 36). At that time, Friedrich was on a journey to Salzburg with his brother Ferdinand. Schnorr's drawing shows him at the Lake of Saint Bartholomew near Berchtesgaden.

One might wish he had never drawn or painted anything else but landscapes, with that deep inner absorption Schnorr saw when he made the sketch.

Friedrich was six years younger than his brother Ferdinand. He at first intended to become a sculptor, then switched over to painting. In 1811 he went to Vienna with his brother. There, both were accepted into the circle that had formed around Friedrich Schlegel, Körner, and Eichendorff. In 1813 and 1814 Friedrich fought, with honor, in the Wars of Liberation. On his return from the wars he first went to Vienna, where his brother was by then the center of a circle of his own. Friedrich did not feel like settling down. He walked through the Salzkammergut of Austria, then went to Rome in 1818. In 1823 he came back to Vienna, then went to Munich in 1829, and to Dessau in 1841.

His was one of those talents that depend entirely on the fortunate moment—to which even a genius like Goethe has repeatedly admitted his debt. Such a moment was given to Friedrich when he painted the Loisach Valley. The peacefulness of gentle wooded slopes, the serenity of the quiet little lake; the mountains in the middle ground, rising steeply behind undulating hills; and the gray-blue partly snow-covered mountain ranges in the distance—all these transitions from near, warm, familiar land where human beings are at work, through the somewhat more antihuman graceful slopes and promontories, to the treeless, cold, completely uninhabitable mountains that seal off the view and tolerate nothing but the sky and clouds over their summits—all this is truly "earth-life art." And for all its realism, it is a poetic landscape.

Friedrich Olivier also painted worldly scenes involving figures: between 1820 and 1825 he did the *Serenade* (Staatliche Museen, Berlin), which is full of a somewhat intentional but nevertheless quite effective primitivism. Somewhat later he painted a *Landscape with Horseman*, now in Leipzig, a picture that has a certain Romantic audacity in that it secularizes the motif of the Virgin and Child. In place of Saint Joseph, who is traditionally shown standing over to one side, he has put a horseman taking leave of his wife and child to ride off into the unknown.

The last years of his life found Friedrich Olivier far from being the bold adventurer and wanderer he had once been. He sometimes lost control of himself, and when his memories overwhelmed him, he would take his 1813 army volunteer's uniform out of the closet, put on his Iron Cross, and, to his wife's dismay, go through military maneuvers in their living room. He had become an object of pity.

KARL BLECHEN (1798–1840)

Girls Bathing in the Park of Terni

1836
Oil on canvas, 39 3/4 × 22 1/4"
Niedersächsisches Landesmuseum, Hanover

Blechen, another of the tragic figures of the period, was born in Cottbus, the son of an exciseman. When he grew up he was at first apprenticed to a banker. But in the winter semester of 1822–23 he won a free place in the second drawing class of the art academy in Berlin, with the stipulation that he would become a landscape painter. His report card says, "He has excelled in every respect." After advancing into the first class, however, he did "not often attend," according to the next report. The academy had nothing further to offer him. He went to Dresden, where he discovered the old masters as well as the works of Friedrich and Dahl. He was deeply impressed by Friedrich's prophetic ruins of churches and monasteries, by his graveyards and lonely monks. They occupied his imagination for years. But he was equally fascinated by the painterly style of Dahl (colorplate 19). He did not know he would become Dahl's successor in the painterly style, but he was strongly attracted to it, even while trying to follow in Friedrich's footsteps.

Upon his return to Berlin in 1824 Blechen was offered the position of set painter for the newly established Königstädt Theater by Schinkel, who had instantly recognized his uncommon gifts. According to Gottfried Schadow, he was "one of the first to decorate that stage with landscapes." At an exhibition at the academy in 1824 he had considerable success with a landscape "of profoundly melancholy character." In 1826 he exhibited another landscape. Of that one, Dr. Seidel says, "It can actually give one a sense of nameless terror to spend any length of time in solitary contemplation of that picture." At the exhibition of 1828, to which Blechen had also sent a painting, more than one "elegant gentleman or lady" exclaimed, "What a dreadful picture!" But the art critic of the *Vossische Zeitung* advised the artist to "keep on following his genius, without paying attention to the half judgments of the crowd."

Blechen followed the critic's advice by starting out for Italy that same year. The general opinion is that Italy had changed the artist, that it had turned the Romantic into a Realist. Certainly such a picture as his *San Francesco in Assisi* (about 1829; Neue Pinakothek, Munich) is full of a new luminosity. The monastery in that picture is not an ominous mood setter, but is shown in its actual dominant situation; nor do the pilgrims at the foot of the mountain behave as if they had reached a long-yearned-for goal. But the mountain, overgrown with trees, has all the magic of Romanticism; the blue-green olive trees directly beneath the substructure of the monastery are like clouds. Of course, the contrast to Schinkel's *Cathedral* (fig. 8) is as glaring as that between Blechen's small Berlin picture of the *Bay of Rapallo* and Friedrich's *Monk by the Sea*. The solitary man near the embankment in Blechen's Rapallo picture does not worship the eternal; he thoughtfully observes the sea as it pounds the shore with mighty waves. What is he thinking about? Most likely, the power of the sea. The sky is partly covered by rain clouds, but clear in the distance. The picture shows that Blechen, like Rebell (colorplate 23), did not see Italy as a land of light only. In Perugia he painted a nocturnal sky.

Blechen has repeated his picture of *Girls Bathing in the Park of Terni* several times (now in collections in Berlin, Frankfurt, Obbach, Düsseldorf, and elsewhere). He must have been particularly fond of it. The Hanover example especially is a painterly masterpiece. The trees have the effect of a cathedral, full of mystery in their blue-green and brown tones that become quite ephemeral in the distance. The blue water in the center and the brownish nudes hovering between light and shade appear no less mysterious. On the pile of discarded clothes and underwear a vaguely identifiable piece of fabric glows in brilliant red. It is more than merely a color effect. And above the mountaintops we see a small piece of the blue sky traversed by white clouds. Strangely enough, this same composition, which Blechen painted over and over again in 1836, was preceded by another version which he also did several times; the earlier version shows not two female nudes but two monks deep in conversation. Certainly the nudes do not diminish the religious quality of the picture.

KARL BLECHEN

The Split Tower of Heidelberg Castle

Date uncertain
Oil on canvas, 31 3/4 × 36 1/4"
Kunsthalle, Bremen

On his return from Italy, Blechen went through Heidelberg and, like many others before and after him, paid artistic tribute to the castle that had practically become a national symbol. The picture in Bremen (colorplate 30) has a very similar counterpart in Cottbus. The composition is based on the contrast between the brightly sunlit demolished tower in the foreground and the darker gate tower that has remained standing. The mighty round tower is like a hero with an open wound; the gate tower, with its lead-colored roof, like a helmeted soldier. The road that leads to it is dappled with brown shadows. The trees in the foreground, left, have a ghostly quality; the gray house with its dark red roof, farther back, has a spectral look. A thunderstorm seems to be coming up from the plains despite the bright light in the sky that is especially strong behind the gate tower.

It is possible that Blechen was familiar with Hölderlin's famous poem about Heidelberg. Certainly there are correlations between the poem and his picture.

> The giant
> Fortress, fraught with destiny; rent by the elements
> Down to its very foundations;
> But the eternal sun poured
> Its youth-giving light over the huge
> Aging structure, and all around, there was
> Live green ivy.

It would be interesting to know the exact date when the picture was painted; it could well have been several years after Blechen's visit to Heidelberg. The artist was himself to become a "ruin" only too soon! In Berlin he did not meet with the immediate and general appreciation he had hoped for. In a very desperate letter, dated 1830, he complains about the small sum he was paid by the Verein der Kunstfreunde (Art Lovers' Association) for one of his pictures—he, who felt that he had "grasped and experienced nature as God made it . . . [better] than certain others [of his] profession."

In 1831 Schinkel insisted that Blechen should be appointed professor of landscape painting at the academy "because of his brilliant interpretation of nature"—and this was done shortly thereafter. But he was not meant to enjoy his position for long. In 1836, the year of the Terni pictures, he began to suffer from mental derangement, and it became so severe that his wife had him committed to an insane asylum in 1838. Some of his friends felt this was a terrible thing to do. Bettina von Arnim wrote a deeply moving letter about this: She was certain that it would be possible, "without hurting his wife, to do everything for the poor patient and thus also to achieve the most important thing: that he should be treated with extreme delicacy and receive more consideration for his spirit. . . . The painter Xeller . . . is not inclined to this task nor has he been found suitable after more detailed discussion, for his love of comfort and his ideas about money do not make it advisable to employ him for this job requiring so much patience. . . . We can offer no other reward to the person who will accompany the patient than the honor he will derive from carrying out a noble task. . . ."

Blechen died on July 23, 1840. His is a rich but by no means artistically exhausted legacy. He painted important subjects and lesser ones (such as the view across the rooftops of Berlin) with a noticeable growth of artistic power, and he remained poetic even when depicting everyday subjects.

"Our German aesthetes," said Goethe to Eckermann on July 5, 1827, "talk a great deal about poetic and unpoetic subjects, and in certain respects they may be right; but basically no genuine subject need be unpoetic if the poet knows how to use it properly." In his middle years Goethe had at times held a very different opinion. The words quoted here are a repetition of what he said in his youth, but this time he applied them to painting rather than poetry. Of course he did not include monumental art, which poses a very special set of demands.

FERDINAND GEORG WALDMÜLLER
(1793–1865)

Old Elms in the Prater

Signed and dated: Waldmüller 1831
Oil on wood, 12 1/4 × 10 1/4″
Kunsthalle, Hamburg

Waldmüller once confessed that a certain customer's request for a perfect likeness had been an artistic revelation to him. "Now suddenly, the blindfold fell from my eyes. The only true way, the eternal, inexhaustible source of all art—vision, interpretation, and understanding of nature were opened up for me!" We have heard similar remarks from other artists of that period. And like those others, Waldmüller fought the academies, perhaps more aggressively and more publicly than most. He did so in spite of the fact that in 1829 he had been made a professor at the academy in Vienna and curator of its painting collection. Waldmüller was born near Vienna and was the son of a majordomo; he left his parents' house at fourteen to study at the academy under Zintler, a flower painter. In 1810 he won several prizes for his portraits and figure drawings. Then he worked as a scenic artist in the theater for a while. In 1825 he made his first journey to Italy. Returning home, he was considered so skillful and promising that he received the academic post mentioned above. When he went to Paris in 1830, he achieved some international successes. But his relations with the academy became more and more strained. "Freedom is the essence, the soul of art. Only the kind of instruction that is free from all academic coercion, all pedantry of form, all bureaucratic supervision, all paternalism on the part of the state—only such completely free instruction can create artists. In the academic straitjacket the master school loses all meaning. Professors, sunk in mindless routine, create an army of apprentices in such a school, which should instead be a place where independent, devoted teachers pass their experience on to willing students whom they cherish as future comrades-in-art. It is a historic fact that the spirit of art has begun to decline from the moment when academic research came into existence . . . under such conditions, our academies will produce only an artistic proletariat and the state will bear the responsibility for this." In 1857, when Waldmüller publicly called for the abolition of the academies, he was punished by a 50 percent reduction of his professorial

salary. He accepted this in the name of "martyrdom for art."

The public did not penalize him though. His pictures continued to sell. Those painted after 1840 especially met with general admiration. But his best work is to be found, with few exceptions, among the things he did a decade earlier. It was at the beginning of that earlier decade that he created the picture reproduced here. An equally fine companion piece, dated 1830, is in Berlin.

Waldmüller's remarks about being absolutely and unconditionally true to life as the chief condition for all genuine art might be regarded as a manifesto of realism or even naturalism. Waldmüller is certainly a realist, a greater one, no doubt, than, say, Friedrich. But an artist who can fill a picture surface almost entirely with trees; an artist who can see those trees in their full majesty, in the splendor of their growth, the "infinite variety" of their leaf shapes; an artist who places a dead tree in front of its luxuriantly alive fellows—not, perhaps, as an obvious symbol of the transitory quality of all life, but yet in such a way that growth and death are seen as belonging together; an artist who can show a man and a woman beneath those mighty trees in such tiny dimensions that the viewer almost misses them; an artist who can create so mysterious a horizon, and so vast a sky—such an artist is not a realist or a naturalist in any sense that implies mere copying from nature—he has experienced nature not only with his eyes but with his innermost being. The early Waldmüller's realism poses a problem similar to that posed by Friedrich Wasmann (1805–1886; fig. 44), although the work of the two men is quite dissimilar. Wasmann is more "painterly"; like Blechen, he has discovered the poetry of color; he creates earth-life pictures. It is not quite fair to call him simply a painterly realist. Actually we know of no artist in the period under discussion who did not insist that his chief goal was to capture reality. Only Runge seems to be an exception to this general rule. Seems to be—not is.

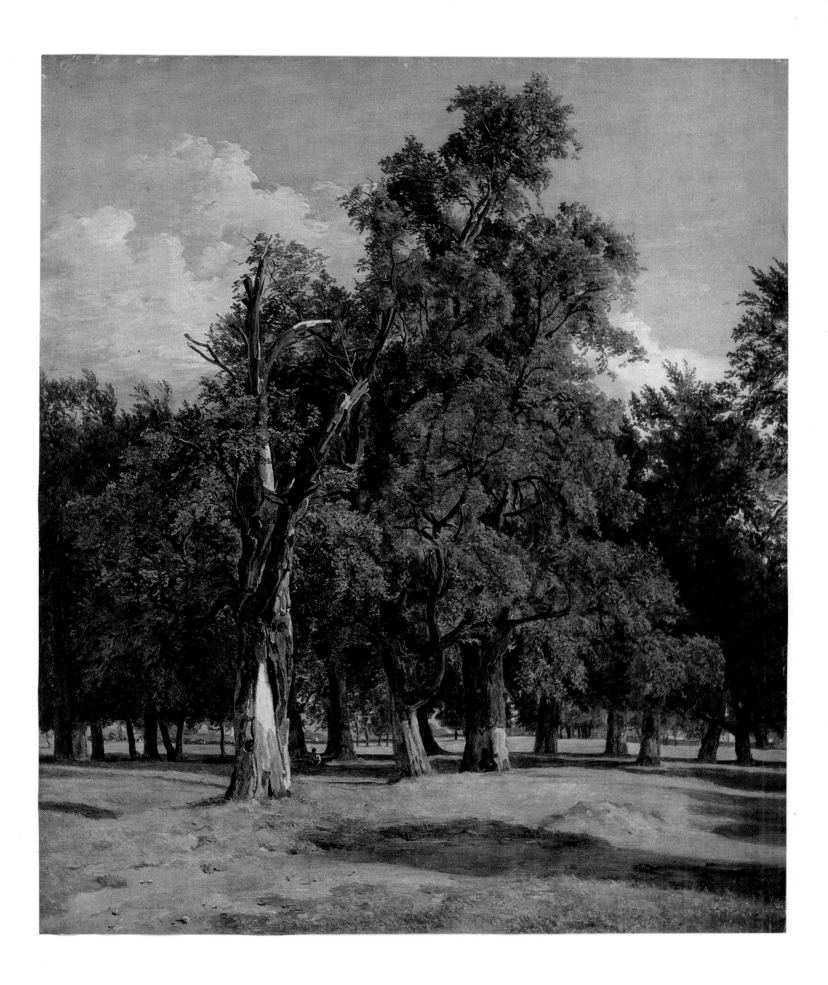

Frontispiece

PHILIPP OTTO RUNGE (1777–1810)

Self-Portrait

1802/03
Oil on canvas, 14 3/4 × 14 3/4"
Kunsthalle, Hamburg (on loan from Dr. Fritz Runge)

Colorplate 32

The Artist's Parents (detail)

1806
Oil on canvas, 76 3/8 × 51 5/8"
Kunsthalle, Hamburg

Philipp Otto Runge was born on July 23, 1777, in Wolgast, which then still belonged to Sweden, as did all of Hither Pomerania. His father was a shipbuilder. The boy, growing up in a large family, was fascinated by the theologian G. L. Kosegarten and his famous, sensitive poetry. Kosegarten's influence on young Runge's religious ideas was probably as great as that of his parents, who were strict and devout Protestants. In 1795 Philipp Otto went to Hamburg to join his eldest brother, Daniel, in business. But the latter soon realized that Philipp Otto was not meant to be a businessman. The youth's early attempts at drawing and painting impressed him so greatly that he decided to support his young brother's artistic efforts in every possible way. He did, and continued to do so most unselfishly until Philipp Otto's death. First, he sent him to study with some artists in Hamburg, but they were not very great masters. Then, in 1799, he sent him to the academy in Copenhagen, which has been mentioned here several times because many artists of that period began their studies there. Runge studied under Juel, the portraitist, and Abildgaard, painter of historic pictures. But in 1801, having been "unable to make any practical progress in painting," he went to Dresden. There he came in contact with Anton Graff, from whom he could learn a great deal about portraiture, and also with Ludwig Tieck, whose imaginative power attracted him greatly. But the year 1801 also brought him "close to the abyss." The cause was Goethe. As has been reported elsewhere, Goethe and Heinrich Meyer had been running an art contest under the title Weimar Friends of Art, to which paintings on a given theme were submitted (p. 72). They were convinced that subject matter was essential to form and that they could provide a new direction for art by circumscribing it thematically. But the themes they chose were of a very questionable nature. "Achilles Battling the River Gods" was the theme for 1801. Runge dared attempt it—and failed, according to the judgment of the Weimar Friends of Art—a judgment in which others concurred. Realizing that the ancient myths no longer offered creative subject matter for the artist, the young man asked angrily, "Where did this unfortunate idea—this desire to revert to the ancient art—come from?" Ancient mythology was not the only theme he rejected. He felt that the traditional subjects of Christian art were exhausted too. The fact that he himself tried his hand at such themes changed none of his basic convictions: ". . . Art today is in a miserable position. I intend to remedy that misery by devoting my whole life to finding out if we cannot build a [new] art on the foundations of our revealed religion."

There are good reasons to believe that it was chiefly Tieck who inspired these ideas in him. But Runge himself was not without a poet's sensibility, as this rhapsodic confession shows: "When the sky above me is strewn with innumerable stars and the wind rushes across the wide open space; the wave breaks thundering in the vast night, and then the air turns red above the forest and the sun begins to light up the world, the valley steams, and I throw myself onto the grass among the dewdrops, every leaf and every blade of grass is brimming with life, the earth lives and moves beneath me, all sounds come together in one great harmonious chord, then my soul rejoices loudly . . . I hear and feel the living breath of God . . . the most exalted experience possible . . . *God!*" But: "You shall not make any image of God, because you are incapable of doing so. God cannot . . . be shown in any work of art."

This enthusiastic and not always logical effusion anticipates the later Runge. He began working as a portraitist and remained one all his life. Among his most beautiful early works are his self-portraits, a chalk drawing of 1801 and the picture of 1802/03, shown on the frontispiece of this book, which is now in Hamburg. That picture does not show the enthusiastic doer so much as the dreamer. The gray-brown coat blends in with the background; the black-brown collar, the white shirt with its brown shadows, the rosy flush of the skin, the brown hair—all stand out from the background in harmonious contrast. The dark eyes are the eyes of a poet, but while they are filled with dreams, they nevertheless look steadily, undauntedly, at the world. In 1805 Runge painted the most sensitive group portrait of his time, *We Three*, which shows him with his wife, Pauline (née Bassenge), and his brother Daniel. It was destroyed by the Munich Glaspalast fire in 1931. In 1805/06 he painted the *Huelsenbeck Children* (fig. 29). This portrait shows the figures in action and yet it is not a genre picture, as pictures of children frequently tend to be, because of the monumentality of the composition. The artist's perception seems to have grown from one portrait to the next. The portrait of the artist's parents (colorplate 32; fig. 30) has been described elsewhere. In the self-portrait of 1809/10 (fig. 31), he shows himself as if unaware of approaching death, or perhaps steadfastly looking death in the eye.

The detail of *Morning* shown here is from the final version, which was cut up after the artist's death and has only recently been put back together out of nine fragments.

As in the earlier version of 1808 (fig. 27), Morning is shown as a person, a descendant of Eos or Aurora (p. 38 f.).

PHILIPP OTTO RUNGE

Morning (detail)

1808/09
Oil on canvas, 12 × 12 1/2"
Kunsthalle, Hamburg

In his 1803 series of etchings, morning was the only time of day Runge did not personify (fig. 25); thus it was merely logical that he gave it human form in the later version. This personification of the figure of Morning somewhat diminished the arabesque quality that had probably been most apparent in the earlier etched version of *Morning*. The small painted version actually turned into a figure composition which incidentally was extremely colorful, with the kind of color effect the Nazarenes were trying to achieve. The combination of Aurora and the lily seems successful. We can't be sure that this also held true for the final version, because there is a piece missing between Aurora and the lily. But we do notice that in this newer version the figure of Morning is heavier, her floating on air somehow less believable (which is not the case in a preliminary drawing now in the Kunsthalle, Hamburg).

Nevertheless, the child in the meadow has unquestionably been made more important. While the oil sketch for *Noon* (fig. 28) recalls Raphael's Madonna compositions, the child of *Morning* brings to mind the Christ Child seen in late medieval Nativity scenes. The fact that Runge was influenced by the art of the later Middle Ages is borne out by the undeniable resemblance of his flower spirits to the children of the Tulip Pulpit in the Cathedral of Freiberg.

Runge, who had planned his *Times of Day* as pure drawings, soon felt impelled to apply color to them, and his use of color became more and more painterly. This development came astonishingly fast. In the *Huelsenbeck Children* we still find an almost frighteningly harsh emphasis on drawing. The speed with which the artist developed in the very last years of his life shows up very clearly if we compare the two colored versions of *Morning*. The same Kammerherr von Ramdohr, incidentally, whose attack on Friedrich is mentioned earlier

in this book (p. 25), must have heard of Runge's high-flown plans for his *Times of Day*, which he himself had earlier called "arabesques." Ramdohr was indignant: not only were "cheap and quickly produced landscapes" pushing their way into the churches—"we'll soon be admitting arabesques to our sacred altars as well," he predicted with animosity. His prediction did not materialize.

When working for a church, Runge confined himself to traditional subject matter. In 1806 he was commissioned to do an altar painting for a small seamen's chapel near Witte on the Baltic Sea. The picture, now in the Kunsthalle in Hamburg, shows Jesus walking on water to save Saint Peter from drowning. Runge worked very hard on the picture but left it unfinished, perhaps because he felt unable to do justice to the subject. Goethe once said that he knew of no "loftier and more meaningful moment in all the Gospels than that when Christ, walking lightly across the sea, comes to the rescue of Saint Peter. There is no more impressive way of showing the Saviour's dual nature; indeed, the very meaning of Christian religion cannot be expressed more completely and succinctly."

Runge did not attain the artistic reality he sought in his somewhat earlier *Rest on the Flight into Egypt* (Kunsthalle, Hamburg), with its surprisingly Baroque compositional elements, but the landscape it shows proves he could have become a painter of earth-life pictures. The Christ Child in that picture does not lie directly on the ground, like the baby in *Morning*, but on the Virgin's outspread mantle. Still, the Son of Mary welcomes the light of day with outspread arms, just as the earth child of *Morning* does.

"I don't believe," Goethe wrote to Brentano the year Runge died, "that it is possible for a single artist to advance the cause of art with profound works in a barren period." The etchings of the *Times of Day*, to which he refers in his letter, were hanging in Goethe's music room. To Boisserée, who was scrutinizing them attentively, Goethe said that they were "maddeningly beautiful and crazy at the same time." And to a rejoinder by Boisserée he replied, "Yes, just like Beethoven's music . . . like our whole period." And then Goethe went on: "Of course it attempts to embrace the whole universe and in the process it loses itself in elemental things, and yet there is infinite beauty in some of the details . . . but the poor devil couldn't stand it himself, he is dead and gone; there is no other way: anyone who stands so precariously balanced on the brink must either die or lose his mind, there is no reprieve. . . ."

How very much Goethe liked Runge, nevertheless, can be seen from a letter he wrote to Perthes shortly before the artist's death: "He is an individual such as are rarely born into this world. His marvelous talent, his truthful, honest personality—as an artist and a man—had long attracted me to him. And if he went a different way from what I considered the right road, I did not feel displeasure, but rather enjoyed following wherever his peculiar method took him." Goethe misjudged many painters and sculptors—we think he did, and we don't hesitate to put it in writing. But then all of us do exactly the same thing quite often. Thus it might be salutary to try to attain the level of kindness revealed in this letter of Goethe's.

GOTTLIEB SCHICK (1776–1812)

Heinrike Dannecker

c. 1802
Oil on canvas, 34 5/8 × 26 3/8″
Staatsgalerie, Stuttgart

Schick is usually considered a Classicist. Of course, after an early apprenticeship with Philipp Friedrich von Hetsch (1758–1838) he did go to Paris and study under Jacques-Louis David from 1798 to 1802. Then he moved to Rome, where he had enormous, if today rather incomprehensible, success with his *Sacrifice of Noah* (p. 42). It was this picture that August Wilhelm Schlegel credited with bringing back to life a "kind of piety that had totally vanished." For our part, we think as little of that kind of piety as of the Classicism of *Apollo with Shepherds*, which Schick completed in 1808 (Staatsgalerie, Stuttgart). According to his own testimony, he worked "very little from models, and it is striking how much better those things turn out that I paint from imagination." He was, we fear, as wrong about that as it is possible to be.

Some of the portraits he did from living models are certainly magnificent, though. It may be a personal prejudice on our part if we prefer the Stuttgart version of his portrait of Heinrike Dannecker to the Berlin version of 1802; but we feel that this not quite finished version (colorplate 34) is definitely more fascinating and certainly more painterly. The popularly held idea that all Classicists were purely draftsmen who used color only as a decorative addition is contradicted by this portrait. It is hard to believe that the same man who did the *Sacrifice of Noah* and *Apollo with Shepherds* created this portrait. Perhaps Heinrike's pose seems a bit premeditated, but how charmingly natural is the gaze from those dark eyes! We can, if we wish, find fault with the position of the crossed legs; we can say that the gown, falling from the right leg, is a piece of drapery; we can point out that there seems to be no arm attached to the left hand resting on the left leg and we can regard it as an isolated hand study—which is, incidentally, reminiscent of Dürer—but none of this will prevent us from counting this portrait among the most beautiful of the period. It is unfinished, as has been stated. The underpainting shows through in many spots, but this heightens rather than detracts from the effect. The limitation of color to several muted shades of white in the dress, brilliant red in the bodice, copper red head kerchief, brown-blond hair, and light gray background is enchantingly delicate in its "classicism." We don't have to learn anything about the life history of Dannecker's first wife. She is alive in this portrait.

No doubt Schnorr von Carolsfeld's equally unfinished *Portrait of Clara Bianca von Quandt* is also extremely fascinating in its coloring, especially of the lady's brilliantly red dress (Staatliche Museen, Berlin). But we must admit that the pose and expression of that portrait are rather affected. No matter how artistic this Frau von Quandt may appear, it is not she but rather Heinrike Dannecker, as seen by Schick, who personifies the women without whose presence the period here described would have scarcely been thinkable. She represents Bettina, Caroline, Dorothea, Henriette, Rahel, and whatever else their names were. For those in the know used to refer to them by their first names only; no further identification was necessary.

PETER VON CORNELIUS (1783–1867)

Joseph Revealing Himself to His Brothers

1816
Fresco, 7′ 8 7/8″ × 9′ 6 1/8″
Staatliche Museen, Berlin

In 1814 Cornelius wrote to Johann Joseph von Görres: "... a small number of German artists have begun to clear the overgrown path to the sacred temple of art; they are filled with awareness of the true nobility and divinity of their art, by divine revelation, as it were ... this small band is waiting for a worthy opportunity, and burning with desire to show the world that art can magnificently come alive now, as it was once. ... The strongest means ... of giving German art the basis for a new direction would be no less than the reintroduction of fresco painting. ... To insure a good start for this, nothing would be more desirable ... than that those who have embraced the true meaning of art with courage in their hearts ... should, according to their unanimous wish, be given a great, worthy, extended task in a public building in some German city."

There was no such public building to be found in Germany. But the Prussian consul general in Rome, Jakob Salomon Bartholdy, commissioned Cornelius, Overbeck, Wilhelm Schadow, and Veit to decorate a room in his rented apartment in the Palazzo Zuccari with frescoes depicting scenes from the legend of Joseph. In 1886 the frescoes were bought by the Prussian Art Commission and transferred to Berlin. Cornelius's is the finest, equally well balanced in composition and color. The influence of Italian Renaissance fresco art is apparent. Nevertheless Cornelius honorably stands his ground against those he emulated. There is genuine feeling in the way Joseph bends down to embrace his youngest brother, Benjamin, with closed eyes. It was clever of the artist to divide the rest of the brothers into two groups, one kneeling in a close semicircle, the other standing in a more casual group. Cornelius has made the heads of the standing brothers level with that of Joseph, the dominant figure, without disturbing the balance of the composition.

Cornelius was born in 1783 in Düsseldorf, where he began his studies at the academy. From 1809 to 1811 he lived in Frankfurt. There he made his first pen-and-ink drawings for a Faust cycle in the "old German manner." When Boisserée showed them to Goethe in 1811, they met with the poet's approval. Boisserée remarked to Heinrich Meyer: "The

olden days are truly being resurrected! The critical old fox muttered something; he had to admire the work but could not refrain from scoring the faults in the old German manner of drawing. Goethe admitted that, but passed over it as insignificant." The whole Faust cycle was published in 1816 as a series of etchings. In 1811 Cornelius went to Rome with Xeller, and joined the Guild of Saint Luke (p. 43 f.). The first thing he did in Rome was to complete his *Nibelungenlied* cycle (1812), in which the page showing Kriemhild viewing Siegfried's corpse is probably the most important. In composition and in the pathos of its figures it anticipates the Joseph fresco of the Casa Bartholdy.

In 1817 the Italian Marchese Carlo Massimo commissioned the Guild of Saint Luke to decorate his casino with frescoes from Dante, Ariosto, and Tasso. For the younger painters such as Ludwig Richter, "it was always a special pleasure to visit the Casa Bartholdy or the still unfinished paintings (1825) in the Villa Massimi. ... Those two sites were like spring gardens of the newer German art. ... We saw Schnorr up on the scaffolding ... he worked with a sure hand that made it a joy to watch him. ..."

Cornelius had just laid out his fresco when, in 1819, he was given the directorship of the Düsseldorf academy and, in the same year, a commission to decorate the Glyptothek in Munich. His work at the Glyptothek led him, as might have been expected, deeply into antiquarianism. His reputation nevertheless continued to grow. In 1825 he became director of the academy in Munich. We have elsewhere quoted his remarks about landscape art (p. 36), which he made while holding that office. However, he did go to see Caspar David Friedrich in 1820. Karl Förster, who went along, reports on that visit: "We walked up to Friedrich, to whom Cornelius did not wish to reveal his name at first. 'Let who I am emerge in due time.' When he finally gave Friedrich his name, Friedrich exclaimed that he had not expected such a great honor. The charming, excellent man in his simple childlike way was delightful, all joy and humility. He showed several of his things with a diffidence that did him honor. He sat down on the ground with us, could not be induced to change his place. 'Got to show my respect somehow,' he said in his lovable Pomeranian dialect. Among the pictures he showed was one called *Reeds with Two Swans in Magic Moonlight*. 'The divine spirit is everywhere, even in a grain of sand; here I have shown it in some reeds!'"

Such a confession was certainly not in the spirit of Cornelius, who felt, like Goethe, that "the worthiest object of art is the human form." But Cornelius did not master the human form quite as well as he imagined, as his later works show even more clearly than his Glyptothek frescoes. Yet, he remained the impressive personality Fohr has captured in his drawing (fig. 38). In 1858, when the painter Edvard Riedel showed him a picture of a girl bathing in which the sunlight was painted so convincingly "that one searched for the window by which it had entered," Cornelius made a pronouncement that altogether characterizes him: "You have perfectly accomplished what I have worked hard all my life to avoid." He died in 1867 in Berlin, where Friedrich Wilhelm IV had commissioned him to decorate the Campo Santo that had been planned alongside the Cathedral.

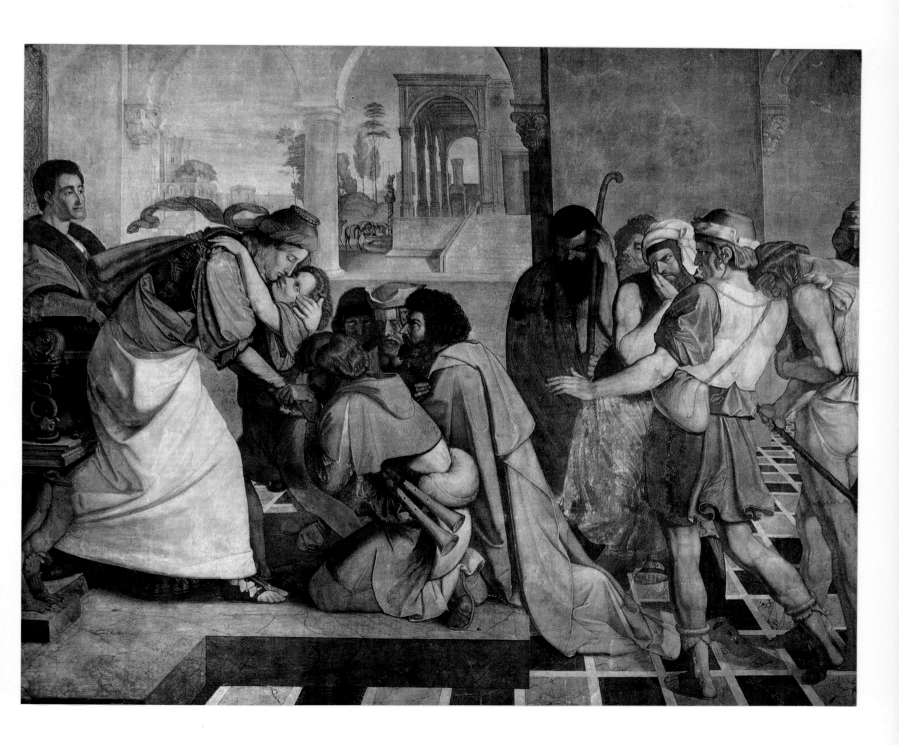

FRIEDRICH OVERBECK (1789–1869)

Italia and Germania

Date uncertain
Oil on canvas, 8 5/8 × 10″
Collection Georg Schäfer, Obbach

Between 1811 and 1828 Overbeck painted a picture called *Italia and Germania*, which King Ludwig I bought in 1833 for the Neue Pinakothek in Munich. It has been there ever since. That painting, like Franz Pforr's quasi–altar-picture *Sulamith and Maria*, in the Georg Schäfer Collection in Obbach, is an artistic manifesto of Nazarenism. We may recall that Overbeck was the "priest" and Pforr the "master" of the Guild of Saint Luke (p. 41). While working on these two pictures, the artists were in constant communication with each other. But researchers cannot agree on whether the oil sketch of *Italia and Germania*, now in the Georg Schäfer Collection, is a study painted by Overbeck himself or the work of an imitator. The composition has made a great impression, and has been lithographed repeatedly. What speaks against Overbeck's having created the oil sketch himself is its extraordinarily painterly character. Compared to the picture in Munich, this sketch might be called a painterly masterpiece. During the years in which the sketch was probably created, Overbeck was far more interested in accuracy of outline and local color. If ever an artist was predestined by his character for such strict purity, Overbeck was that artist. In that respect the oil sketch—if regarded as a confession, which it surely is meant to be—does not fit in with Overbeck's character (fig. 33). On the other hand, it is always a mistake to try to type an artist's style. And Overbeck was a true artist, even if most of his work no longer appeals to us today. His case is quite similar to that of Gottlieb Schick. Besides, the oil sketch in the Schäfer Collection does not necessarily have to be a preliminary study for the Munich picture. It is really quite different, especially in the background treatment. Nor does the Munich picture have a curtain with halo-like designs behind the two figures. The figures themselves epitomize that "sensibility" which the Romantics enthusiastically and affectionately proclaimed as the power by which man perceives the world. Overbeck believed in affection, and in this respect he unconsciously—aren't most artistic processes un-conscious?—followed Gottlieb Schick, who had painted the sisters Adelheid and Gabriele von Humboldt in a tender proximity similar to that of Overbeck's *Italia and Germania*. Schick's picture, painted in 1809, was destroyed in 1945.

Overbeck's family was well situated. His father was a senator, and later became mayor of Lübeck. Young Overbeck had his first painting lessons in his home town, and experienced his first artistic shock at the Vienna academy, where he matriculated in 1806. Indignation against the academy led to the founding of the Guild of Saint Luke and secession to Rome, where Overbeck remained, with brief interruptions, until his death. In 1813 he became a Catholic, much to his family's displeasure. His conversion turned out to be a hindrance rather than a help, however: he strove earnestly and valiantly to create a new image of Christ, but he did not succeed. It is true that Gerhard von Kügelgen wrote in 1809 that Overbeck had created a picture of Christ that was "the most beautiful and noble . . . man could produce. . . ." But in this respect the good Kügelgen is just as untrustworthy a critic as the dead-serious Overbeck. In a letter of 1817 Helene Maria von Kügelgen, confesses that she had revered Christ from childhood on "with human adoration," but had never believed in his divine nature. When she had met Friedrich von Gentz at a dinner party in Berlin, he had suddenly asked her, "You certainly don't believe in Christ's divinity either, do you? Here in Berlin we honor him, but only as a rare human being." Gentz's remark, she writes, had struck her so forcibly that from that moment on she had a complete change of heart.

Friedrich declared: "Of all the many painted heads of Christ I have seen, there was only one, by Titian (*Tribute Money*), which truly meant anything to me." One would expect Rembrandt to be more appealing to Friedrich than Titian, but he probably never got to see any pictures of Christ by Rembrandt.

MORITZ VON SCHWIND (1804–1871)

Nocturnal Duel Beside a Garden Gate

Oil on canvas, 22 1/2 × 13 3/4"
Schackgalerie, Munich

The Germans regard Schwind as a painter of fairy tales, and so he is. But he has probably painted as many historical pictures as fairy tales. Born in Vienna, he went to Munich in 1827, where he was greatly impressed by Cornelius. "*Quod villam* [as for the city]: Munich is a hateful nest, the city is full of arbors and these in turn are full of bread-setters [i.e., bakeries]. A single road leads from the city to the suburbs. Here and there it is lined with trees. A great deal of building goes on in the suburbs and that is strangely beautiful. There is absolutely no landscape." He wrote this to his friend Schober soon after his arrival in Munich. He went to the Glyptothek, where he found Cornelius "on a scaffolding in the second hall. He is a very small man in a blue shirt with a red sash. He looks very severe and elegant, and he has remarkable luminous black eyes." At first the master hesitated to take the young artist into his confidence; but he quickly began to appreciate him, and gave him all sorts of advice: "It would be unfortunate if a painter of historical scenes had to paint everything from nature. One must be able to draw naturally from memory." Fortified with such advice, Schwind painted in the Munich library; among other things, he painted some scenes from the life of Charlemagne. In 1835 he went to Rome. When he returned, he received numerous commissions. Actually his frescoes, most of which are heavily allegorical, are somewhat hard for us to appreciate. He himself complained that by 1825 "... I have been crossed off the list of living artists. Just the same I am active and of good cheer, and in spite of being passed over and having my prices reduced, I can enlarge my house and my small fortune—as my wife calls it—though at a slow pace. The children are brimming with health."

It is indeed impossible to think of Schwind without healthy children, even when he himself was depressed. In 1844 he published an *Almanac of Etchings by Moritz von Schwind with Explanatory Text and Verses by E. Baron von Feuchtersleben*, which glorify the cup and the pipe. No wonder that Schwind, who had been a handsome youth—and had depicted himself as such in an admirable self-portrait—gradually acquired a beer belly. "Folks think that if a man looks well fed he can't be a clever artist! Just look at me!" he wrote beneath a self-caricature that illustrates his point.

In 1847 he became a professor at the academy in Munich and a contributing editor for two humorous periodicals, the *Fliegende Blätter* and the *Münchener Bilderbogen*. In 1849 he composed a very witty painted symphony, after Beethoven, and in 1866 the *Cat Symphony* for Josef Joachim. He painted Cinderella, Puss in Boots, the story of the Seven Ravens, the Fair Melusine, Rübezahl (Old Nip).

The picture of the giant Rübezahl calls to mind a walk Schwind took while he was at work on the Wartburg frescoes. He and a friend were walking along the Anna Valley near Eisenach when the friend remarked with a laugh that it really looked as if the road had been built by giants and wondered if any of them might still be living there. Schwind replied quite seriously, "Don't you believe in them? I do!" Corot, a very different personality, had the same kind of belief. He had always told his students to paint only what they could see. One day a student noticed Corot painting a nymph in a woodland scene. "But Master, haven't you always told us to paint only what we could see? What about this nymph?" "Oh, don't you see her? I do." Schwind, a painter-poet, saw his mountain giants in the same way.

Only a poet could have painted such pictures as the *Wedding Trip*, or the *Hermit* taking horses to be watered, or the *Early Morning*, which shows a young girl, Schwind's daughter, looking out of an open window into a sunny landscape. It is a charming echo of Friedrich's *Woman at the Window* (colorplate 15).

Schwind's picture of a *Nocturnal Duel* in front of a Baroque park gate is less well known. But its painterly quality is superior to that of many of Schwind's other pictures. The highly dramatic gray-green architecture stands tall against a mighty dark green tree and an equally dark hedge. The sky, blue green and blue gray, reflects the tonality of the architecture. The duelers are both partly dressed in red: the man on the left wears a dull red jacket and matching hat, the other has dark red trousers under a dark green cloak. Their faces are barely discernible. The atmosphere of the whole picture has a ghostlike quality, one might say, a touch of Shakespeare.

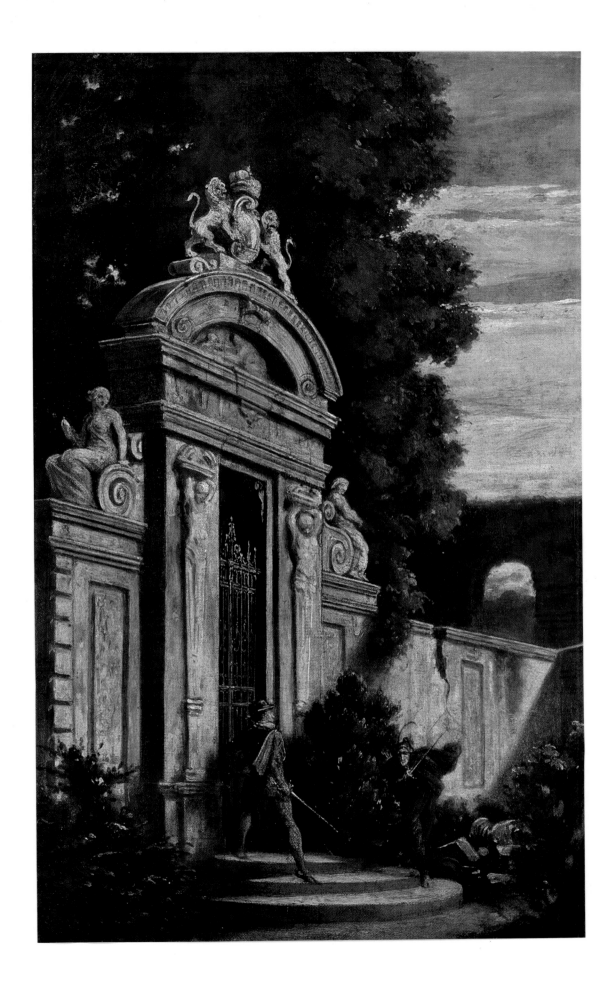

CARL SPITZWEG (1808–1885)

Hermit Playing the Violin (detail)

Oil on canvas, 12 1/4 × 21 1/4″
Schackgalerie, Munich

We can laugh about him to our heart's content. That is a rare thing in art, but especially surprising at the end of a period that began with art reverence. However, that same period also introduced a great century of caricature. Of course Spitzweg was no more a caricaturist than, say, the novelist Fritz Reuter. He was an eccentric who tended to see the humorous side of things; he was often charming, inclined to cheerful teasing, full of crazy ideas. But he could also personify the first syllable of his last name, which means "point" or "pointed" in German. The picture of the *Hermit* is signed, as many of his other pictures are, with a monogram that consists of the letter *S* and the point of a lance.

At first Spitzweg had not the slightest intention of becoming a painter. His father, a cloth and spice merchant in Munich, wanted his eldest son to become a doctor and Carl to become a pharmacist. Carl did become a pharmacist, and in 1832, when he wandered through Italy, he did not yet seem to have artistic ambitions. Then in 1833 he came down with a nervous disease. He went to a spa, Bad Sulz, to recuperate. There he met some artists, among them Christian Heinrich Hansonn, who influenced him so decisively that he made up his mind to become a painter. But in his own stubborn way he insisted on relying solely on himself. Everything he saw became a lesson for him. And he was enormously industrious. He even made a rhyme about his zeal:

> Take joy, take pleasure in your art,
> The toil by which you live
> And cherish, too, with all your heart
> What pleasure you could give.

These are the kinds of verses that might have been penned by the *Poor Poet*, whom he painted in 1839 (Staatliche Museen, Berlin). To create poetry, this poet has to lie in a well-cushioned bed, wearing a nightcap on his head even though it is broad daylight. He is surrounded by books, and his hands scan the meter that is marked on the wall, as on a blackboard. And because the roof leaks the Poor Poet has to have an open umbrella propped up over his head. But that isn't nearly all the Poor Poet needs: the picture records every tiniest detail with penetrating, pointed brush and, one might say, pharmacological accuracy. It is all done in a draftsmanlike, typically Spitzwegian way; it is both drawn and painted at the same time. As for the idea of the picture, it is by no means inferior to any of Daumier's. Only Spitzweg's setting is somehow "cozier." We feel that this picture clearly shows that Spitzweg would never get married, and he never did. He stayed a bachelor, albeit a well-heeled one, all his life. This biographical deduction is important, but what is even more important is that Spitzweg has succeeded in immortalizing the "starving" poetaster in this picture. No doubt about it.

He immortalized other characters, too—a man reading a letter, and a guardsman saluting his superior who is strolling along with his wife and a mutt, but is not yet quite close enough to be saluted. In this picture it is hard to say which of the two has the more impressive paunch—the guardsman or the officer. Another of Spitzweg's targets is the librarian who stands on a ladder in front of a bookshelf like a misshapen statue on its pedestal—a book between his legs, another under his left arm, a third in his right hand, and a fourth in his left. He is myopically reading the last one. Then there

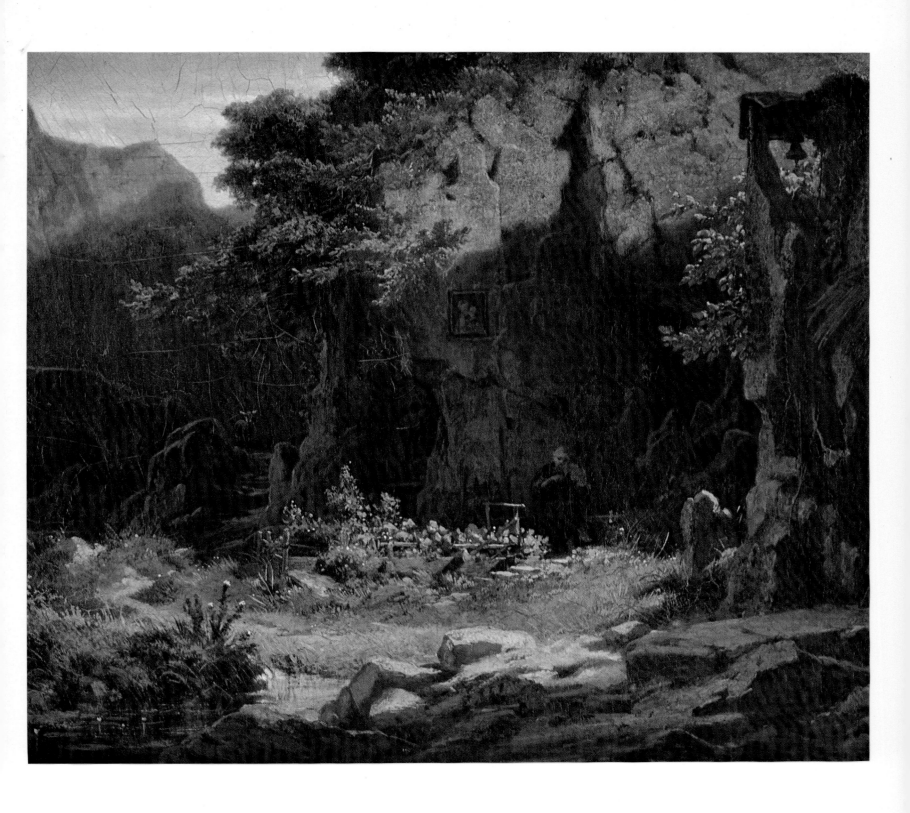

CARL SPITZWEG

The Love Letter

1845/46
Oil on canvas, 9 1/2 × 8 1/4"
Staatliche Museen, Berlin

is the antiquarian, as much a match for any of Daumier's antiquarians as an old man watering his flowers from a window is a match for Daumier's night-capped ancient in *Regrets*—except that Daumier's is not using a watering can but his very own dripping nose. Generally speaking, a detailed comparison between Daumier and Spitzweg would probably prove more rewarding than the frequent but rather exaggerated comparison between Daumier and David Wilkie, whose *Reading of the Will* (1820) was bought for the Pinakothek in 1826 by Ludwig I.

Eccentric bachelor that he was, Spitzweg naturally had great understanding for hermits. His *Hermit Playing the Violin* no longer has the pointed-brush quality of the *Poor Poet*. The colors are handled much more freely. The painterly freedom Spitzweg achieved around the middle of the century is usually attributed to a trip to Paris which he and his friend Edward Schleich made in 1851. Undoubtedly what most impressed him in Paris were the works of Diaz and Eugène Isabey. But Spitzweg remains essentially the same, even after his visit to Paris. His fiddler sits all alone behind a bright green flowering meadow; he leans against a steep rock wall with only the Virgin and Child in a picture hung on the rock, and a deer coming up the path on the left to listen to him—is he so very different from the Poor Poet in his garret? One suspects the quality of the hermit's fiddling is no greater than that of the Poor Poet's verse. And yet there is a world, there is earth-life, in the rocky landscape surrounding the hermit.

The Love Letter is in a different genre than the *Poor Poet*, but is related to it. The old mother, sitting so broadly, could be a mixture of an English and Spanish old woman, but we can be assured she is really a native of Munich. It would be hard to show innate ill humor more clearly than the way it is painted on her bonnet-framed face. Is the old woman listening to what her daughter, wonderfully dressed in red, is reading aloud? Whatever it may be, it has made the old lady sleepy. Meanwhile here is the postman, peering over the wall that shuts mother and daughter away from the world. He doffs his blue top hat. There is a letter in his right hand, and his wide-open eyes indicate that something terribly secret and important is going on. But the love messenger's letter remains sealed, the daughter's back is turned to the viewer, the mother dozes—listening or not listening—and the window of the house remains closed. The blue of the postman's top hat is matched by the corresponding patch of color in the weaving frame that leans against the small round table. The round table itself is not the center of the composition; mother and daughter are seated away from it, as if it weren't there at all. But its circular shape is complemented by the round straw hat which the daughter, her costume glowing like a red heart, has hung up on a bush. Everything is so patently bourgeois that it makes us laugh, and yet there are hidden depths that take the edge off our laughter. And as far as painterly concepts are concerned, the picture can easily take its place alongside any European painting of the period.

126

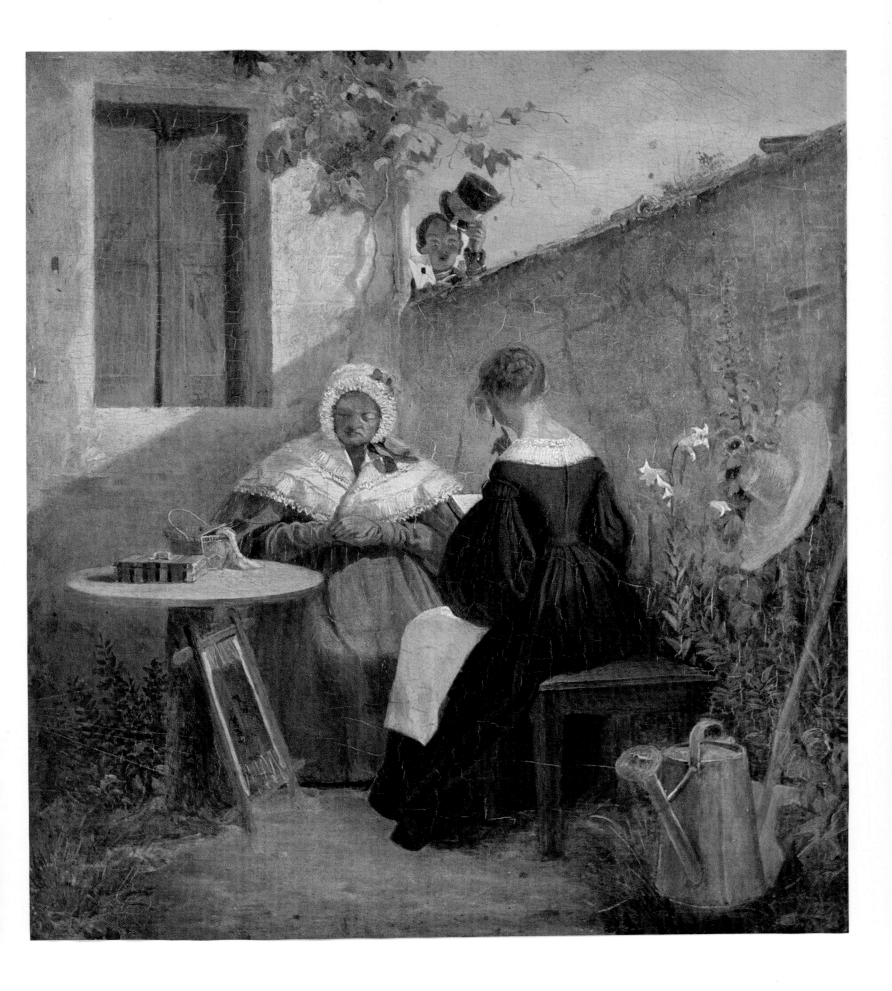

AFTERWORD

The selection of pictures from the so-called Romantic period which I have shown here is necessarily a subjective one, but I hope I have not left out anything of real importance. I further hope that the deliberate departure from narrow, not really valid, stylistic criteria will help to give an idea of the artistic riches of the period. A book that is not addressed to scholars cannot possibly offer more than hints and indications, but I hope that even an art historian may find it not altogether unrewarding to pick up this book. And not only the art historian, the historian of religion, too, might possibly find something of interest here—for the problem of the aesthetic church, upon which I have touched in the introduction, is a problem of religious as well as art history. Of course the subject could not and should not be treated exhaustively here. Among others, the question of the "invisible church" would have had to be treated in detail. That question has not been laid to rest since the Reformation. Hegel answers it with his lapidary statement: "The kingdom of God is, above all, the invisible Church, which encompasses all zones and all different religions." In this respect his ideas are shared by Count von Zinzendorf, for whom "the children of God are one in all religions." Ludwig Richter, whose memoirs I have quoted repeatedly, feels himself a member of "that invisible community that is scattered throughout all Christian sects and branches . . . I hope to God that this invisible community will grow." And Wilhelm von Kügelgen says: "True knowledge does not reside in this or that denomination . . . it resides in all of Christianity, of all denominations, in other words, in the general Christian Church."

Neither Ludwig Richter nor Wilhelm von Kügelgen is very fashionable today. But that does not make their statements wrong or unhistorical. On the contrary, one must bear in mind that neither Philipp Otto Runge nor Caspar David Friedrich could have functioned—as Protestants or as artists —without these ideas. There can, then, be no doubt that belief in a general invisible church is the indispensable precondition for the aesthetic church which, in turn, could not have become a reality without the aesthetic tolerance demanded by the young Goethe, Wackenroder, and the young Friedrich Schlegel. The young Goethe: "Rembrandt, Raphael, Rubens . . . I put these three masters together though they are usually thought of as being separated by mountains and oceans: but I could easily add many more great names and prove that they all were alike in one essential respect," namely, that they all "felt God's presence everywhere, at every step, indoors and out." Wackenroder: "The Gothic church and the Greek temple are equally pleasing in the sight of God." Friedrich Schlegel: "The ancients . . . are not God's chosen artists, nor are they the only people possessed of the true sense of beauty."

Along with aesthetic tolerance there emerges that relationship to art that requires and deserves to be called art reverence. It is a reaction against the pure love of pleasure embodied by the Rococo, and also against the rationalistic moralism of the Enlightenment. It regards art as such as something sacred. Works of art exist in a "self-created world," and remain there, says August Wilhelm Schlegel: "It is eternal life made visible." Schlegel admits the possibility that this admiration may become "pious idolatry, as with the ancient statues of the gods." His remark was aimed at Raphael's *Sistine Madonna*, but he added that there was "no danger as long as Raphael is the hierophant."

There were other hierophants, however; the old German masters had been rediscovered, and this led—all previously proclaimed aesthetic tolerance notwithstanding—to the partisan divisions we have mentioned so often in this book. Yet no matter how sharply divided the antagonists thought they were—chiefly because religious as well as national matters were involved—they actually stood much closer to each other than they realized. In 1775 the young Goethe wrote his *Dritte Wallfahrt nach Erwins Grabe* (Third Pilgrimage to Erwin's Grave). His secret journey to Dresden

had been a pilgrimage too, for, as he says in *Dichtung und Wahrheit*, he entered the Dresden Galerie as he would a sanctuary, with "a sense of awe, unique in its way, resembling the feeling with which one enters a house of God, the more so as there were so many temple ornaments, so many objects of religious veneration on display, but this time only for the sacred purposes of art." Goethe was one of the originators of the "art pilgrimage." His journey to Italy was meant to help him find himself, to become "at one with myself." At the same time, it was, and was meant to be, an art pilgrimage.

In his last report from Rome, dated April 1787, he described his attempts to visit the catacombs he had hitherto neglected, although they were the goal of so many pious pilgrims and relic hunters. But the "stuffy rooms gave me such a disagreeable feeling that I immediately climbed back up into the daylight." "Another pilgrimage, however, proved more inspiring. Its goal was the Lukas academy. We wanted to pay our respects to the skull of Raphael, which is being kept there as a relic . . . a truly wonderful sight! As beautifully joined and rounded a cranium as one can imagine . . . I could not tear myself away from the sight, and I remarked, on leaving, how meaningful it would be for admirers of art and nature if they could have a casting of it." No doubt this is a different kind of relic worship from that of the pilgrims in the catacombs and churches. But, relic worship it is.

And then the "old heathen" continues: "The most delightful sight was the artist's charming painting of Saint Luke, to whom the Virgin appears in order that he may paint her in all her divine grace and majesty as truly and naturally as he can. Raphael himself, still young, is seen standing off to one side, watching the evangelist at work. There is probably no more graceful way to express and confess one's love for a chosen profession."

Neither Overbeck nor Pforr could have shown deeper reverence for art when they founded the Guild of Saint Luke and chose a picture of Saint Luke for their symbol. They would have considered it a sin not to visit Raphael's birthplace during their journey to Rome. Pforr heads his travel report with the title "Our Pilgrimage to Urbino, on July 15, 1810." They entered the little town like reverent pilgrims and visited the house where Raphael was born. "It would be vanity to try to describe my emotions as I walked through those rooms and corridors where Raphael had played as a child, where the delicate flower of his spirit unfolded. . . ."

Goethe calls Raphael's villa in Rome, ". . . where he preferred the enjoyment of life at the side of his mistress to all art and all fame," a "sacred monument." No doubt the first part of the poet's remark did not appeal to the "Friars of San Isidoro." But his calling the villa a "sacred monument" places him in close spiritual proximity to the Nazarenes, who called the artist's birthplace "Saint Raphael."

Actually Pforr even goes beyond the limits of Nazarene piety when he boldly asserts that "God has created man so that he might attain the highest step among all the creatures on earth," and that to help him attain it, God "has placed the joys of art beside the hardships of life, as a substitute for the lost Paradise." This is simply another way of saying exactly what Schlegel had said about art: "It is eternal life made visible." It seems no less remarkable that the earnest, pious Overbeck did not content himself with the beatitudes promised by the Catholic Church, but yearned for his own "temple of immortality" in the essay *Die drei Wege der Kunst* (The Three Paths of Art). We shall not elucidate on the three paths here. They are infinitely difficult, but they all lead the "indefatigable wanderer to his goal, the temple of immortality." "At times the wanderers run into some danger . . . and there have been cases when death overtook them before they could reach the temple." More than one of the artists in this book was overtaken by death before he could reach his goal. "But then there comes a well-meaning companion and carries the corpse to that threshold where suddenly life and eternal youth are returned to him." Overbeck does not say who these well-meaning companions might be. But it is safe to assume, from the conclusion of the essay, that what he had in mind were the dead man's emulators. Nowhere does Overbeck indicate what he thinks the temple of immortality should look like. Perhaps like the "temple of immortality" which Jean-Nicolas Sobre, an architect of the French Revolution, had designed?

Sobre's temple never got beyond the planning stage. The only temple of art that was actually

built as such is the Alte Museum in Berlin, created by Carl Friedrich Schinkel between 1820 and 1830. It was intended as a structure of sacred dignity. Schinkel designed an imposing facade of columns, the first such unabashedly solemn Greek temple facade in Germany. But the sacred character of the building was not to end at the facade. The interior, too, had to be placed above the merely utilitarian sphere. The central hall is circular (subsequent renovations have destroyed the original effect). The interior, too, was designed after an ancient model, the most perfect circular room known at the time, the Pantheon in Rome, and the central room was meant to elevate the visitor. It was to be "a sanctuary for the most precious objects. We enter from the outer hall and the sight of a beautiful and lofty room must make us receptive, and put us into the proper mood to enjoy and experience the treasures the building contains."

Modern museum architecture does not attempt to create a sacred atmosphere. Nor do we practice art reverence nowadays. But we must admit that our predisposition to be stirred by art as art stems from the period discussed here. We too are members of the aesthetic church founded at that time, and while we have done away with religious-sacramental forms and phrases, we do want to be members of that church. Except that our membership is more difficult for us than it was for the people of the early nineteenth century. Our contemporary art is far more varied in its forms and aims. The earlier period could still proclaim that the noblest subject of art was man. To this we must add that, with certain exceptions, the artists of the period did not venture to realize their announced goal. Caspar David Friedrich knew very well why not. He declared: "Man is equally close to God and the Devil. He is the highest and the lowest of creatures, the noblest and the most corrupt, the essence of all that is good and beautiful, and of all that is evil and damned. He is the crown of creation and also a blot upon it." Here is the deeper reason why the human form did not mean much to Friedrich and why he preferred to show people with their backs to the viewer. But even apart from Friedrich's special case, the artistic power of the period found its most convincing expression in earth-life art. It presupposes the young Goethe's experience of nature's superhuman power when he quotes from Psalm 8: "What is man that thou art mindful of him?" The period began with a strong formal emphasis on the drawn line and became increasingly more painterly, as Schiller expresses it in his distich on "Light and Color":

Light, eternally one—oh dwell with the One
 Eternal!
Changeable color, descend—friendly to
 dwell among men.

BIBLIOGRAPHY

GENERAL

Andree, R. *Katalog der Gemälde des 19. Jahrhunderts im Wallraf-Richartz-Museum*. Cologne, 1964.

Andrews, K. *The Nazarenes: A Brotherhood of German Painters in Rome*. Oxford, 1964.

Badt, K. *Wolkenbilder und Wolkengedichte der Romantik*. 1960.

Benz, R. *Goethe und die romantische Kunst*. Munich, 1940.

————, and Schneider, A. von. *Die Kunst der deutschen Romantik*. Munich, 1939.

Brion, M. *Art of the Romantic Era: Classicism, Romanticism, Realism*. New York, 1966.

————. *German Painting*. New York, 1959.

————. *Romantic Art*. New York, 1960.

Deusch, W. R. *Malerei der deutschen Romantiker und ihrer Zeitgenossen*. Berlin, 1937.

Eitner, L. *Neoclassicism and Romanticism: 1750–1850*. 2 vols. Englewood Cliffs, N.J., 1969–70.

Finke, U. *German Painting from Romanticism to Expressionism*. London, 1974.

Firmenich-Richartz, E. *Die Brüder Boisserée*. Vol. 1. 1916.

Fleischhauer, W.; Baum, J.; and Kobell, S. *Die Schwäbische Kunst im 19. und 20. Jahrhundert*. Stuttgart, 1952.

German Painting of the 19th Century. New Haven, Conn., Yale University Art Gallery, in collaboration with The Cleveland Museum of Art and The Art Institute of Chicago, 1970. Introduction and catalogue by Kermit S. Champa with Kate H. Champa.

Goethe, J. W. von. *Schriften zur Kunst*. Vol. 33/34.

————. *Theory of Colors*. Translated by Charles Lock Eastlake. London, 1840. Facsimile. London, 1967.

Grote, L. *Das Antlitz eines Jugendbundes*. Berlin, n.d.

Holt, E. G. *From the Classicists to the Impressionists: A Documentary History of Art and Architecture in the 19th Century*. New York, 1966.

Jensen, J. C. *Die Bildniszeichnung der deutschen Romantik*. Lübeck, 1957.

Justi, C. *Winckelmann und sein Jahrhundert*. 1923.

Klassizismus und Romantik. Gemälde und Zeichnungen aus der Sammlung Georg Schäfer, Schweinfurt. Nuremberg, Germanisches Nationalmuseum, 1966.

Knauss, B. *Das Künstlerideal des Klassizismus und der Romantik*. Reutlingen, 1925.

Kobell, W. von. *Gedächtnisausstellung zum 200. Todestag des Malers*. Munich and Mannheim, 1966.

Kügelgen, H. M. von. *Ein Lebensbild in Briefen*. Stuttgart, n.d.

Kügelgen, W. von. *Jugenderinnerungen eines alten Mannes*. Düsseldorf and Leipzig, 1922.

Lindemann, G. *History of German Art: Painting, Sculpture, Architecture*. New York, 1971.

Lohmeyer, K. *Heidelberger Maler der Romantik*. Heidelberg, 1935.

Mann, G. *The History of Germany since 1789*. London, 1968.

Noack, F. *Das Deutschtum in Rom*. 2 vols. Stuttgart, 1927.

Nochlin, L. *Realism and Tradition in Art 1848–1900: Sources and Documents*. Englewood Cliffs, N. J., 1966.

Novotny, F. *Painting and Sculpture in Europe 1780–1880*. The Pelican History of Art, edited by Nikolaus Pevsner. Baltimore, 1960.

The Romantic Movement. London, The Tate Gallery, 1959.

Rosenblum, R. "German Romantic Painting in International Perspective." *Yale University Art Gallery Bulletin*, vol. 33, no. 3 (1972).

————. *Modern Painting and the Northern Romantic Tradition: Friedrich to Rothko*. New York, 1975.

Schilling, E. *Deutsche Romantiker-Zeichnungen*. Frankfurt, 1935.

Schmidt, P. F. *Deutsche Landschaftsmalerei von 1750 bis 1830*. Munich, 1922.

Schrade, H. "Die romantische Idee von der Landschaft als höchstem Gegenstande der christlichen Kunst." *Neue Heidelberger Jahrbücher*, 1931.

————. *Schicksal und Notwendigkeit der Kunst*. 1936.

Thieme, U., and Becker, F., eds., *Allgemeines Lexikon der bildenden Künstler von der Antike bis zur Gegenwart*. 37 vols. Leipzig, 1907–50.

Zeitler, R. *Klassizismus und Utopia*. Stockholm, 1954.

ARTISTS

BLECHEN: Rave, P. O. *Karl Blechen: Leben, Würdigungen, Werk*. Berlin, 1940.

CARSTENS: Einem, H. von. *A. J. Carstens. Die Nacht mit ihren Kindern*. Cologne, 1958.
Kamphausen, A. *Asmus Jakob Carstens*. Studien zur Schleswig-Holsteinschen Kunstgeschicht, vol. 5. Neumünster in Holstein, 1941.

CARUS: Carus, C. G. *Neun Briefe über Landschaftsmalerei*. Leipzig, 1831. 2nd ed., Dresden, 1955.

CORNELIUS: Kuhn, A. *Peter Cornelius und die geistigen Strömungen seiner Zeit.* Berlin, 1921.

VON DILLIS: Lessing, W. *Johann Georg von Dillis als Künstler und Museumsmann, 1759–1841.* Munich, 1951.

FOHR: Hardenberg, K., and Schilling, E. *Karl Philipp Fohr.* Frieburg, 1925.
Schneider, A. von. *Carl Philipp Fohr. Skizzenbuch.* Berlin, 1952.

FRIEDRICH: Börsch-Supan, H. *Caspar David Friedrich.* New York, 1974.
Eberlein, K. K. *Caspar David Friedrich. Bekenntnisse.* Leipzig, 1924.
Einem, H. von. *Caspar David Friedrich.* Berlin, 1938.
———. "W. A. Joukowski und C. D. Friedrich." In *Das Werk des Künstlers*, I. 1939–40.
Ettlinger, L. D. *Caspar David Friedrich.* London, 1967.
Romantic Landscape Painting in Dresden. London, Tate Gallery, 1972. Essays on Friedrich by H. J. Neidhart and W. Vaughan.
Schrade, H. "Ph. O. Runge und C. D. Friedrich." In *Die grossen Deutschen*, III, 1936.
Traeger, J., ed. *Caspar David Friedrich.* Munich and New York, 1976.
Wilhelm-Kästner, K.; Rehling, L.; and Degner, K. F. *Caspar David Friedrich und seine Heimat.* Berlin, 1940.

HACKERT: Lohse, B. *Jakob Philipp Hackert.* 1936.

KERSTING: Gehrig, O. *Georg Friedrich Kersting.* Leipzig, 1931–32.
Vriesen, G. *Die Innenraumbilder Georg Friedrich Kerstings.* Berlin, 1935.

KOBELL: Lessing, W. *Wilhelm von Kobell.* Munich, 1923. 2nd ed., Munich, 1966.
Wichmann, S. *Wilhelm von Kobell. Monographie und kritisches Verzeichnis der Werke.* Munich, 1970.

KOCH: Lutterotti, O. R. von. *Joseph Anton Koch 1768–1839 (Denkmäler deutscher Kunst).* Berlin, 1940.

MENZEL: Kaiser, K. *Adolph Menzel.* Berlin, 1956.
Meier-Graefe, J. *Der junge Menzel.* Munich, 1914.
Wolff, H., ed. *Adolph von Menzels Briefe.* Berlin, 1914.

OLIVIER: Grote, L. *Die Brüder Olivier und die deutsche Romantik.* Berlin, 1938.

OVERBECK: Heise, C. G. *Overbeck und sein Kreis.* Munich, 1928.
Jensen, J. C. *Friedrich Overbeck.* Lübeck, n.d.

PFORR: Lehr, F. H. *Die Blütezeit romantischer Bildkunst: Franz Pforr, der Meister des Lukasbundes.* Marburg, 1924.

REINHART: Feuchtmayr, I. *Johann Christian Reinhart 1761–1847. Monographie und Werkverzeichnis.* Munich, 1975.

RICHTER: Neidhart, H. J. *Ludwig Richter.* Leipzig, 1969.
Richter, L. *Lebenserinnerungen eines deutschen Malers.* Leipzig, 1909.

ROTTMANN: Decker, H. *Carl Rottmann.* Berlin, 1957.

RUNGE: Bisanz, R. M. *German Romanticism and Philipp Otto Runge: A Study in Nineteenth-Century Art Theory and Iconography.* Dekalb, Ill., 1970.
Grundy, J. B. C. *Tieck and Runge: A Study in the Relationship of Literature and Art in the Romantic Period, with Especial Reference to "Franz Sternbald."* Strasbourg, 1930.
Langner, J. *Ph. O. Runge in der Hamburger Kunsthalle.* Hamburg, 1963.
Maltzahn, H. Frh. von, ed. *Philipp Otto Runges Briefwechsel mit Goethe.* Weimar, 1940.
Runge, P. O. *Briefe in der Urfassung.* Berlin, 1940.
Schrade, H. "Ph. O. Runge und C. D. Friedrich." In *Die grossen Deutschen*, III, 1936.
Simson, O. von. "Philipp Otto Runge and the Myth of Landscape." *Art Bulletin* 24, 1942.
Traeger, J. *Philipp Otto Runge und sein Werk: Monographie und kritischer Katalog.* Munich, 1975.

SCHINKEL: Rave, P. O. *K. F. Schinkel.* Munich and Berlin, 1953.

SCHNORR VON CAROLSFELD: May, H. "Zur Schnorr von Carolsfelds künstlerischen Entwicklung." *Wallraf-Richartz-Jahrbuch*, vol. 12, no. 13 (1943).
Singer, H. W. *Julius Schnorr von Carolsfeld.* Bielefeld, 1911.

SCHWIND: Busch, H. *Moritz von Schwind.* Königstein, 1949.
Halm, P. "Moritz von Schwind, Jugendgedanken und reifes Werk." *Eberhard Hanfstaengl zum 75. Geburtstag.* Munich, 1961.

SPITZWEG: Roennefahrt, G. *Carl Spitzweg.* Munich, 1960.

TIEPOLO: Bott, G. *B. Tiepolo. Das Fresko im Treppenhaus der Würzburger Residenz.* 1963.

TISCHBEIN: Stoll, A. *Der Maler Joh. Friedrich August Tischbein und seine Familie.* Stuttgart, 1923.

WASMANN: Nathan, P. *Friedrich Wasmann: Sein Leben und sein Werk.* Munich, 1954.

Page numbers are in roman type. Black-and-white figures and colorplates are specifically so designated. Titles of works are in *italics*.

PHOTOGRAPHIC CREDITS

Alinari, Florence, 4; Archiv der Österreichischen Nationalbibliothek, Vienna, 36; Bayerische Staatsgemäldesammlungen, Munich, 21; Wilhelm Castelli, Lübeck, 33; Deutsche Fotothek, Dresden, 15, 41; Freies Deutsches Hochstift, Frankfurt, 35; Germanisches National-museum, Nuremberg, 16; Gundermann, Würzburg, 1; Louis Held, Weimar, 5; Walter Klein, Düsseldorf, 53; Kleinhempel, Hamburg, 6, 17, 18, 20, 24, 25, 26, 27, 28, 29, 30, 31, 51; Landesbildstelle Rheinland, Düsseldorf, 13; Nationale Forschungs- und Gedenkstätten, Weimar, 19; Nationalgalerie, Berlin, 32; Helga Schmidt-Glassner, Stuttgart, 3; Staatliche Graphische Sammlung, Munich, 34, 45; Staatliche Museen, Berlin, 43; Staatsgalerie, Stuttgart, 47; Walter Steinkopf, Berlin, 8, 11, 14; Eberhard Zwicker, Würzburg, 2.
The following photos were supplied by the author: 7, 9, 10, 12, 23, 37, 38, 39, 40, 42, 44, 46, 48, 49, 50.